THE
MAKING OF AMERICA
SERIES

KISSIMMEE
GATEWAY TO THE KISSIMMEE
RIVER VALLEY

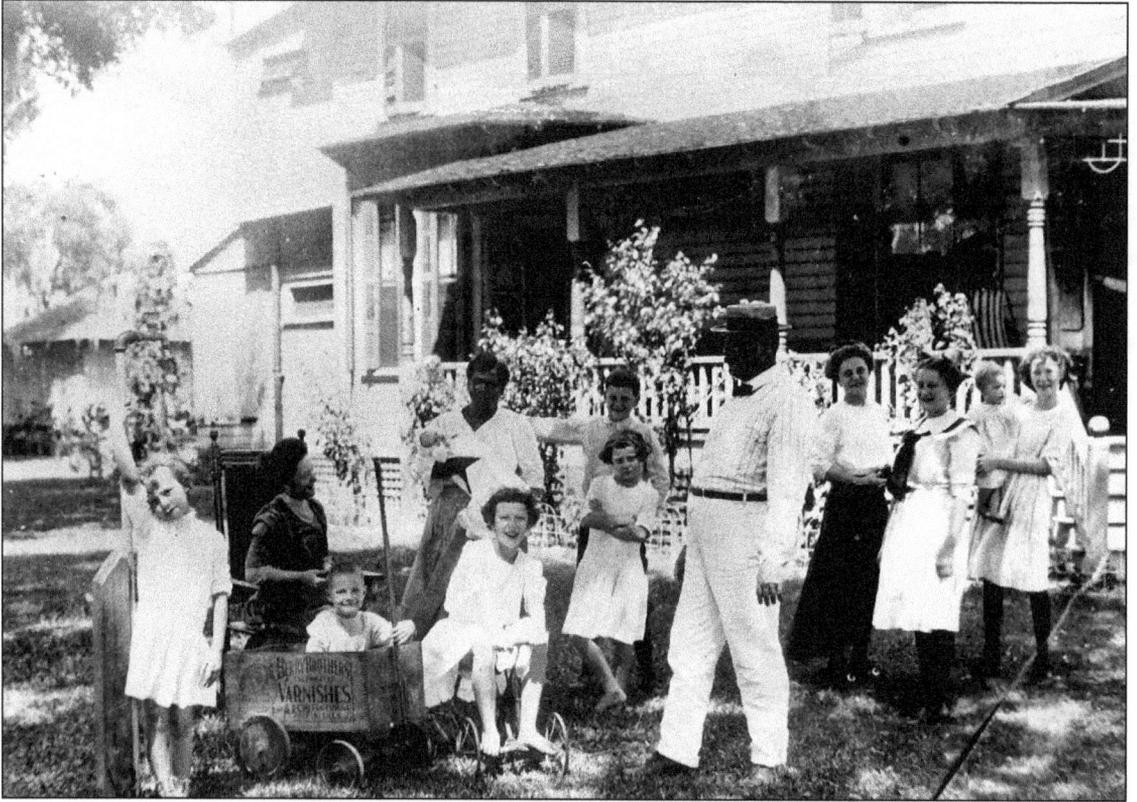

W.B. Makinson enjoys an afternoon with his family at their Kissimmee home at 404 Lake Street. Makinson's store sold lumber and nails and everything the early settlers needed. Trappers sold him hides, furs, and alligator skins. Makinson also would load a barge with groceries and other supplies and barter his goods for fish that settlers caught along the Kissimmee River and its lakes. Makinson's continues today as Osceola County's oldest business under the same family name.

THE
MAKING OF AMERICA
SERIES

KISSIMMEE
GATEWAY TO THE KISSIMMEE RIVER VALLEY

JIM ROBISON
OSCEOLA COUNTY HISTORICAL SOCIETY

ARCADIA

Published by Arcadia Publishing
an imprint of Tempus Publishing Inc.
Charleston SC, Chicago, Portsmouth NH, San Francisco

For all general information contact Arcadia Publishing at:
Telephone 843-853-2070
Fax 843-853-0044
E-Mail sales@arcadiapublishing.com
For customer service and orders:
Toll-Free 1-888-313-2665

Visit us on the Internet at http://www.arcadiapublishing.com

Front cover: *A downtown Kissimmee event in January 1927 shows the lengths to which Broadway merchants went to attract attention during the boom days of Florida land sales. The promotion was an open-air community dinner around a 900-foot table. An estimated 2,500–3,300 people gathered in downtown. Merchants served up 600 sandwiches, 75 gallons of coffee, 700 bottles of soda, 500 buns, 500 pounds of salad, 73 bottles of pickles and olives, 2,000 oranges, 1,800 bananas, 150 large cakes, 980 pounds of sliced ham, and 36 cases of minced ham.*

CONTENTS

ACKNOWLEDGMENTS

This book strives to provide readers with insights into Kissimmee's early families. It was made possible because of the efforts of David Snedeker and Clara Johnson of the Osceola County Historical Society. The society runs a research library and pioneer center on Bass Road. David and Clara helped in the selection of the photographs used to tell the stories of early Kissimmee and the river of the same name. The society's archives of photographs and research materials were built from donations from some of the county's leading ranching and citrus families. The author extends his thanks to David, for spearheading this project and for making his private collection available, and to Clara, for contributing her cheerful encouragement and for sharing some of the stories that cannot be told in print. A special thanks also is due to Will Wallace Harney, Joe A. Akerman Jr., Elizabeth A. Cantrell, Myrtle Hilliard Crow, Brenda Elliott, Arthur E. Francke Jr., Patricia R. Wickman, Gilbert A. Tucker, Ed Winn, Alma Hetherington, and the many Florida history authors who provided the research foundation for this book. *Orlando Sentinel* colleagues Jovida Fletcher, Joy Wallace Dickinson, Mark Andrews, Rick Brunson, Jerry Fallstrom, Mark Pino, Mark Skoneki, John Bersia, Don Boyett, John Babinchak, and especially Lee Fiedler and Maryanna Gentleman also earn thanks for their encouragement and guidance over the years. Finally, the author again thanks his wife, Robyn Robison, for giving up use of the dining room table during countless hours of organizing the photographs and text and overlooking the stacks of books and piles of papers cluttering the living room. Future generations of Kissimmee residents will owe thanks to the families who donated their photo collections and family memories to the society's archives. Sales of this book will help the Osceola County Historical Society continue preserving the heritage of the county's pioneer families.

INTRODUCTION

I am a spoiled American, Florida-style. Five home-delivery pizza chains serve my neighborhood. I can pull out of my driveway and get to a 7-Eleven in a few minutes, no matter what direction I drive. Last weekend, I drove the mile or so to return the Blockbuster videos, waiting for just the right parking spot to avoid walking too far. Then, I drove one lane over to park a little closer to the front door at Publix to grab a few things for dinner. If something in my household breaks, there are at least four warehouse-size superstores within a few miles with more choices than I need. American free enterprise and consumerism have spoiled me.

I mention this because I was thumbing through Elizabeth A. Cantrell's *When Kissimmee Was Young*. She writes of the Kissimmee of the late 1800s, "No small item of interest to a tropical community like ours was the news of the building of the first ice plant here, which was also one of the few south of Jacksonville, and was promoted by the Willsons of Kentucky and Tennessee who had been among the first of the new settlers." People lived in Florida before they had ice? Why?

Cantrell, who in the late 1940s wrote her book to chronicle the early days of Kissimmee, St. Cloud, and Osceola County, states that the first merchants served "all South Florida by rail and boat and buckboard." There's a reason people who managed to find their way to the flat pineland and cypress swamps that became Osceola County could just claim open land as their own or buy it for a few cents an acre. If they wanted anything they couldn't make themselves, it was a long, long trek to find it. Before the railroads of the 1880s reached Kissimmee, about the nearest place to go shopping was the cluster of wharves and trading posts on the south side of Lake Jesup. That was as far as the big St. Johns River steamboats could deliver cargo. Rugged wagon trails linked the docks at Tuskawilla and the settlements along Lake Tohopekaliga.

Osceola County's early settlers did much of their trading with W.G. White, writes Myrtle Hilliard Crow in *Old Tales and Trails of Florida*. Settlers in caravans arrived at White's wharf and camped nearby for several days while they stocked up on supplies. White employed up to six clerks when goods arrived by steamer.

White later opened another store in Orlando, and with Dr. W.J. Sears, he opened a Kissimmee store called White and Sears. The doctor would also open a Main Street drugstore. The White and Sears store was the beginning of what

would become Florida's oldest retail hardware store, downtown Kissimmee's Makinson Hardware Company. "This general merchandise store was purchased by M. Katz and Carroll Makinson," Crow writes. "They enjoyed a big trade from the surrounding country and the Kissimmee River, but for some reason they were unable to collect the large sums of money due them."

Family help arrived aboard the first train to run from Sanford into Kissimmee. William Burroughs Makinson, arriving from Maryland in 1883, invested $1,000 in his brother Carroll's business. W.B. Makinson eventually took over the business and in 1884 opened his hardware store. The two-story, wood-frame Makinson & Katz building was at what today is Darlington Avenue and Pleasant Street. It later burned.

J.M. Katz, sometimes identified as Moses Katz, was one of the first Jewish immigrants to reach Osceola County, writes Joseph Wittenstein in *A Chronology of the Early Jewish Settlers in the Orange County Area from 1875 to About 1925*. After the Makinson and Katz partnership ended about 1900, Katz opened a clothing store on Broadway. Makinson opened his hardware store on the same street, selling lumber and nails and everything the early settlers needed. He bought trappers' hides, furs, and alligator skins. Makinson would also load a barge with groceries and other supplies and barter his goods for fish settlers caught along the Kissimmee River and its lakes. He iced down the fish and shipped out boxcars to Northern markets.

Hum . . . I wonder if Makinson's would consider opening up a pizza chain.

—Jim Robison

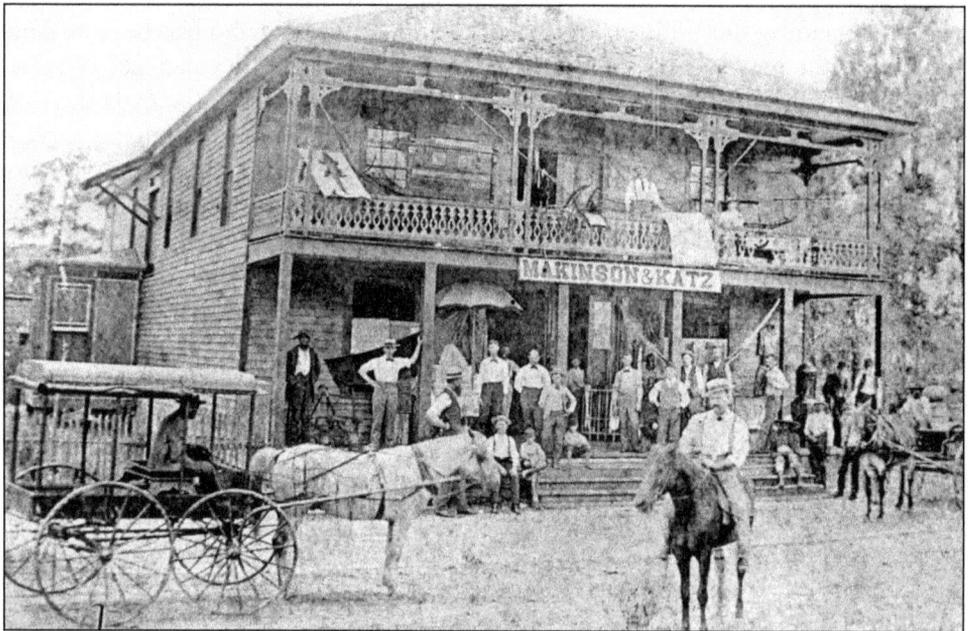

This is Makinson & Katz hardware store in the late 1880s, Florida's oldest retail hardware store, started as White and Sears and purchased by M. Katz and Carroll Makinson.

1. The Jororo and the Origin of the Kissimmee Name

The land of Florida's flats, just south of Lake Blue Cypress and west of Vero Beach, rises just enough from the pine and palmetto prairie and the cypress hammocks to send two major rivers in opposite directions.

About 125,000 years ago, the St. Johns River began its gentle flow north some 310 miles to the Atlantic Ocean at what now is Jacksonville. From roughly the same starting point but 40 miles further west, the Kissimmee River flows 80 miles south into Lake Okeechobee. The St. Johns, beginning in the marshlands at the Brevard–Indian River County line, slowly spills its way north to Lake Harney. Fed by natural springs—some of which have never been found—that begin north of Lake Monroe, the little St. Johns grows wider, swelling to 2 miles across when it flows past Palatka and stretches to become Florida's largest river. This was the land of the giant sloth with claws the size of men's arms and the saber-toothed tiger, standing 4 feet high at the shoulders and 9 feet long, with 6-inch fangs. The giant beasts of the St. Johns also included early alligators and huge armadillos called Glyptodonts, some 5 feet high and 9 feet long, plus elephant-like mastodons and mammoths, growing to 14 feet high and weighing 6 tons.

Much of the land between the St. Johns and the Kissimmee was low, flat marshland. For centuries tribes lived along meandering shorelines, marshes, and throughout nearby prairies and hammocks. Earlier tribes used the name "Ays" for the river now known by another tribal name—Kissimmee. That name might refer to the site where Spaniards led by Hernando de Soto slaughtered native people in about 1540. Then again, some books say it comes from a tribal word for "long water." Still others say its origin is two Seminole words meaning, roughly, a place where mulberries grow. Whatever the origins, a Spanish map used the name Cacema.

"Kissimmee" is traced to the Jororo, who were among the first tribes to settle along the Kissimmee River Valley. The Spanish documented missions set up in the 1600s to convert the Jororo and other tribes to Christianity. The Jororo village of Atissimi, sometimes spelled Jizimi or Tisimi, is believed to be the origin of the

9

Cypress trees, such as these along Lake Tohopekaliga, are similar to those found in the flatlands that send two major rivers in opposite directions.

Spanish mission identified on a 1752 map as Cacema, which over time became the current spelling, Kissimmee, for the river and the city on Lake Tohopekaliga.

The legacy of those early peoples—the treasure and trash buried under mounds of shells and soil raised from saltwater and freshwater marshes and wetlands—has survived the centuries. The Ais of the east coast and the Kissimmee River Valley in the middle of the state, the Calusa, Tequesta, and other tribes of South Florida and the Keys and the Timucua-speaking people of North Florida left mounds and middens that preserved the stories of Florida's

beginnings. A thousand years ago, Floridians—the children's children's children of those who had migrated to Florida from Siberia at least 10,000 years earlier, when glaciers held most of the saltwater of the oceans and a land bridge to the Americas opened from Asia—continued to pile up the shells of the ocean's bounty of clams and oysters.

The generations before them had lived in a different Florida. Their shoreline was as many as 150 miles farther out to sea. Inland, the land was dry with scrubs, grass prairies, and savannas. Freshwater springs created Florida's rivers and streams, and watering holes lured wild game. By 1100, the Floridians were building canoes to travel the rivers to hunt and fish. Historians assume that early Florida men and women divided their duties much the same as modern hunter-gatherer cultures: The men killed and butchered game and fish, and the women gathered fruits and nuts and prepared food.

By 1500, Florida's first people numbered as many as 350,000, and most of them disappeared during the next 200 years. They were the victims of European-introduced diseases, repressive attempts by missionaries to force their conversion to Christianity and use as slave labor, and execution for those who rebelled against the cultural changes that came with Spanish rule.

Frank W. Fogg of Hampton Falls, New Hampshire, shot this early 1900s scene of his family at Boggy Creek after the marshlands at the northwestern shoreline of East Lake Tohopekaliga were drained.

2. THE SPANISH ERAS AND THE FIRST CATTLE AND HORSES IN FLORIDA

Europeans washed over the Ais, Timucuans, the Tequestas, the Calusas, and all the other early tribes of Florida. The clash with European diseases, slavery, and warfare wiped the early tribes from La Florida. Florida's written history begins with the arrival of the first ships from Europe in the late 1400s. Florida didn't have any gold or silver, but the Old World turned this part of the New World upside down looking for treasure.

Hundreds of thousands of those first Floridians disappeared within a few generations of what historian Jerald T. Milanich terms "the invasion from Europe." The Spanish would call the land Los Mosquitos—mosquito territory—and the first settlers arriving at steamboat landings deep in Florida's interior knew why.

Until the mid- to late 1800s, few people lived very far from the coast. Most stayed near the old Spanish settlements at Pensacola and St. Augustine or to the south at Key West. Claims to Florida bounced back and forth between several nations. Spain gave up control of Florida in 1763 in a trade with Great Britain, which had captured Havana near the close of the Seven Years' War. In the mid- to late 1700s, land grants had persuaded British settlers, many from the West Indies, to establish ambitious sugar cane and indigo plantations and colonies along the St. Johns River. Growing and processing indigo for cloth dye provided substantial profits until a cheaper chemical dyeing process was developed.

Havana had been a major shipping port for more than two centuries, and Cuba was close to the West Indies, islands that prospered by exporting sugar, spices, and other tropical commodities. Britain chose to round out its possessions in North America—having also taken Canada from France at the end of the war at the same time. Many Spanish names were translated into English. A surveyor used the Spanish word mosquito to name the inlet and lagoon he found when he first sailed down the east coast of Florida from Georgia. Eventually, the name was used for the land as well. Osceola County was once part of the huge Mosquito County of Florida's territorial period.

Great Britain held on to Florida for 20 years, regarding it mostly as a military outpost. Florida became a haven for British loyalists who had fled rebel wrath in the other colonies, especially in 1782 after the fall of Charleston and Savannah. Although the United States did not take possession of Florida at the end of the Revolutionary War, Britain still lost it. A year after joining France in declaring war against Britain in 1779, Spain captured Pensacola and took control of western Florida. At the end of the war in 1783, Spain added the huge Louisiana territory farther west and also took possession of eastern Florida from Britain. The Spanish crown continued to encourage plantations on the vast Florida interior.

On February 7, 1806, the U.S. Senate approved a secret appropriation of $2 million to be used for the possible purchase of Florida for expansion by plantation owners. In the spring of 1818, General Andrew Jackson brought with him to North Florida his desire to drive the Creeks from the Southeast. The American hero at the Battle of New Orleans invaded Florida with 2,000 troops, prompting Spain to give up Florida.

With a few pen strokes on February 22, 1819, the signing of the Adams-Onis Treaty set up the end of Spain's claims to Florida. The deal, which required the United States to settle about $5 million in debts Spain owed to Florida property owners, wasn't final until February 19, 1821, when the U.S. Senate approved the treaty. With the exception of some early Spanish explorers and missionaries, no Europeans ventured south to what became Kissimmee until the 1830s.

Still, Spanish hogs, horses, and cattle had found their way to the land of the Kissimmee River. Many Spanish settlers had ranches on both sides of the St.

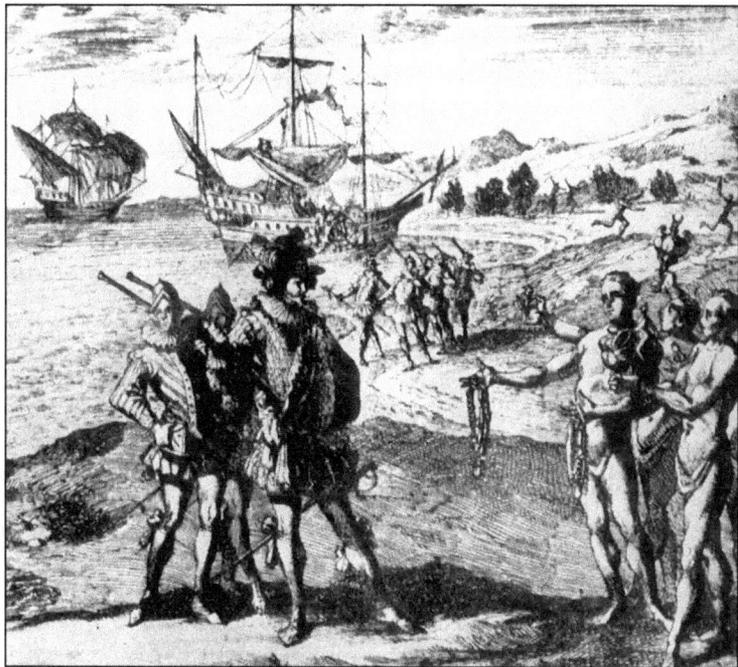

This European artist's painting recreates bartering with native tribes by the early Spanish explorers.

Johns River. It wasn't long until some of that livestock escaped into the wilderness of mostly open range, marshes, and woodlands.

Florida's wilds suited the hogs. Some of the roads Floridians and tourists travel today are there because of the hogs. Portions of U.S. Highway 17-92 and many of the other roads that wind around lakes started out as hog trails. Short, compact, and with plenty of weight behind them, hogs were trailblazers. Early tribes and later the military and pioneer settlers followed the same trails.Considering that the terrain was poorly mapped, making it easy to get lost in the swamps, it is not hard to see why early road builders took a look at the winding maze of paths around wetlands and lakes and decided the creatures were on the right trail.

Florida citrus grower and sometimes-author J.M. Murphy wrote in 1891 that portions of the state "are so overrun with wild hogs that even snakes and alligators have sought security in places to which the razorbacks have not yet penetrated." Murphy's "Florida Razorbacks" is a chapter in *Tales of Old Florida*, a collection of stories from the 1800s when Florida was a whole lot wilder. He wrote:

> It is even dangerous for armed men to pass through the haunts of the hogs, as the brutes seem to be always on guard and to have eyes, ears and nostrils educated to perfection for their purpose. They are ready to fight with or without provocation, and being stupid, stubborn, daring and malignant, they would rather die in their tracks than yield an inch of

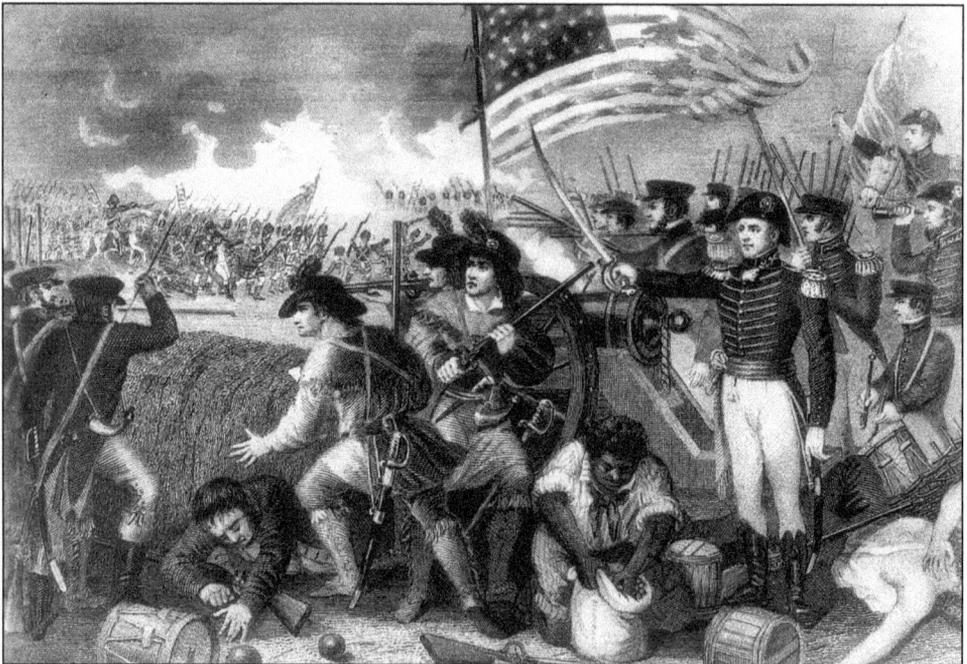

The Battle of New Orleans, a victory over the British during the War of 1812, established General Andrew Jackson as an American hero.

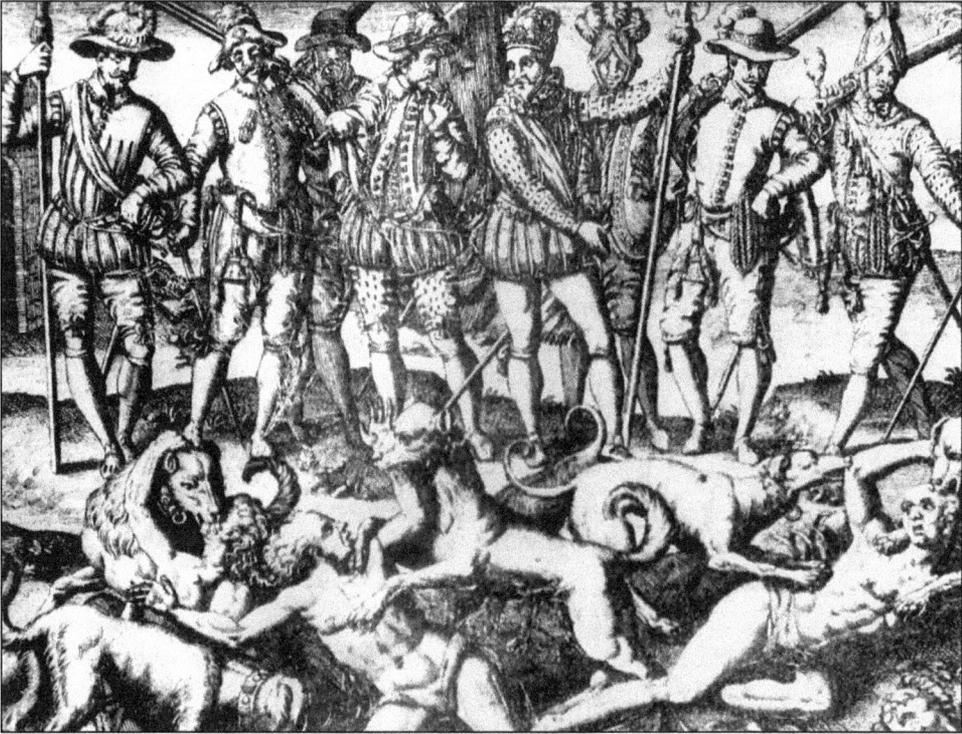

The slaughter of native tribes by Spaniards led by Hernando de Soto is shown in this scene of dogs attacking native people.

> ground to a foe. . . . I doubt if there are many old hunters in Florida who would not rather face a pack of wolves or family of pumas than a sounder of razorbacks flushed with a recent victory.

Murphy wrote that a wild hog seemed perfectly suited to Florida's wilds, "its legs being long, lean and sinewy, its hocks short, its body attenuated to the verge of the ridiculous, its snout prolonged and tapering, its skull low and elongated, its neck scrawny and its back arched in the center and sloping gradually toward the flanks." He added that hogs—"all muscle and activity"—were major nuisances for citrus growers:

> These porcine vagrants are the bane of the orange growers of Florida for no fence is strong enough to keep them out of a grove, and a pack of dogs cannot drive out a small herd—if they once get inside—in 24 hours, unless they are helped by a man or several men. I have had the brutes turn on me while trying to drive them out of the grove and chase me up a tree or else force me to kill them with my rifle.

But, he adds, at one time hogs were the saviors for pioneer families. When the pine forests and prairie of the Kissimmee River Valley were full of black bears,

wolves, alligators, and bobcats, hogs saved other livestock from harm. "Ferocious animals were so abundant in Florida at one time that the farmers could not raise any stock, it being nothing unusual for them to find all the hogs, sheep and calves in the barnyard destroyed in a night by a bear, puma or pack of wolves," Murphy wrote. He continued:

> While matters were in this discouraging condition, it was accidentally learned that spayed hogs were the most daring fighters in the forest. The farmers promptly availed themselves of this knowledge, and thereafter made these amazons not only the guardians of the sounders but the protectors of every defenseless domestic animal that roamed the forest. They not only held wolves, bears, pumas and alligators at bay, but actually drove them from the vicinity of settlements.

The wild hogs are not welcomed at Forever Florida, William Broussard's 3,200-acre nature preserve that adjoins his 1,300-acre Crescent J cattle ranch in eastern

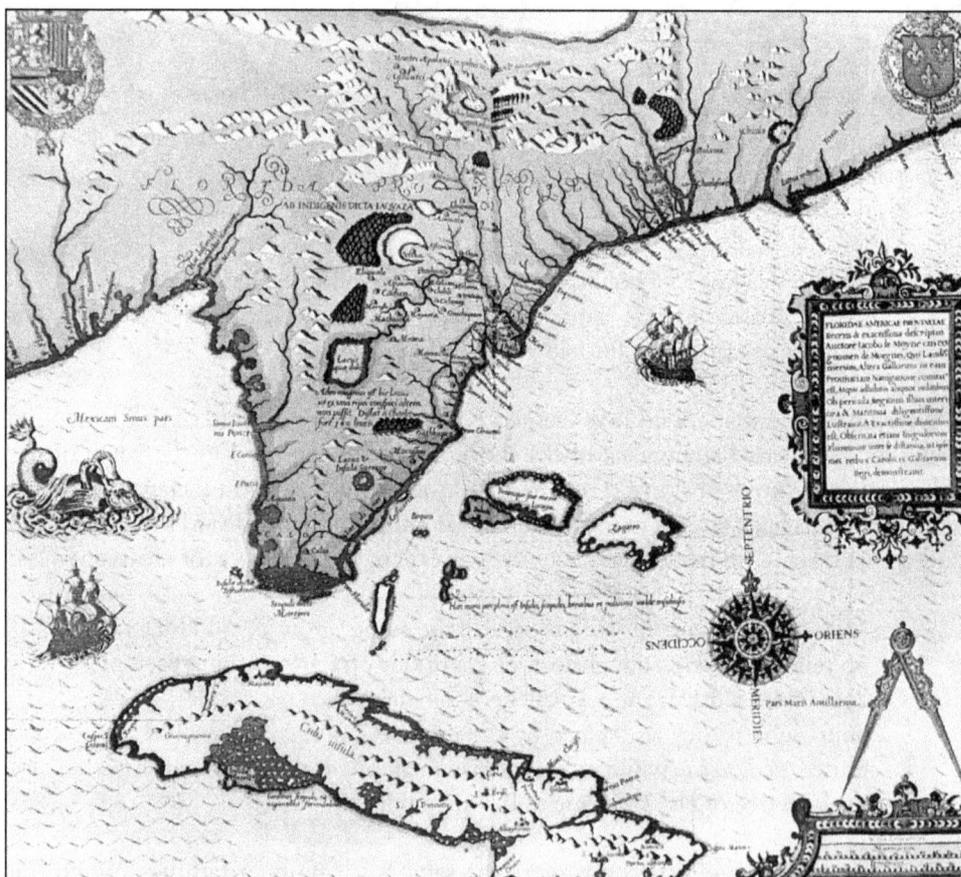

Cartographer Jacques le Moyne drew this early Florida map from his travels with a French expedition.

This Spanish mission built near Tallahassee is typical of the villages established in the 1600s to convert Florida's tribes to Christianity.

Osceola County. But Broussard owns one of the largest herds of Cracker horses anywhere, all from the blood lines of the Spanish horses brought to Florida centuries ago. Broussard has a growing herd of Cracker cattle, too. Florida Cracker horses share the genes of horses the Spanish brought to the Caribbean islands, Cuba, and North, Central, and South America. They include the Spanish mustang, Paso Fino, Peruvian Paso, and Criollo.

In Florida, the Cracker horses escaped or were let loose. They roamed free. Natural selection and the Florida environment produced horses that "excelled as working cow ponies," according to a history written for the Forever Florida website. "Although best known for their talents at working cattle, Cracker Horses were frequently pressed into service as buggy horses, work stock and, in many instances, were the only horse power for many family farms well into the twentieth century. They are indeed a vital part of Florida's agricultural heritage and are very deserving of a place in Florida's future."

More than 100 horses—and sheep, hogs, and cattle—came along when Pedro Menendez de Aviles established a Spanish colony in St. Augustine in 1565. Others established ranches along the St. Johns River.

Several Central Florida history books, including Minnie Moore-Willson's *History of Osceola County* and Alma Hetherington's *The River of the Long Water*, suggest that Spanish explorer Hernando de Soto's trek in search of Florida's gold

17

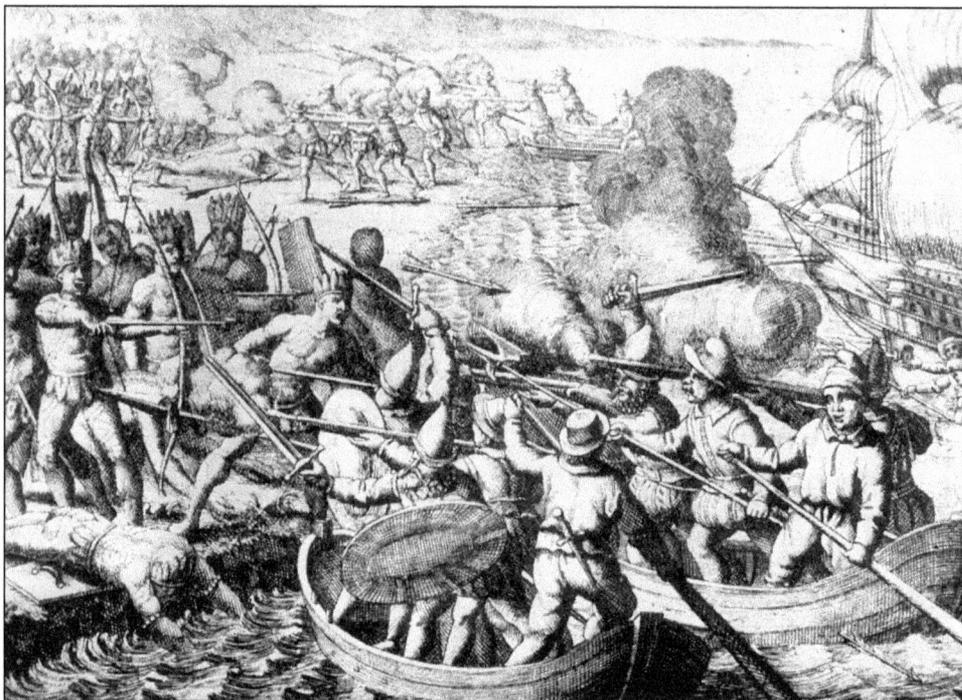

Warfare between Spaniards and the native tribes of Florida, as well as slavery and European diseases, would wipe out nearly all of the early tribes.

led him to a native settlement at what today is Walt Disney World. Some believe he crossed the Kissimmee River at the spot where Osceola, Highlands, Polk, and Okeechobee Counties meet. But Michael Gannon's *The New History of Florida* includes a map showing the explorer marching north from Tampa Bay and skirting far to the west of the Orlando area. So if any horses ever got here during the Spanish era, they would have been wild horses, or they arrived as the new mounts of exiles from tribes of the Southeast.

About 1,600 Chickasaws were among the tribes of the Southeast who filtered into Florida before the United States took it away from Spain in the early 1800s. Horses bred in southern Spain or the Caribbean for speed and stamina were brought to Florida. Some became the famed Chickasaw horses, sprinters favored by the gentlemen match racers of the American colonies and the forerunners of the American quarter horses. Nelson C. Nye writes in *Champions of the Quarter Tracks* that the planters of Virginia and the Carolinas imported Chickasaw horses from Florida for their racetracks. "In America the sport of match racing was an established pastime of the gentry as early as 1600, not everywhere of course, but in certain colonies," he writes.

Three hundred years after the Spanish introduced horses to Florida with Arab and Turk bloodlines going back to the crusades, pioneer families, often called Crackers, drifted into Central Florida's pine and palmetto flatlands. Some of their

wagons were drawn by Chickasaw horses. Later they broke these horses to help them chase wild horses and cattle (rangy offspring of Spanish herds) from the scrub lands of the St. Johns. The Crackers, a name some attribute to the snapping sound of their whips and that others say comes from their diet heavy with cracked corn, drove cattle to the coast and loaded them into ships bound for Cuba. Cattle trade with Cuba filled Cracker saddlebags with Spanish gold. In this way, the Florida Cracker horses share a circular bloodline right back to the Spanish era.

Florida's wilderness also was a haven for Africans escaping slavery. As early as 1526, nearly 40 years before Spain established St. Augustine as the first permanent European settlement in what is today the United States, African slaves escaped when Spaniards mutinied at the failed San Miguel settlement along the Georgia coast. The Africans fled into the wilderness and joined native tribes.

Spanish explorer Ponce de Leon had stumbled upon Florida in 1513 and claimed it for Spain. Twenty years later, Hernando de Soto had explored the Gulf Coast of Florida, landing somewhere in the area of Tampa Bay and possibly venturing inland as far as the Kissimmee River. Pedro Menendez de Aviles landed on the east coast, establishing the first permanent settlement at St. Augustine in 1565. In each case, African slaves escaped and joined the native tribes.

By the time the Spanish had established St. Augustine, Africans had established their villages. During his exploration of the new land, Menendez found Luis and

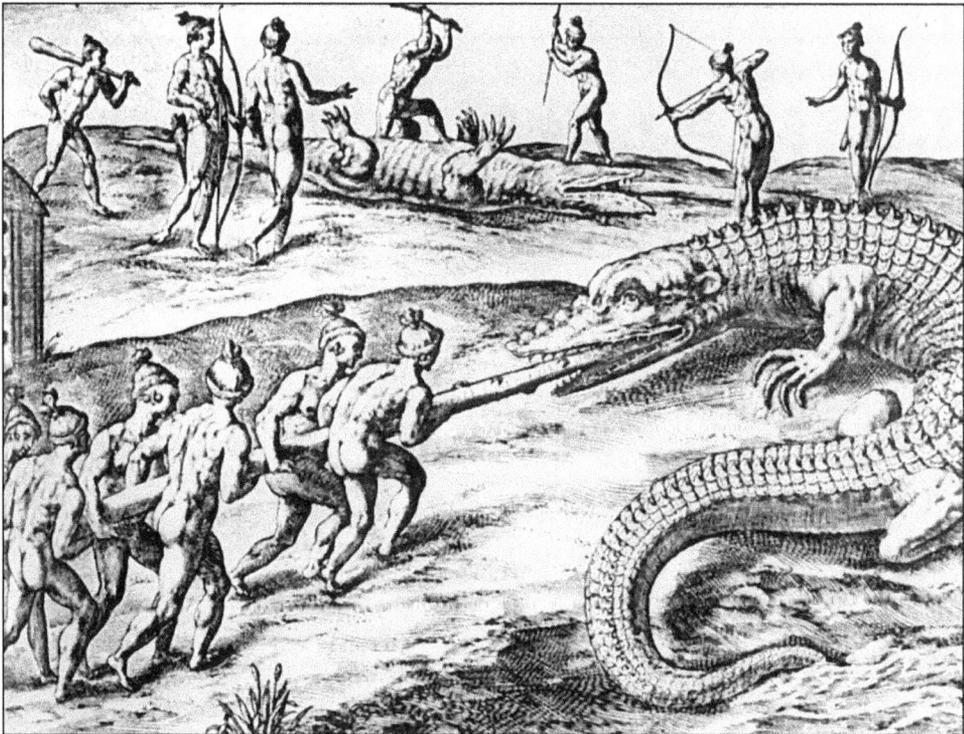

This sketch by Jacques le Moyne shows how the Florida tribes hunted for giant alligators.

described him as a shipwrecked mulatto man living among the Ais villagers. Many other Africans would find sanctuary in Florida. Marriages of former slaves and the Ais irritated Menendez, who needed laborers from the native tribes.

By 1683, though, free black people and some slaves had formed a militia at a St. Augustine satellite settlement that became Fort Mose. News of the existence of the African-run fort reached slaves on the English plantations of Georgia and the Carolinas. General James Oglethorpe destroyed the first Fort Mose, but the black militia helped turn back his 1740 assault on St. Augustine. Once rebuilt, Fort Mose allowed Africans to farm land and build houses, further increasing its allure to American plantation slaves. The numbers of Africans climbed during the American Revolution. Spain, which temporarily lost Florida to England, regained it after the Americans defeated the British. The chaos allowed more plantation slaves to flee to Florida.

Florida had remained a loyal—or at least neutral—British colony when the original 13 colonies went to war to win their independence. Slavery was practiced throughout the American colonies, and during the American Revolution, British planters moved into what was called East Florida. Florida's population spiked by 12,000 new people. An estimated 75 percent were Africans. Very few were free, and most of those served in the British military.

When Spain took back Florida after the American Revolution, slaves again took advantage of the chance to escape in larger numbers to the remote

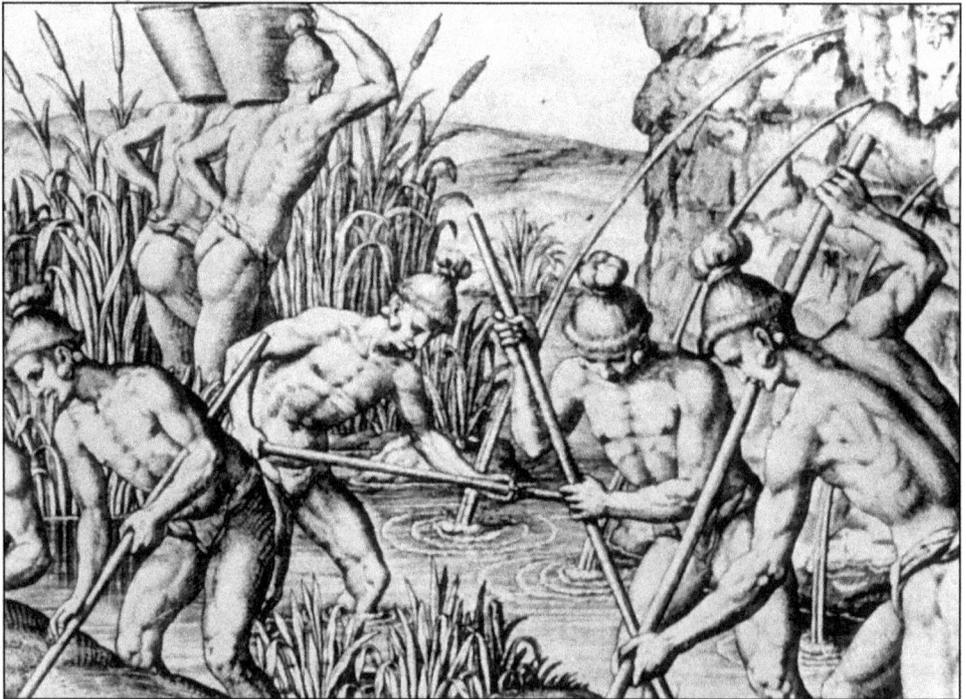

Early tribes, drawn by a European artist, are shown fishing with spears.

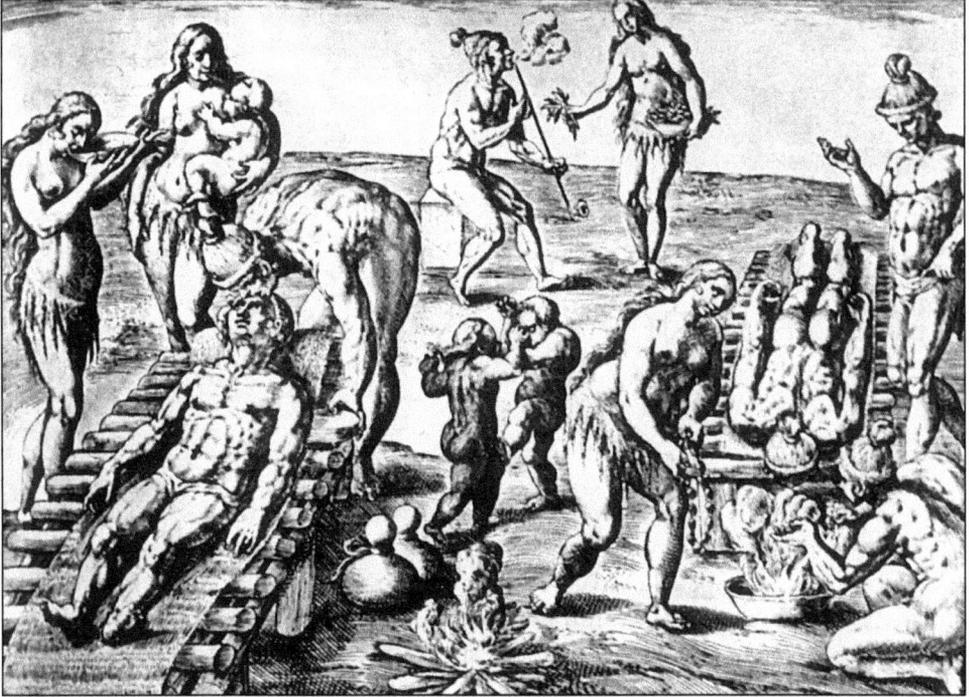

Le Moyne drew this scene of native medical treatments, including bloodletting.

wilderness of the Florida frontier. They took sanctuary among the growing Seminole nation and the Spaniards, who lured Africans by giving them sanctuary and opportunities to win freedom by converting to Catholicism. A black overseer named Edimboro ran a Spanish cattle ranch. Juan Bautista Collins, a black merchant, traveled throughout the Spanish ranches and settlements and deep into the Seminole lands.

The alliance of former slaves and the Seminoles mounted three wars over four decades against U.S. forces bent on removing the Seminoles from Florida and recapturing slaves for American plantation owners.

3. Osceola, Wildcat, and the Seminole Resistance

Lake Tohopekaliga's name is closely associated with the Seminoles, who fled into the vast wilderness of Central Florida and lived on island sanctuaries in the lake. The islands of Tohopekaliga (or "fort site") provided thick, dense forests that shielded Seminole villages from the view of U.S. Army patrols.

The Creek word for fort is *tohopke*. The spellings Topkoliky and also Tohopkeliky appear in the journal of Myer M. Cohen, an officer during the Seminole wars. "There is a large lake, containing a number of islands, upon the largest of which Philip is established," according to Cohen's *Notices of Florida: The Campaigns*. Philip or Philiptown or even Philip's Town are references to a Lake Tohopekaliga island village of Seminole chief Emathla, known to the army as King Philip, who selected the island because its thick foliage provided stockade-like protection for his family while he led raids on sugarcane plantations and for freed Africans who joined the Seminoles as allies against the army. It was his sanctuary or "fort site."

"This island is surrounded with water so deep, that it cannot be forded, except in one place, nor can it be approached from any point without discovery," Cohen writes. "Here the old chief resides, with his women, children, old men and negroes, attending to the cultivation of his crops, whilst his warriors are marauding about the country." In the years to come, Philip's son, Coacoochee, who was born on the island in 1807, carried on his father's battle. Coacoochee, a fierce warrior known to the army as Wildcat, led the February 8, 1837 attack by more than 200 Seminoles on the army camp on Lake Monroe. His battle cry, according to Dr. Jacob Motte's war journal, was "tohopeka."

Cohen lists a battle at Tohopka as one of the "forts of Indian allies" where General Andrew Jackson defeated the Creeks of the Southeast before invading Spanish Florida, an act that set off the first of the three Seminole wars and led to Spain's decision to let the United States take Florida in 1821. Raiding bands of renegade Creeks—who would later be joined by runaway slaves to become Florida's Seminoles—forced settlers to abandon their plantations and colonies. Soon, all the white settlements in interior Florida had been destroyed or abandoned, except for a few widely scattered trading posts.

When Florida became a U.S. territory, it had just two counties. The former Spanish East Florida was all St. Johns County and West Florida was Escambia County. Three years later, Mosquito County was established, covering much of Central and South Florida. In 1830, the sprawling county had but 733 white settlers and about the same number of black slaves. The U.S. Army came down the St. Johns River and established a string of inland forts that stretched to the gulf as part of the military's effort to drive the Seminoles out of Florida and capture runaway slaves.

Wildcat would become one of the last of the great Seminole chiefs in Florida. His childhood ended with the beginning of the Seminole wars, which were sparked by Andrew Jackson's determination to punish the Seminoles for giving asylum to runaway slaves and to force all the tribes onto land west of the Mississippi River. Wildcat spoiled many of the military's attempts to negotiate with the Seminoles, rallying scattered Seminoles, leading ambushes, and evading soldiers by disappearing into the swamps.

In the cypress swamps of Reedy Creek west of what today is Kissimmee, hit-and-run Seminoles were spotted by an army scouting patrol. General Thomas Sidney Jesup, then in charge of the 8,000 troops in Florida, had assembled about 1,000 troops at a site approximately where Kissimmee's airport is today. On January 26, 1837, a patrol encountered Seminoles near the north end of Lake Tohopekaliga.

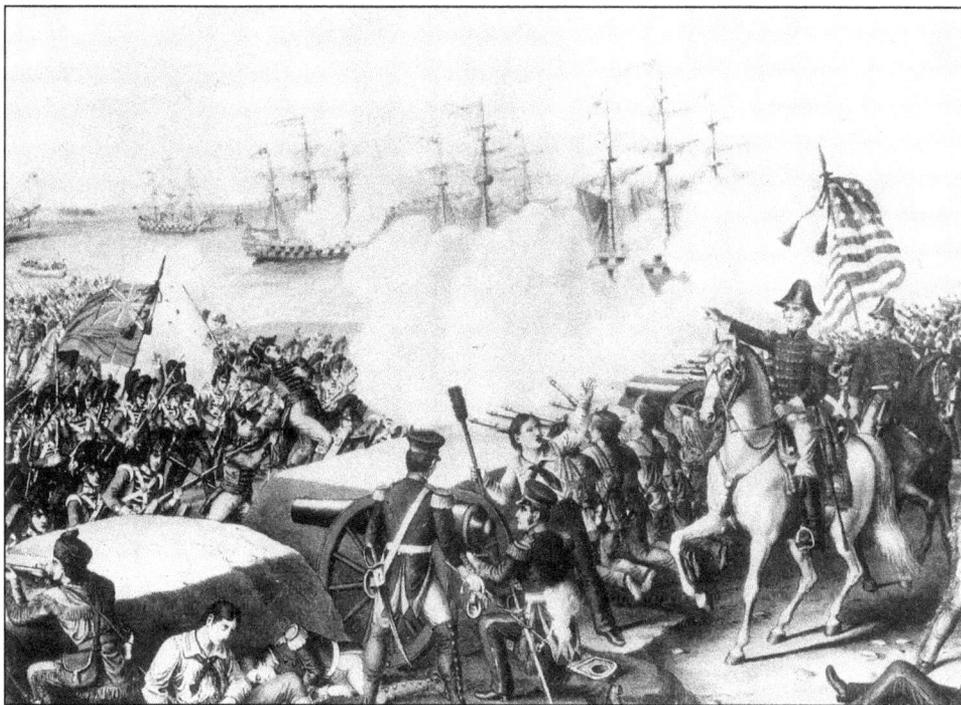

General Andrew Jackson, shown on horseback at the Battle of New Orleans, soon carried his war on the Creeks and escaped African slaves to Florida.

A daylong battle followed, but the Seminoles disappeared into a 15-square-mile swamp known to them as Hatcheeluskee, which means "big swamp." Jesup's troops attempted to give chase but retreated when fired upon by an enemy they couldn't see. The army managed to capture 25 Seminoles and black allies—mostly women and children—and Seminole supplies, cattle, and horses.

Still, Jesup later wrote, he chose to save his troops from further losses in the swamp. The difficulty of fighting the Seminoles in the Florida swamps, Jesup wrote, "can be properly appreciated only by those acquainted with them." After other similar encounters with the Seminoles, Jesup ordered construction of a series of forts about a day's march apart from Sanford to Tampa, including several along the St. Johns and Kissimmee Rivers. Many were abandoned soon after, but several became pioneer communities. Fort Gardner was on the west side of Lake Kissimmee. Fort Taylor was near the St. Johns at what today is the Orange County line.

Fort Basinger was south along the Kissimmee River. It was named for Lieutenant William Elon Basinger, who just two weeks before his death on December 28, 1835, wrote his mother that Fort Brooke on Tampa Bay had been

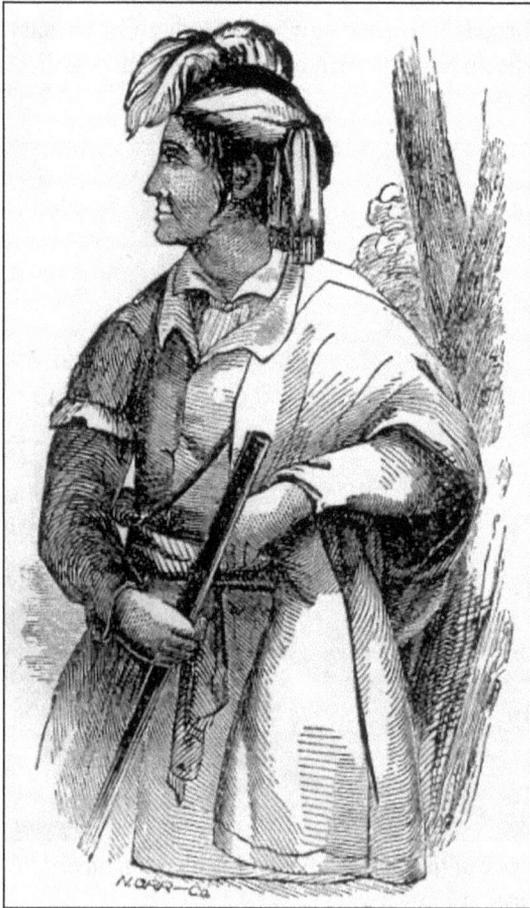

Coacoochee, known to the army as Wildcat, was born on the island in Lake Tohopekaliga his father selected because its dense forest provided protection for his family while he raided plantations. Wildcat led the February 8, 1837 attack by more than 200 Seminoles on the army camp on Lake Monroe. His battle cry, according to Dr. Jacob Motte's war journal, was "tohopeka," which he said was their term for a fort or strong place.

fortified in anticipation of a Seminole attack. "But everything is finished and . . . all the Indians in Florida could not do us the slightest injury," he wrote.

Such words were with him when he marched through the protective gates at Fort Brooke with troops headed to relieve soldiers at Fort King near Ocala. He had no way of knowing the Seminoles had planned an ambush of Major Francis L. Dade and his men near what today is Bushnell. Basinger, 29, of Savannah, Georgia, was one of the 105 deaths at the Dade Massacre.

The frontier citrus and cattle communities of Fort Basinger and Basinger on opposite sides of the Kissimmee River are named for this professional soldier. The area was part of Osceola County until 1917, when the legislature sliced off a portion of southern Osceola, added portions of St. Lucie and Palm Beach Counties, and created Okeechobee County.

Basinger commanded Company C, 2nd Artillery Regiment. Young and handsome with a short black beard, he was admired by other officers and the men under their command. He excelled at everything, and others looked to him for strength. At West Point he had succeeded Cadet Adjutant Robert E. Lee and graduated second in his class. Others were confident in his leadership.

On the fifth day of their 50-mile march, Dade's soldiers already had passed through what they considered the most dangerous portion of their journey. They were relaxed as they entered pine woods southeast of Wahoo Swamp. Some had seen signs of Seminoles, but none were aware that they had been watched every day since leaving Tampa Bay. The woodland was cold and the soldiers buttoned their overcoats over their cartridge boxes. Their march was ending, and their commander had promised a delayed Christmas celebration at Fort King. And they did not know that their army guide, a slave named Louis Pacheco, might already have tipped off the Seminoles of the site where they could attack and that he would duck to safety and later join them for protection.

On the same day of the slaughter of the Dade troops, Osceola ambushed and killed Indian agent Wiley Thompson near Fort King, the key event that touched off the Second Seminole War, which molded the image of the Seminole resistance leader as a martyr. The circumstances of Osceola's arrest and his death in captivity gave him a worldwide reputation.

Captain John Masters was one the officers General Thomas J. Jesup ordered to arrest Osceola even though the Seminole leader expected protection under a white flag of truce. Masters was a descendant of Minorcans who were part of the Turnbull colony that came to New Smyrna in 1768 and later moved to St. Augustine. John Masters's name was anglicized from Juan Pablo Mestre. He served under the military command of General Joseph Hernandez, a Spanish planter with a personal grudge against the Seminoles, who had raided his plantation near St. Augustine and driven off his African slaves.

Jesup sent Hernandez to meet Osceola and arrest him. J. Leitch Wright Jr.'s *Creeks and Seminoles* describes the scene: "A white flag previously given to the Indians waved over Osceola's camp. . . . As the parley began, Hernandez's men unobtrusively surrounded the Indians and then, without a shot, captured them."

25

That is pretty much the same account given by most historians. Kissimmee historian Millie Moore-Willson adds in *The Seminoles* that years after the arrest, "an old soldier, John S. Masters," told his story of seeing "Osceola knocked down with a musket butt," a detail John K. Mahon, author of *History of the Second Seminole War*, writes is not supported by contemporary documents.

Masters, described in family heritage as "an unwilling member" of the group of soldiers who arrested Osceola, is quoted in an article that appeared in the *Jacksonville Times-Union* on August 2, 1896. Masters said the arrest "was not a capture, but a breach of confidence." The eyewitness account of Masters, who lived to be 94, contributed to Jesup's lifelong attempt to clear his name. Mahon writes that Jesup claimed Osceola once killed a messenger sent with a truce flag and that Osceola often used a white flag to gain safe entrance to St. Augustine and spy on the army. He also claimed the Seminoles had broken truces and continued raids. Capturing Osceola even when he flew the white flag was justified because Jesup said drastic measurers were needed to end the war.

John Ross, a powerful Cherokee, persuaded the U.S. Senate to investigate Jesup's action. The general was cleared, but historians nevertheless have vilified him. Enough continuing dissent was stirred up to force Jesup to write a defense

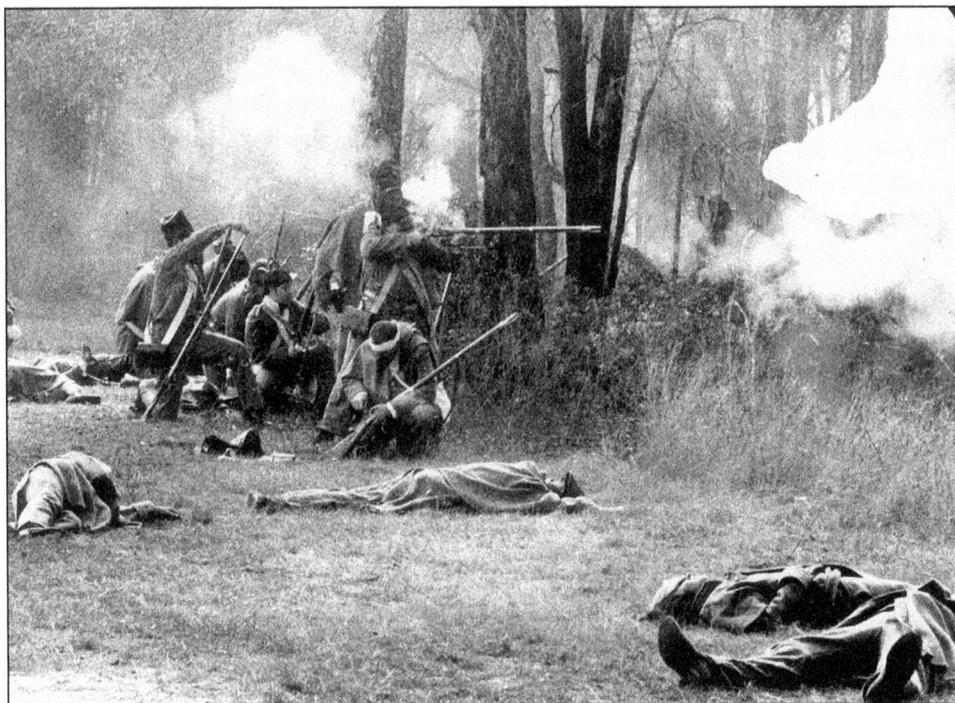

This re-enactment shows troops under Major Francis L. Dade defending themselves during the Seminole ambush near what today is Bushnell. Fort Basinger along the Kissimmee River would be named for Lieutenant William Elon Basinger, who was among the more than 100 soldiers killed at the Dade Massacre on December 28, 1835.

Osceola, who became the best known among the Seminoles resisting the army's effort to drive them out of Florida, is shown at Lake Monroe.

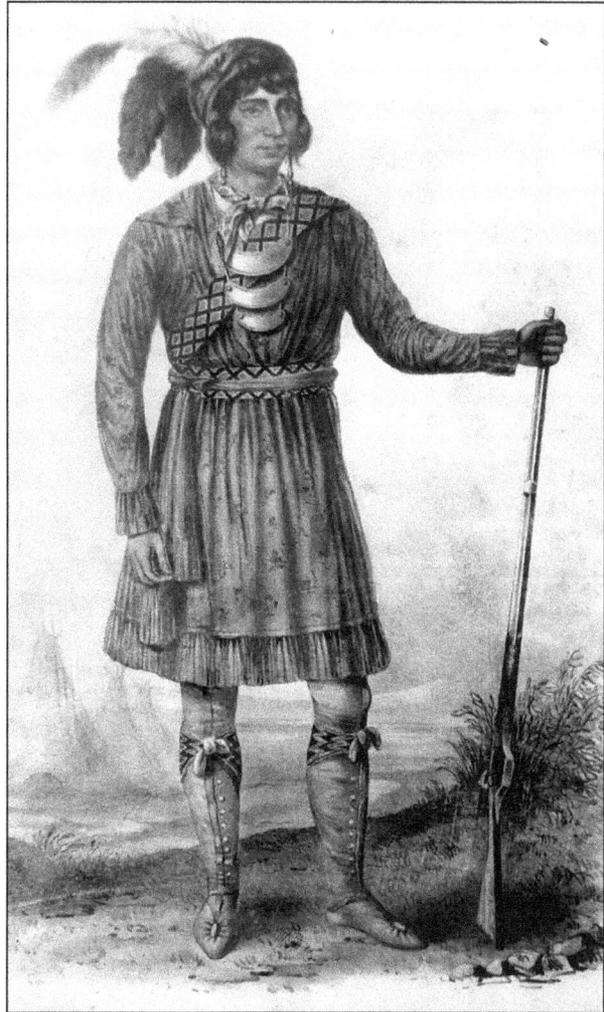

of his action in *The New York Times*. "General Jesup may finally have convinced himself of the honorableness of his conduct, but he was still writing justifications of it twenty-one years later," Mahon writes. "Viewed from the distance of more than a century, it hardly seems worthwhile to try to grace the capture with any other label than treachery." Mahon adds, "Floridians nearly to a man approved of what he had done."

Osceola was among 237 Seminoles who on December 31, 1837, were taken from St. Augustine to Fort Moultrie on Sullivan's Island near Charleston, South Carolina. Besides his fevers, Osceola's failing health was complicated by abscessed tonsillitis. Osceola died January 31, 1838, at age 34. He was buried at Fort Moultrie.

There's a touch of irony that the Seminoles of today give Jesup a break. *The Seminole Tribune*, the newspaper published by the Seminole Tribe of Florida, has portrayed Jesup as acting more out of frustration and desperation than evil.

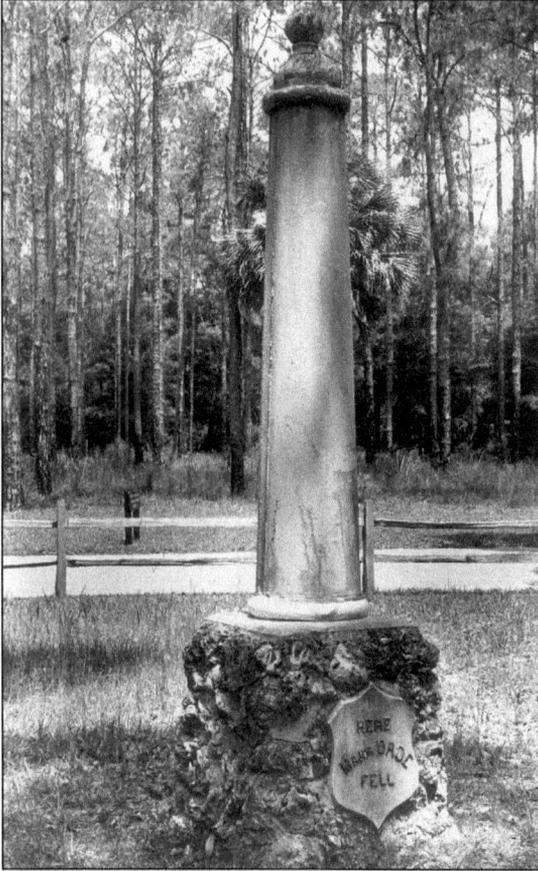

A monument marks the spot at the Dade Battlefield where Major Francis L. Dade was killed during the first shots fired by Seminoles when they ambushed troops on their way to Fort King near Ocala. On the same day, Osceola killed federal Indian agent Willey Thompson. The acts touched off the Second Seminole War.

Osceola's health was failing, but he had plenty of fight left, according to the newspaper's 1988 series on Jesup and Osceola.

A youthful son of a powerful chief would carry on Osceola's resistance war. His father was the Miccosukee chief Philip and his mother was the sister of powerful Micanopy, the head of the Alachua Seminoles. But in late winter 1841, Wildcat looked more like an out-of-place stage actor. He was dressed in the theatrical garb of Hamlet. Several other Seminole leaders and warriors also were clothed in Shakespearean costumes.

Near St. Augustine a few days earlier, they had attacked and murdered a traveling troupe of actors and seized their wagon and stage attire. Dressed as the Danish prince from Shakespeare's tragedy, Wildcat had come to Fort Cummings, near what today is Lake Alfred. There he would deliver his most eloquent statement to Walker Armistead, then commander of the army in Florida.

The date was March 5, 1841—four years after he and his father had led 300 Seminole warriors in a frustrated attack on Camp Monroe, the supply post and staging area for army troops just a few miles from the Seminole settlement at Lake Harney. During his long address, Wildcat told his foe:

> I have said I am the enemy to the white man. I could live in peace with
> them, but they first steal our cattle and horses, cheat us, and take our
> lands. The white men are as thick as the leaves in the hammock; they
> come upon us thicker every year. They may shoot us, drive our women
> and children night and day; they may chain our hands and feet, but the
> red man's heart will be always free!

Historian John Mahon, whose writings on the Second Seminole War include this passage from Wildcat, said the young chief was famed for his valor and leadership in battle.

His daring escape from the Spanish-built fort at St. Augustine by starving himself to become thin enough to slip through narrow bars inspired and rallied scattered Seminoles. Wildcat would go on to frustrate the army, leading ambushes, then evading soldiers by disappearing into the swamps where troops were bogged down with supply wagons and artillery. Wildcat also joined 400 warriors under two other Seminole chiefs who battled Zachary Taylor at one of the biggest confrontations of the war north of Lake Okeechobee on Christmas Day 1837. Taylor claimed a victory because the Seminole fled, but twice as many soldiers died and five times as many were wounded.

Still, the Seminoles remained an elusive foe. Taylor later drew national criticism for bringing in Cuban-bred bloodhounds to track the Seminoles. The nation was outraged that packs of dogs would be used against the Seminoles. Taylor was not alone in using drastic measures to fight the Seminoles. Colonel William Harney, for whom Lake Harney on the St. Johns River takes its name, once used tribal disguises and dugouts for his troops to attack a Seminole camp.

After four hard years of fighting, Wildcat was broken and tired. He was willing to surrender to end the army's campaign to exterminate or force the Seminoles to share land west of the Mississippi with the Creek, bitter rivals of the Florida Seminoles. In the coming months he would travel between military camps, where he gathered free food and whiskey for his supporters and tried to persuade other chiefs to surrender. At one point, he was slapped in irons and shipped to New Orleans, but before he reached the Indian Territory, Colonel Williams Worth, the new army commander, ordered his return. The colonel's plan was to force the chief to use his influence to bring other Seminoles into camp.

Frustrated in battle, Worth and other army commanders had turned to capturing Seminoles who came into camp under white flags. The army, knowing the fighting and harsh winters had killed Seminole crops, also used food and whiskey to lure Native Americans to surrender.

Degraded by manacles on his hands and legs and knowing his daughter was also imprisoned, Coacoochee was aboard a military ship off Florida's west coast. Coacoochee addressed Worth, "You have brought me back; I am here; I feel the irons in my heart." Wildcat was 30 years old in October 1841 when he and 320 adults and children left Florida by ship. From New Orleans, the exiles traveled west by foot and wagon with limited rations and clothing.

The following spring, Worth used the same tactics to capture Seminoles who had fled to the Everglades and Big Cypress Swamp. Facing limited success, Worth gave up trying to round up the scattered Seminoles. On August 14, 1842, the U.S. government declared the war ended. Some 3,800 Seminoles and black allies had been forced to Western reservations.

No truce was even signed to end the costly war. The government, which spent $40 million, more than the cost of the American Revolution, failed to defeat the elusive Seminoles in battle. Still, the war's end brought government offers of 160 acres for those brave enough to settle Florida's interior.

Settlers arrived by steamboat on the St. Johns River to the community of Mellonville, which had been one of the military's major staging areas during the war. Mellonville would become one of the first county seats for the new Orange County, carved out of the former Mosquito County in 1845, the same year Florida became a state.

Coacoochee, whose father died on a ship before reaching the West, migrated to the hills of Mexico, where he died of smallpox in 1857. Soon, the army's attention was drawn away from Florida's remaining Seminoles by the approach of another war, this time between the Union and the Confederacy.

At the turn of the last century, a Kissimmee couple helped organize Friends of the Florida Seminoles. "In 1899, an organization known as the Friends of the Florida Seminoles was formed in Kissimmee, and it began pushing a program aimed at assisting the Indians," writes Seminole historian James M. Covington in "Formation of the State of Florida Indian Reservation," published in the July 1985 issue of *The Florida Historical Quarterly*. "Prime movers in the drive to obtain a state reservation for the Seminoles were James Willson Jr., a Kissimmee real estate man, and his wife, Minnie Moore-Willson, who wrote the popular *The Seminoles of Florida*, published in 1896," Covington adds. Lobbying efforts by the Willsons prompted Florida lawmakers on May 28, 1899, to set aside 36 townships on the western edge of the Everglades.

A state commission led by cattle king F.A. Hendry, a state legislator from Polk and Lee Counties, soon abandoned the notion of persuading the Seminoles to move to state-owned land and instead tried to buy land where the Seminoles lived. The Willsons' lobbying would continue for nearly two decades.

In those years, John Otto Fries undertook the difficult task of finding out just how many Seminoles still lived in Florida and mapping their villages. A relative of renowned scientists and trained in Sweden as a civil engineer, Fries surveyed much of the Central Florida wilderness, including the routes of several pioneer railroads. After the Great Freeze of 1895, Fries had moved from Orlando to the east coast and was surveyor for Brevard and St. Lucie Counties for many years.

One of his biggest challenges came when he was hired to conduct the first census of the Seminoles. In 1900, Fries led an expedition into the Everglades and other lands where Seminoles established villages and camps. Much of his work would help the Willsons gain support for a Seminole reservation. Fries and his crew traveled more than 900 miles, mostly by a flat-bottom boat that had to be pushed through the sawgrass swamps with a long pole.

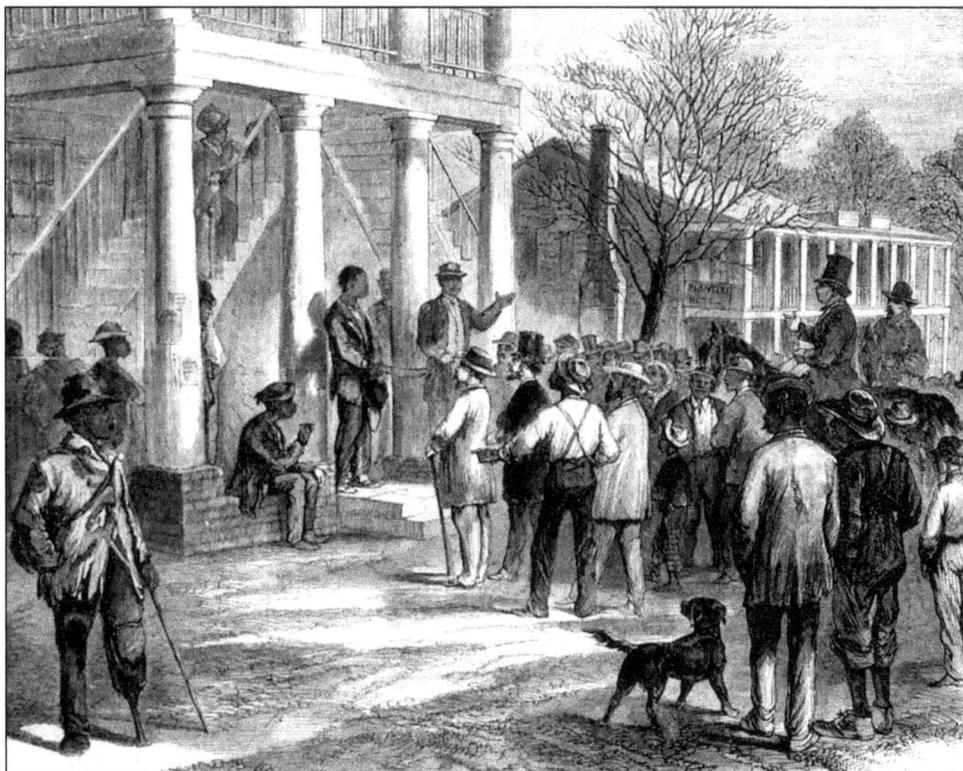

This is a slave auction in Florida just after the last of the three Seminole wars. The U.S. Army, sent to Florida to round up Seminoles and runaway plantation slaves, would be drawn away from Florida by a new war between the Union and the Confederacy.

Eve Bacon's account in *Orlando: A Centennial History* quotes from a newspaper account of that era: "As the nature of the Indian is suspicious, care must be taken not to let them know what the object of the trip is. Patient and tactful strategy will have to be exercised to obtain the information which the government requires. Mr. Fries reports that the population of the various settlements is decreasing because of a high rate of infant mortality."

Eighteen years passed from the time the Willsons started Friends before they were able to secure land in Florida for the Seminoles. On May 9, 1917, Governor Sidney J. Catts signed a law that had passed with unanimous votes in the House and Senate for the Seminoles to have their own land. The measure set aside nearly 100,000 acres of state-owned land in Monroe County for the reservation.

When the Everglades National Park was created in 1935, the Seminole land was exchanged for 104,000 acres in Broward and Palm Beach Counties, Covington writes. The largest parcel became the Big Cypress reservation. Covington credits several people, but he writes, "The success of the operation was due to the dedication of the Willsons. . . ."

31

4. THE KISSIMMEE RIVER VALLEY'S COW CAVALRY

About 60 Confederate veterans are buried in Osceola County. Researchers have found 91 people in Osceola County who applied for Confederate veteran pensions after the war. Many of those served in Florida's cavalry of cattlemen. They rounded up and drove Florida cattle to feed others near starvation in Southern states and served as a home guard, protecting homesteads, farms, and ranches of those who left to fight the Union.

"As the war dragged on into the final years, the South was reeling from the acute shortage of food as a result of the continuous Union sea blockade," writes William Russell, who publishes a historical newsletter called *Civil War Reenactment News*. "They needed meat and other goods and they needed them badly. Thus, Florida, with her great cattle herds was ordered by the Confederate government in Richmond to furnish meat for the army of Gen. P.G.T. Beauregard, who maintained his headquarters in Savannah, Georgia."

Florida leaders in the fall of 1863 persuaded Confederate General Braxton Bragg to allow some of the Floridians serving in the Army of the Tennessee to return to their home state and round up herds and drive them north. (Russell drew much of his research from a paper prepared by Theodore Lesley, in a 1940 presentation for the Florida Historical Society that described his father and grandfather's cattle drive from Fort Meade, southwest of Kissimmee, to Savannah.)

Officially named the 1st Battalion Florida Special Cavalry, the 800 cattlemen-soldiers more often were called the Cow Cavalry. Their commander was Major Charles J. Munnerlyn, of Decatur County, Georgia, who had lost his seat in the Confederate Congress after voting in favor of the highly unpopular Conscript Law, America's first draft. Despite losing his re-election campaign, Munnerlyn had the political connections to advance from private to major. He set up his headquarters in Brooksville and stationed his troops "where they might meet any Union invading party and at the same time bring confidence to the surrounding countryside," Russell writes in "CRACKER, The Story of Florida's Confederate Cow Cavalry."

Kissimmee River Valley cattlemen Captain Leroy C. Lesley, his son, John T. Lesley, and Captain F.A. Hendry were the officers for three of the cow cavalry companies that included some of the Florida soldiers sent home from the Army of the Tennessee. Many others were teenagers from militias. "The state law at the time required every able-bodied man between a certain age (and it varied as the war went on) to belong to some command," Russell writes. "Also, cattle owners who had previously been exempt from military service were now subject to the draft, either as 'conscripts,' or 'reserves.' The Cow Cavalry also included a few deserters who had been rounded up."

Cattle baron Jacob Summerlin, who after the war bought out Hendry's cattle empire, had been selling beef to the Spanish in Cuba during the war. He got a better price in Cuba, but he was soon part of the Cow Cavalry, serving in Hendry's Company A near Fort Meade. The cattlemen-soldiers were used to capture deserters and fight Union troops in Jacksonville and St. Augustine as well as confront the Union Navy along the rivers and coastline.

They drove wild cattle from the pines and palmetto scrub along the Kissimmee and Indian Rivers north to Lake Monroe on the St. Johns River and on to the railhead at Baldwin near the state line. "Along the way there would be stopovers [including one at Enterprise on the north shoreline of Lake Monroe] at locations that had cow pens or corrals where the animals could be contained for the night," Russell writes. "Mostly, the drives remained east of the St. Johns and crossed wherever drive leaders considered appropriate."

Sometimes they evaded Union troops, sometimes not. "Then it was back, round up another herd and drive north again, experiencing stampedes, bad

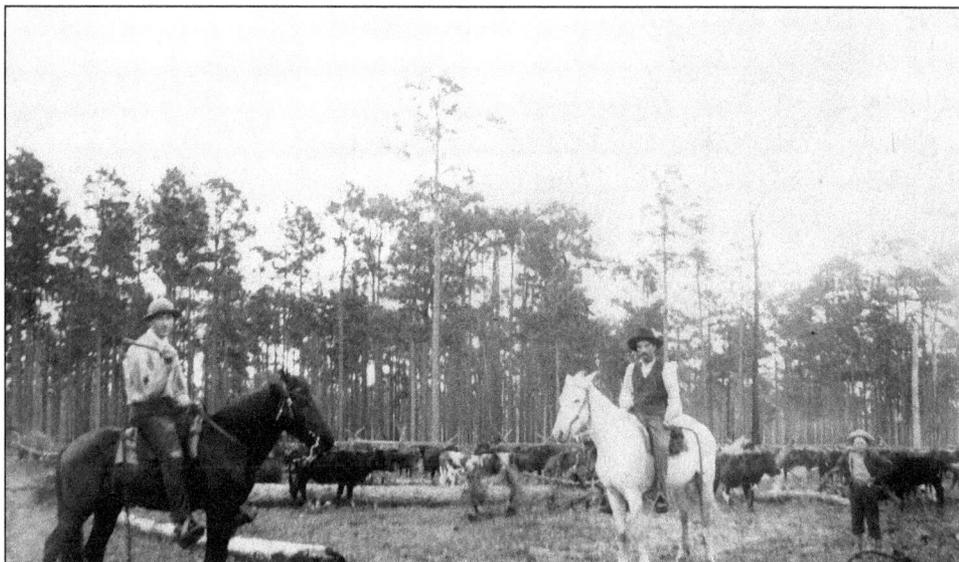

Florida's cavalry of cattlemen during the Civil War rounded up and drove Florida cattle to feed others near starvation in Southern states and served as a home guard.

33

weather, the environment, and the occasional detour around Union patrols out looking for them in an attempt to 'rustle' the herd and take them to St. Augustine. Outlaws, deserters, and other bad hombres preyed on the cattle guard, also."

The Florida cow cavalry in one season drove some 15,000 head of cattle and hogs to Charleston, Savannah, and the Confederate Army. By October of 1863, Florida's Cow Cavalry was about to become a major part of the Confederacy.

Throughout the war, rebel rancher-soldiers rounded up Florida scrub cattle to feed the troops in Georgia, Virginia, and Tennessee. But after shutting off boat traffic on the Mississippi River in the summer of 1863 and blocking Western cattle from reaching Southern troops, the Union turned its attention to Florida, the South's remaining beef supplier. Union troops attacked Confederate soldiers on cattle drives. In some cases, Confederate deserters rustled herds, raided Confederate cattle camps, and terrorized rural settlements.

The Cow Cavalry not only tried to protect every one of the scrawny Florida scrub cows, but scattered units also raided Union troops up and down the St. Johns River. The Confederate government had organized the cattleman cavalry from some rough characters, cow hunters, ranchers, and settlers.

This hand-drawn map by Myrtle Hilliard Crow shows the old Seminole War–era military trails later used by Civil War cattlemen driving herds north from the Kissimmee River Valley.

They included Isaiah Barber, who drove cattle from Florida to the Confederate Army in Virginia. His father, cattle legend Moses Barber, spent much of the war rounding up young men to join the cattle cavalry. Driving a herd of rangy, thin cattle across a South Carolina river to reach starving Confederate soldiers, Isaiah Barber disappeared in raging waters.

Robert A. Taylor's *Rebel Storehouse: Florida in the Confederate Economy* goes into great detail about Florida involvement in feeding Southern troops. On October 19, 1863, the chief commissary officer for General Braxton E. Bragg's Army of Tennessee, Major J.F. Cummings, "appealed to Florida Commissary Agent, Maj. Pleasant W. White, for more Florida cattle for Confederate soldiers fighting in northern Georgia." Cummings told White that "Captain Townsend, assistant commissary of subsistence, having a leave of absence for thirty days from the Army of Tennessee, I have prevailed on him to see you and explain to you my straightened condition and the imminent danger of our army suffering for want of beef."

In December 1864, the Yankee ship *Adele* destroyed the wharf at Fort Brooke on Tampa Bay, cutting off a cattle-shipping port. Union troops drove off 200 Confederates who had tried to rebuild the shipping port. Cattlemen Moses Barber and Jacob Summerlin and cattle trader James McKay moved farther down the coast, where they found a point to build cattle pens and a dock in water deep enough for a small steamer.

Some cattle were driven to the east side of Lake Kissimmee to cross the Kissimmee River at Fort Basinger. Others rounded up from the scrub west of Kissimmee were pushed southwest to the Caloosahatchee River. Some of the crossings took three to four hours. Moses Barber and other cattlemen built a 10-foot-wide road with cross ties of heart pine over a saltwater bog and patches of quicksand to Punta Rassa on the gulf, where cattlemen traded their herds for gold coins paid by Spanish ships bound for Cuba.

Florida cow cavalry would be among the last of the Confederate units to surrender. Promoted to lieutenant colonel for his efforts at commanding the cavalry, Munnerlyn surrendered the cow cavalry to the Union on June 5, 1865. Russell notes that Robert E. Lee had surrendered at Appomattox nearly two months earlier.

But the cow cavalry had one more mission. In June 1865, in what Russell describes as "a final act of Confederate patriotism," Leroy and John Lesley and the McKay family aided the escape of Confederate Secretary of State Judah P. Benjamin, who slipped past Union forces to Cuba and on to England. "In general, the Cow Cavalry was successful in its attempt to feed the South, and although it was active for only about a year, it drove a number of beef north (the total number is not known) and succeeded in keeping at least central and south Florida free of Yankee occupation," Russell writes.

The Civil War helped make Jacob Summerlin a cattleman legend. Florida lore holds that on February 22, 1820, Florida's first U.S. citizen was born in what then was the village of Alligator. In the early 1800s, some of the first American settlers

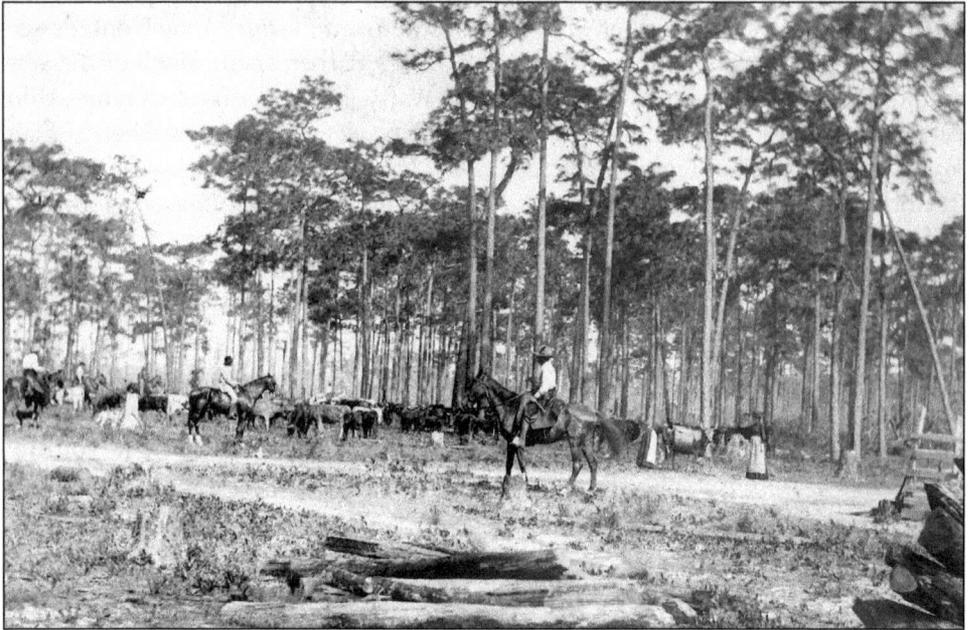

In the fall of 1863, Floridians serving in the Confederate's Army of the Tennessee returned to their home state and rounded up herds and drove them north.

in North Florida brought with them cattle herds from Georgia. Among them were Jacob Summerlin Sr. and his wife, Mary. They took refuge from Seminole attacks in a fort near present-day Lake City in 1820.

Jacob Summerlin Jr. would be recorded as the first child born in Florida after the United States acquired it from Spain. With some cattle from his father and an inheritance of 20 slaves that he sold to buy more cattle, Summerlin moved his herds into what is now is Osceola, Polk, and Orange Counties. By the 1850s, Summerlin's reputation as the "Cattle King of Florida" had stretched his cattle empire to southwest Florida. The Spanish filled saddlebags with gold coins to pay him for cattle loaded into ships bound for Cuba. He amassed a fortune, raising cattle on the grasslands of the Kissimmee, Peace, and Caloosahatchee Rivers.

Legend also tells that he had a soft spot for people with less means. To repay the hospitality of those who opened their doors to him during his travels, he left behind hidden stacks of Spanish gold coins. During the war years, after the South tried to pull away from the United States, he supplied beef to the Confederacy and he branded some of his cattle donated to starving Floridians with a "W" for widows and "O" for orphans.

That is the Jacob Summerlin for whom the Kissimmee-area chapter of the Sons of the Confederacy took its name. The Jacob Summerlin Camp 1516 sponsors the Battle at Narcoossee Mill every spring. Kissimmee also granted permission for the Jacob Summerlin chapter's Confederate monument at the city-owned Rose Hill Cemetery, south of Kissimmee. The polished gray granite marker includes the

names of the Confederate soldiers from the area. (St. Cloud, founded in the early 1900s by a veterans association, is the site of the Mount Peace cemetery, which includes the graves of more than 300 Union soldiers and 2 Confederates.)

Henry McLaughlin's name is one of those memorialized on the Confederate soldiers monument. He walked a long way to get there.

McLaughlin was a Confederate soldier at Appomattox Court House when General Robert E. Lee surrendered the Army of Northern Virginia to end the War Between the States on April 9, 1865. Soon after, McLaughlin set off on foot to return to Florida. The story of McLaughlin's walk back to Florida is a legacy of one of the oldest Osceola County families.

Three Irish brothers came to America in the 1700s. They settled in Charleston, South Carolina. William McLaughlin, one of the brothers, had three sons in America: John, James, and Daniel. John's son, Frederick McLaughlin, traveling by covered wagon and driving a herd of cattle, made his way to Florida around 1846. His family shows up in the 1850 census for Duval County (Jacksonville). It's not clear exactly how long he stayed in North Florida, but family legend suggests he returned to South Carolina several times during the coming years, perhaps bringing other family members back to Florida. The first McLaughlin birth in Florida was recorded in 1847 in Duval County.

Florida had become a state in 1845, and much of the interior along the St. Johns River was remote. Family members think Frederick McLaughlin eventually followed the St. Johns River south to the vast open range of Orange County, then a much larger county that spread over much of Central Florida. The river brought

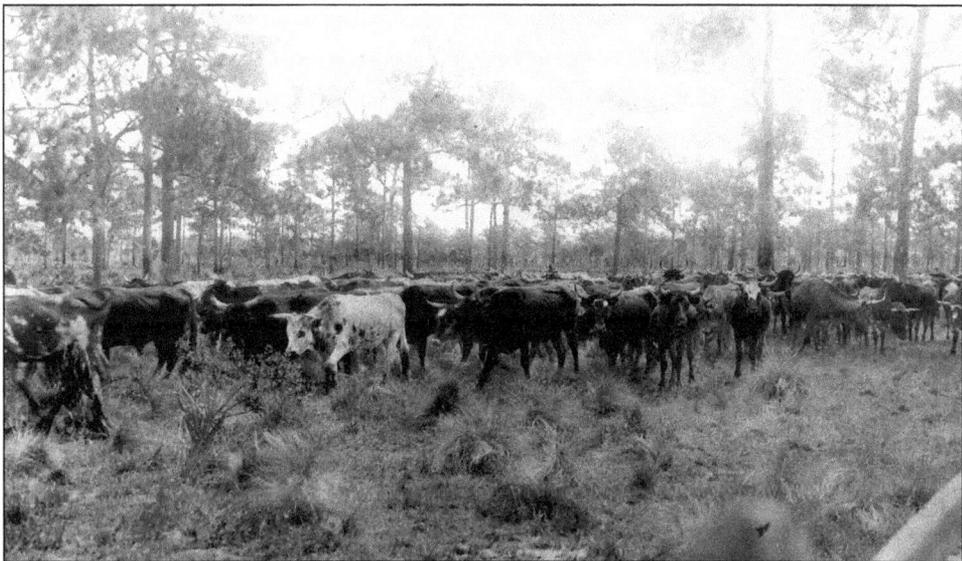

Cattle were worth far more to Florida cattlemen if they could sell beef to the Spanish in Cuba during the war. But many of those cattlemen lost their herds to the Cow Cavalry to feed the soldiers.

McLaughlin to Mellonville on Lake Monroe, then the largest river ship port on the St. Johns. McLaughlin traveled over land to the Narcoossee area, and for the next few years the families lived in that area and east to the Atlantic coast. Three of McLaughlin's sons would fight for the Confederacy—Littleton, John, and Henry, all listed on the soldiers memorial at Rose Hill.

Many other Floridians felt a stronger pull to stay in the Union than to side with the North Florida cotton planters who favored the war. The Seminoles were more of a threat to the frontier cattlemen than the Union soldiers. Few of the cattlemen owned slaves. Summerlin had built his first herds by selling the slaves given to him by his father.

Summerlin was pulled into the war when he won a two-year contract to supply the Confederate Army with beef at a time when the Union controlled the Mississippi River. Summerlin's Cow Cavalry rounded up 25,000 head of cattle to feed rebel troops. Stopping the Confederate cattle drives out of Florida was one of the Union goals that resulted in the largest battle fought in Florida during the war, the Battle of Olustee on February 20, 1864. Confederates turned back the Union invasion, but the costs were severe for both sides. The Union lost 1,861 soldiers. The Confederates lost 946 men. Confederates continued to drive cattle north until the war's end.

Summerlin would be among the former Confederates pardoned by President Andrew Johnson. In the 1870s, Summerlin moved to Orlando because it was in

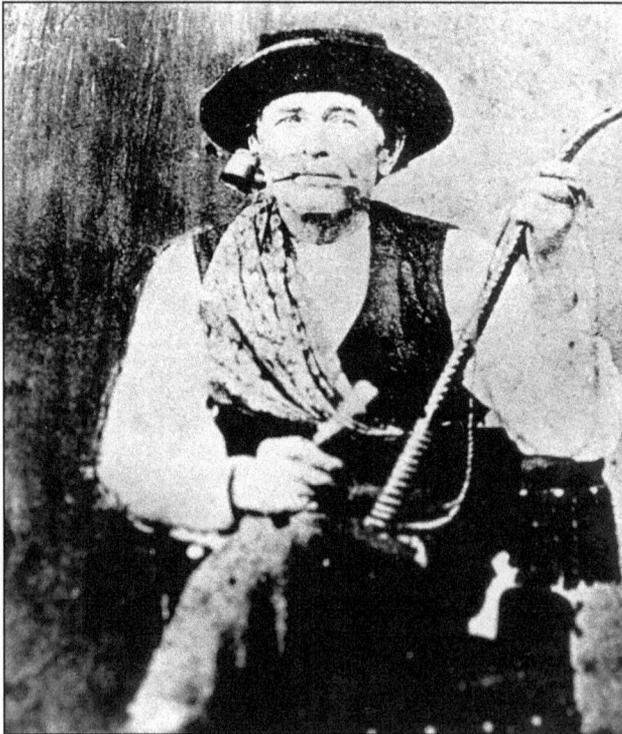

During the war, Jacob Summerlin sold cattle to Cuba and the Confederacy. After the war, he bought more herds to become the Cattle King of Florida.

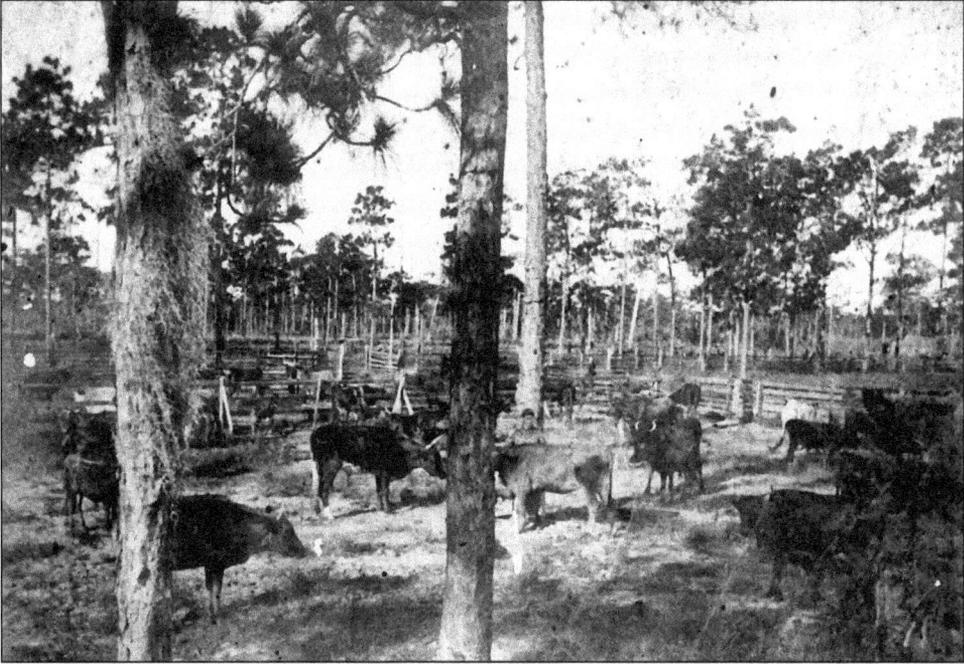

After the war, the Kissimmee River Valley's scrubland was home to herds owned by some of the largest cattle barons of their time.

the center of his vast ranching empire. He built a hotel and gave the city the land that now includes Lake Eola Park with its centerpiece fountain. An editor for the *Tallahassee Floridian* in 1873 named Summerlin "the largest cattle owner in the world."

His fame spread in 1875 when he outwitted city-founder Henry Sanford, the Yankee lawyer and diplomat who wanted to move the seat of government for Orange County from Orlando to the new town of Sanford at what had been Mellonville when this territory had been part of massive Mosquito County. Sanford, who wore a high silk hat and spotless linen and carried a gold-headed cane, thought he could persuade Orange County politicians with an offer of free land for a courthouse. But Summerlin, the Florida Cracker more inclined to carry a corncob pipe than a gold-headed cane, won the day, telling the county, "Leave this point the county seat, and I will build a $10,000 courthouse. And if the county is ever able to pay me for it, all right, and if not, I won't ask to be repaid," according to the news report. The county accepted, taking 10 years to repay Summerlin's loan.

5. THE PIONEER SPIRIT AND CHALLENGES OF LIVING IN THE PINE AND PALMETTO PRAIRIE

The land we know today as Osceola County was once the southernmost edge of what was considered "settled." Settled areas had more than two people per square mile. In the late 1850s, everything to the south of Lake Tohopekaliga, except the settlements at Tampa Bay, was true frontier. "South Florida, in fact, was the largest remaining frontier east of the Mississippi," according to John Solomon Otto's "Florida's Cattle-Ranching Frontier: Manatee and Brevard Counties," published in 1985 in *The Florida Historical Quarterly*.

The Kissimmee area was part of Orange County at the time, but much of the rest of Osceola was part of Brevard. The county named for Theodore Brevard had only a few dozen inhabitants when it was created from St. Lucie County in 1855. By the eve of the Civil War, when beef would become Florida's major contribution to the Confederate war effort, all of historic Brevard had 246 residents and 7,714 head of cattle. "Despite the influx of the cowmen and their families, Brevard's population was too sparse to support a formal county government," Otto wrote. But Brevard did have a state legislator, Needham Yates, elected in 1860. He owned no slaves, but he did own 80 acres and 1,300 head of cattle. The family's ranch land grew to include what became Poinciana.

A government report on growing cotton described the land that made up early Brevard as mostly pine barrens. "One who had never traveled through the pine barrens can have little idea of the impression of utter desolation which they leave upon the mind," the report states. The only growth that broke up the pines, palmettos, and grasses were scattered stands of magnolias and live oaks on high ground and strips of forested hammocks along rivers. These soils were rich enough to support cash crops such as sugar cane and cotton, but they were small and isolated. Decades would pass before swamps that were drained for farms would reach into the vast prairie of the St. Johns and Kissimmee Rivers.

About the only way to make any money was raising cattle. But because grass was sparse on those lands, a single cow needed a lot of land—up to 100 acres, Otto

wrote. By the late 1850s, dozens of cattle families from nearby states and other parts of Florida had moved into the prairie. Settlers could buy land for pennies an acre, and veterans could claim free homesteads of 160 acres. In most cases, the cattle families were "the advancing line of settlement" because ranching needed a lot of open land.

The Florida scrub cattle—descended from the cows brought to Florida by the Spanish—were immune to stock diseases and could live on the coarse native forage with no need for veterinary care. The ranchers burned off the flatlands in the late winter to curb ticks and encourage the growth of new grasses. "Within a few weeks, the blackened flatwoods gave rise to a carpet of fresh grass that sustained the cattle during the spring months," said Otto. "After the steers had fattened on the spring pasturage, cowmen called on their neighbors, forming communal work groups to collect steers for market." One surveyor in the 1850s called it "the finest cattle-range in the world."

Life on the open range also had its rewards. In return for eating cattle-drive rations of dried beans, corn bread, beef jerky, and salt pork, washed down with black coffee, early Florida cattlemen earned gold doubloons from selling cattle to the Spanish in Cuba. A lot of those coins found their way into saloons. The prairie cow towns, including Kissimmee, were pretty rough when the cattlemen showed up after a roundup. Those Cracker cowboys, Mark Derr writes in *Some Kind of Paradise*, often frightened winter visitors to Kissimmee's railroad resort hotel. Kissimmee, he adds, had the nation's first "ride-up saloon, where cowmen could imbibe without dismounting or entering the building."

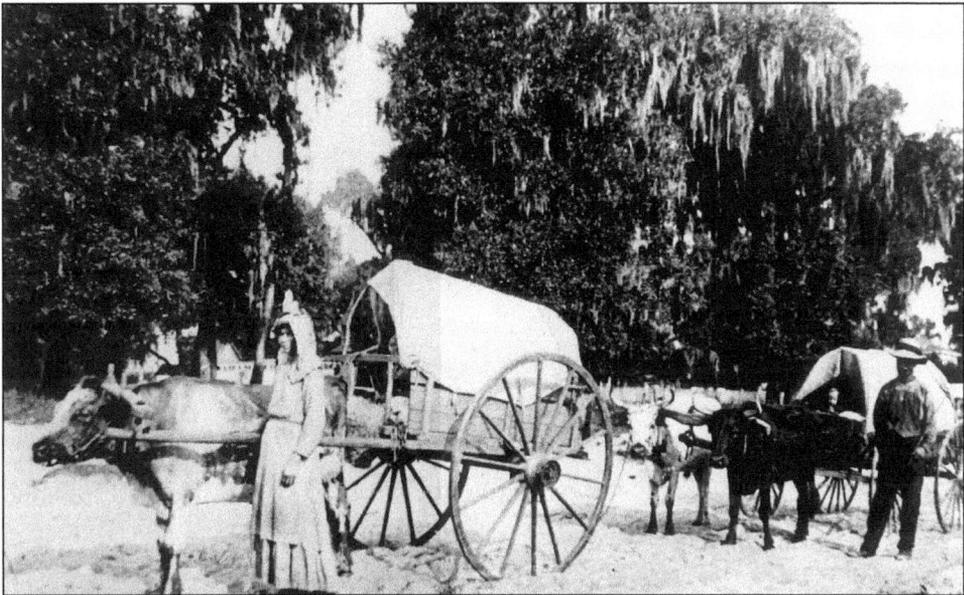

These ox carts are carrying the belongings of a Cracker family making its way south into the frontier on the Kissimmee River Valley after the Civil War.

And, if the saloon was open, "Bone" Mizell was not far away. Jim Bob Tinsley in *Florida Cow Hunter: The Life and Times of Bone Mizell* tells the legends of the hard-drinking, free-spending wild cattleman. Morgan Bonaparte Mizell, known as "Bone," became something of a celebrity, the center of attention, wherever he went, Tinsley writes.

Range foreman for the Parker and King cattle families, Mizell was a product of his harsh scrub-land environment and provided comic relief for those around him. Through such stunts as riding into town rip-roaring drunk with dollar bills pinned all over his clothes, he provided people some distraction from the hardships of life on the range. Among the tales about Bone in Tinsley's book are:

A traveling circus in Arcadia banned him from its tent because he was attracting too much attention. He went outside and tied the tent's main rope to a nearby freight train. When the train left, it took the circus tent with it. He also once rode his horse into a Tampa bar and ordered a drink while still in the saddle.

When the wealthy family of a young man who had died in Florida asked to have his body shipped home to New Orleans, Bone instead sent the remains of a destitute friend who had always wanted to ride on a train.

"Bone never seemed to worry about legalities," Tinsley wrote. "He simply got drunk instead." His exploits made the front page of a New York newspaper, and a ballad was written about the body-switching stunt. Bone was occasionally accused of changing the brands on cattle and once was convicted of cattle theft. According to Akerman's account, a judge was moved by Bone's friends' petition for a pardon.

Life on the pine and palmetto prairie was primitive. Mabel W. Fogg is shown at the home of her father, George Fogg, at Pine Grove.

But the law required that a convicted felon serve some time before being pardoned. So Bone dressed up in his finest clothes and boarded the train for the state prison. Upon arriving, he was given a banquet, invited to speak to a crowd and then sent home to Arcadia, having "served" his time. He was later reported to have said of the prison that he "could find no fault with the management."

When Bone sold cattle, he sometimes took his profits and chartered a steamer to carry him and his friends on party excursions up and down the Kissimmee or some other Florida river. One trip reportedly cost him $9,000. He told people he was satisfied with being "powerful rich" for one day, then going "back to cow hunting again . . . very happy," according to a friend of Bone quoted by Tinsley. "He never married, never owned a home and seldom slept in a bed," according to Tinsley's account. "He was shrewd in his dealings and knowledgeable about cattle, but heavy drinking, wild sprees and generosity toward his friends took everything."

Bone was a cousin of David Mizell, the Orange County sheriff who was ambushed and murdered in what is now Osceola County in 1870. The incident triggered a bloody series of revenge killings known as the Barber-Mizell feud. Tinsley wrote:

> It was inevitable that drinking and a boisterous life would eventually silence Bone Mizell. Once he told a friend, "Someday when I'm about 85 or 90, they'll find me dead, and everyone'll say, 'Well, old Bone's dead, and liquor killed him.' " He was right—except about the age. He died under the influence in Fort Ogden on July 14, 1921, at the age of 58.

Bone is buried near Arcadia at the Joshua Creek Cemetery. His grave never had a marker until about 30 years after his death. Legend holds that the marker isn't really on the right grave, a mistake that probably pleases the spirit of the old guy. Bone doesn't really need a marker on his grave or a plaque at some historic site. Bone Mizell lives on through the stories that have been told along the Kissimmee River Valley's cattle trails to Punta Rassa on the gulf.

Annette J. Bruce's *Tellable Cracker Tales* includes this story that is typical of the Bone legend:

A friend accused of butchering a stolen cow turned to Bone for help. "Bone said, 'You buy me a John B. Stetson hat, and I'll get you out of this in two minutes,' " Bruce writes. At the trial in Arcadia, Bone was called as a witness after several others testified about cattle brands and other facts. "When Bone was put on the stand, he testified that he had seen the alleged butchering. When he was asked where he was at the time, he answered, 'Bee Ranch.' "

"Where is Bee Ranch?" asked the prosecutor.

"Everybody knows where Bee Ranch is. It's two or three hundreds yards over in the next county," answered Bone.

The judge threw out the charge because it had been filed in the wrong county, and Bone tipped the new hat he had worn into the courtroom. The judge, seeing

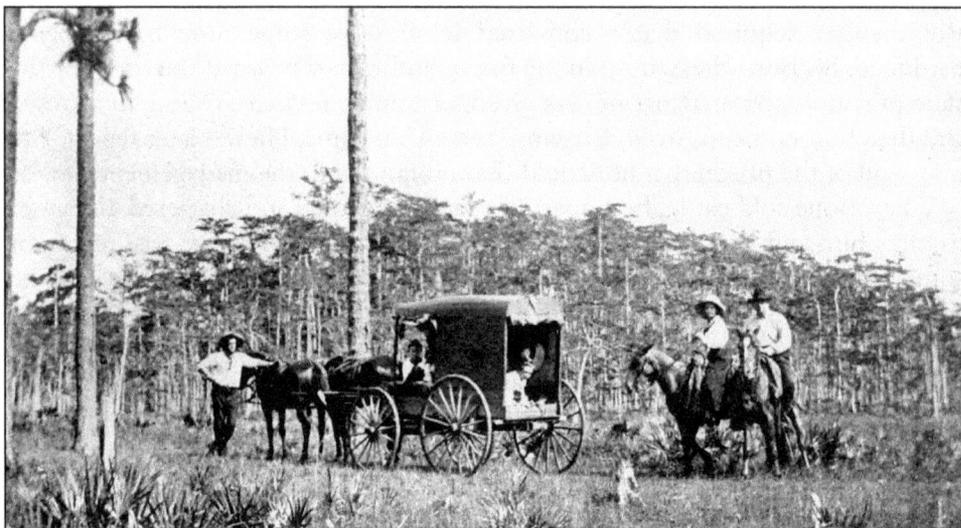

The pioneer Donegan family is shown on their ranch in the pine and palmetto forest at Jog Creek.

that the prosecutor had been snookered, spotted the hat and fined Bone $20 for not taking it off in court. "Bone," writes Bruce, "took a $20 bill from his pocket and laid it in front of the judge. Then, he reached in his pocket, took out another one, and said, 'Judge, you better take forty, sir, 'cause I walked in here with my hat on, and I'm gonna walk out the same way.' "

Bone Mizell lived during Florida's harsh cattle era, providing those from his time to ours with many half-true tales that are the heart of folklore.

Such characters attracted the attention of Frederic Remington. Writing about Florida's "Cracker cowboys" in the June 1895 issue of *Harper's New Monthly Magazine*, Remington called them unkempt and wild and, "as a rule, they lack dash and are indifferent riders." The land, he wrote, was "flat and sandy, with miles of straight pine timber, each tree an exact duplicate of its neighbor tree, and underneath [the trees grew] the scrub palmettos, the twisted brakes and hammocks, and the gnarled water oaks festooned with the sad gray Spanish moss—truly not a country for a high-spirited race or moral giants."

Remington could not have been talking about Harrigan Patrick, who saw just about all that interior Central Florida had to offer. It was his job.

In the late 1870s, when Osceola County's communities were getting their start, Patrick carried mail on horseback from Orlando to Bartow. And sometimes the mailbag was pretty light. He once made the trip with only one postcard in his sack, writes Myrtle Hilliard Crow in *Old Tales and Trails of Florida*. Crow interviewed Patrick late in his life. "The sparkle of youth came back into his eyes as we told him of our visits to the old trails, and it gave him a desire to visit again the places that were so familiar to him in the long ago," Crow writes.

Patrick's father was 2 years old when his family moved to Florida from South Carolina. Patrick was born on Lake Conway near the old military trail that wandered

from Fort Gatlin (Orlando) to Fort Brooke on Tampa Bay. Patrick, the oldest of 14 children, was born in 1861 when few people lived in the territory that stretched from Mellonville on the St. Johns River at Lake Monroe south to Lake Tohopekaliga.

Patrick told Crow of arriving at the steamboat docks at Mellonville to see as many as 30 teams of horses and oxen lined up along the shoreline, waiting for the steamer *Darlington* to reach the wharf and unload its cargo of supplies. And he told Crow he recalled when the courthouse in Orlando was made of logs. He also recalls 75 mustangs arriving from the West for sale to the cattlemen. Most had been riding the small but tough horses brought from Cuba.

But what he remembered most were his long and sometimes lonely rides delivering the mail from Orlando through the Shingle Creek community to Bartow. Most of the time, he carried a dozen letters and five newspapers on his 65-mile route. He left Orlando on Monday. On most days, once he left Shingle Creek, he would see no one from noon until 3 p.m. He reached Bartow by Tuesday morning. Leaving the next morning, he would meet another mail rider a few miles northwest of Haines City. They camped together overnight. The following morning, after exchanging mail, they rode off in different directions. Patrick's route took him back to Bartow by Friday morning. On Saturday, he began the ride back to Orlando.

"This must have been a great trip for a lover of nature," Crow writes. "There were all kinds of beautiful birds, and the woods were alive with animals." On one trip, he tried without success to sneak up on a herd of deer he spied on a hillside northwest of Haines City. Crow continues:

> Mr. Patrick tells about the first wild bear he ever saw. The bear emerged from the reeds at Reedy Creek and was standing in the road ahead of him. The horse stopped, and the bear looked up and saw him. Then looking at the reeds and then at the woods, he [the bear] decided to seek protection in the latter. Not being armed, Mr. Patrick amused himself by chasing the bear for some distance.

He got his job delivering mail through his father, Jim Patrick, who owned a livery stable and other businesses in Orlando. His father also built bridges and corduroy roads of cypress poles. "Once when Mr. Patrick was riding his horse, a man wanted to follow him in his buggy on a trip to visit his lady friend," Crow writes. "When they reached Reedy Creek, Mr. Patrick told the man to put his groceries up in the seat because there was a deep hole ahead. He hung his blanket over his shoulders and said that the rest of his load would be all right; but his buggy went down into the hole, and the canned goods went to the bottom of the creek. They found a boat, and the man rescued part of his load."

By the early 1880s, the railroads took over carrying the mail, but Patrick found work driving a coach taking passengers to Fort Meade and Tampa. One passenger on a trip to Kissimmee was Hamilton Disston, the Philadelphia entrepreneur who would make a deal with the state to drain much of the swamps and dredge

a river highway from Lake Tohopekaliga to Fort Myers. Patrick was 93 when he died in 1954.

Florida is preserving some of the land that Patrick knew. South of where the Kissimmee River flows into Lake Okeechobee, at what in the late 1800s was the southernmost tip of Osceola County, Florida's wilderness is a patchwork of cattle ranches, groves, farms, and nature preserves, some of it wilderness favored by Florida panthers.

That would have pleased Tuestenugee, a large and muscular Seminole cattleman known in Kissimmee as Tom Tiger or Tom Tiger Tail. Army soldiers gave him the nickname when he showed up at a sporting match wearing a panther hide with the tail dangling. Tuestenugee raised cattle from Lake Tohopekaliga south to Basinger. As a leader among the Cow Creek Seminoles, he acted for the tribe in trading and land deals with white cattlemen.

In the late 1800s and early 1900s, logging, sawmill and turpentine operations dotted the wilderness land. Troy Mason's father and uncles worked in the phosphate mines near Fort Meade until they saved enough money to run their own turpentine partnership in the late 1800s. "This was wild, wild country, with an abundance of fish and wild game, such as black bear, panther, wildcats, wild hogs and deer," writes Mason in a paper he donated to the state archives. "There also were semi-wild cattle, many smaller animals and the now almost extinct whooping cranes, a large and beautiful bird to see." Logging, sawmill, and turpentine operations dotted the land.

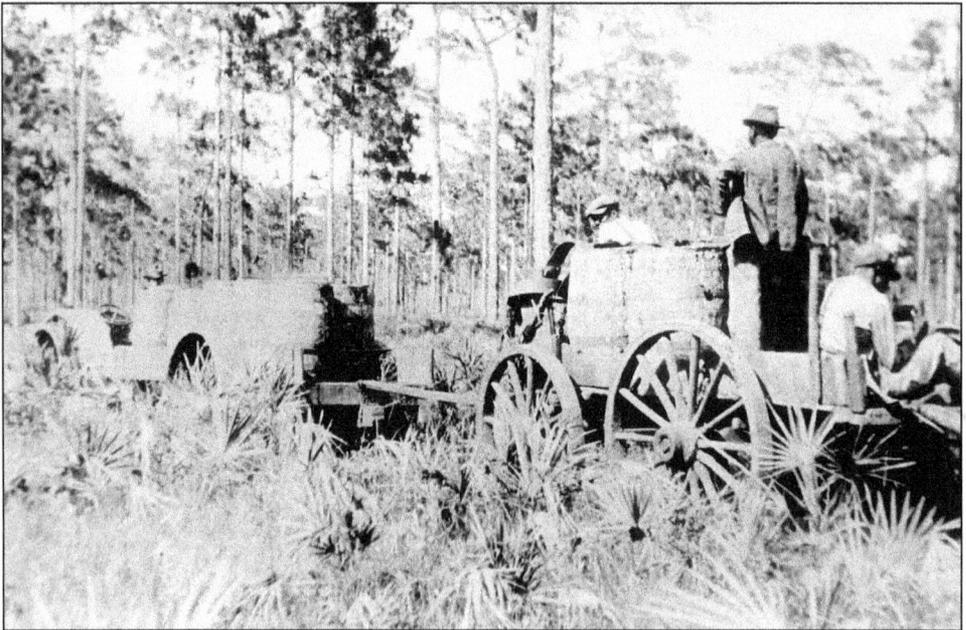

Turpentine workers ride in a wagon loaded with barrels of pine sap that will be processed at a still. The big wheels help the wagon moved over palmetto bushes.

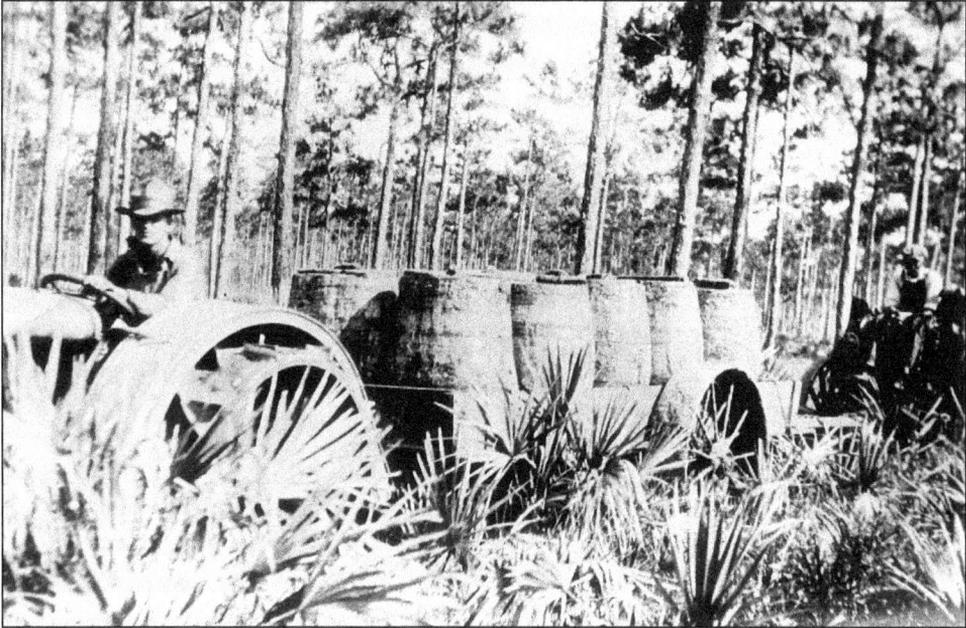

From the late 1800s through the 1940s, the pine forests of Osceola County provided a thriving turpentine industry. This wagonload of barrels came from turpentine camps in Deer Park.

One night, Mason was driving a buggy with another man as they passed a herd of cattle. Something had spooked the animals, but they didn't know what until they heard "a blood-curdling scream split the air to the rear." Mason cracked a whip and the horse took off. As Mason worried that the buggy would spill over along the rough trail, both men heard a second—and closer—cry of the panther. Mason's passenger was ready to jump from the buggy, telling Mason he could run faster, but Mason gave another snap of his whip and the buggy soon sped away to safety.

Kissimmee River steamboat captains told similar tales. "Passengers," writes Fred A. Hopwood, author of the 1992 book *The Rockledge, Florida, Steamboat Line*, "were alternately thrilled and frightened by the terrible screams of prowling panthers."

S.B. Aultman worked at the Lake Tohopekaliga shipyards and the dredges draining the Kissimmee River Valley. He later captained his own boat, *The Black Witch*, trading with the Seminoles and settlers for furs and hides and providing provisions for a string of plantations along the river.

One evening found Aultman escorting a young schoolteacher home from a social gathering. Aultman's daughter, Elizabeth A. Cantrell, writes in *When Kissimmee Was Young* that they were passing through a cypress swamp near what today is east Vine Street when they "met the savage animal." "He says the scream of the panther is like the voice of a woman terrified beyond all imagination and is enough to curdle the blood of anyone who hears it, and his was no exception," Cantrell wrote of her father.

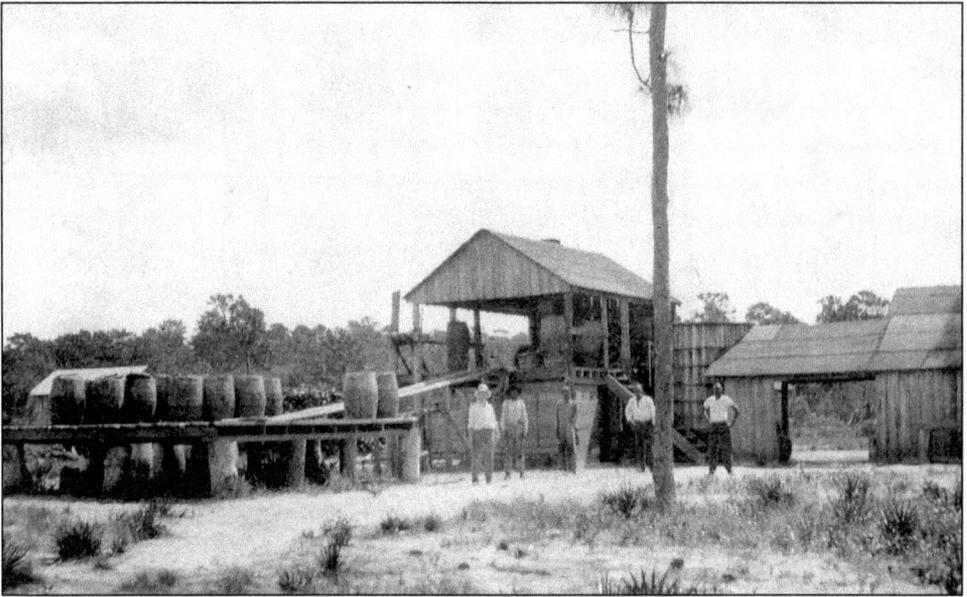

This scene from about 1900 shows an early turpentine still in Osceola County.

Aultman and the teacher listened as the animal's scream became louder. As they crossed an open area, they spotted the panther at the edge of the clearing. "The animal faced them for what seemed minutes, still emitting those frightful screams. As he was armed only with a knife and knew it was madness to turn his back on it, he faced it in desperation, and then by the mercy of Providence, and he can think of it nothing less, the great cat slowly turned and, still screaming, vanished in the darkness of the swamp."

Another of the old timers, Gilbert A. Tucker, knows just why this land was once called Mosquito County. Mosquitoes and horse flies caused trouble for the cattle, the horses, and the Tuckers.

"We split big burlap bags and tied them under our horses' bellies to help keep the flies and mosquitoes from killing them," writes Tucker in his Cracker history of life in Central Florida in the early 1900s, *Before the Timber was Cut.* Tucker's father had a large mosquito net he pulled over himself when camping during cattle drives.

"All us boys put down our blankets so we could put our heads under his net," Tucker writes. "Even when it was hot in the summertime you had to keep your slicker over your body to keep from being eat up by the mosquitoes. We would sweat most of the night, but usually were exhausted enough that we could sleep some." In the winter, they had cow dogs to keep them warm. "I was always glad when a dog came by and lay by my bed in order to share a little warmth," Tucker says in the book.

Fencing what had been open range was slow to catch on. At times, the Tucker boys cut fence lines in their way, even sneaking in at dark and driving off cattle

impounded by deputies or other cattlemen. But they also cut cypress posts and strung fence lines to keep other people's cattle off their leased grazing land. The Tucker boys patrolled the fences carrying rifles.

The Tucker family came to the Fort Christmas area of Central Florida in 1866, "to get away from the carpetbaggers," Tucker writes. Along with them came men, women, and children who had been slaves on the Tucker farm in Georgia. Tucker records, "A group of community leaders came to my great-grandfather and told him that no Negroes were allowed in Fort Christmas. The Tuckers divided their mules, plows, and household furnishings with the Negroes and my great uncle Johnny Tucker, at age 18, carried them back to Georgia and deeded their land to them."

Later, many of the workers at lumber and turpentine camps of the early 1900s were black laborers. Sometimes, while out in the woods looking for cattle, Tucker could hear the songs of laborers chopping cross ties for the railroads. "They each had a chant and rhythm to it as they cut. I wish I had a recording of this today. I don't know whether they were happy as they sounded or just doing it to break the monotony. But I sure loved to sit and hear the chant as they chopped. Out in the woods there was absolutely no entertainment, but we accepted it, stuck it out and did our job."

Tucker writes that his father was always in debt, usually for cattle. "My daddy was a hard-working man who paid his debts. His word was his bond and he did not steal and hated liars and thieves with a passion. . . . He always loved his young children, but was tough on us when we got old enough to work. His children and Mama were his crew." Once when Tucker's father suspected a neighbor of stealing his hogs, he penned a few hogs and fed them strychnine and turned them loose. Within days, the neighbor's children were sick. "Luckily no one died, but word got out pretty fast not to steal Drew Tucker's hogs."

In 1935, the Tuckers leased and fenced 44,000 acres of pasture in Flagler and Volusia Counties. The lease was for 5¢ an acre a year. They had more land than they needed for their 1,800 head, so they bought select bred cattle from Osceola County's Keen family, who lived between Lake Kissimmee and Lake Wales. Instead of driving the cattle by horseback all the way back to Flagler County, they stopped at Kissimmee and hired Cecil Yates and Slim Partin, who had a truck that could haul ten head at a time and make two trips a day. Gilbert Tucker recalls "bumping" a jug of moonshine one night and listening to the ranch boys playing records on a hand-cranked phonograph. "Needless to say we did not get much sleep that night."

By 1937, the Tucker brothers had their own cattle truck and drove all over the state and Georgia buying cattle for their father's ranch. Gilbert Tucker remembers stopping traffic on U.S. Highway 192 to drive cattle across. "Of course this made some folks mad, but at the time there was not much traffic and those old cracker cowmen were pretty tough to tangle with."

While much of the land was swamp, Florida had its share of long dry spells. Tucker and the other cattle ranchers knew when to seek help from the alligators. A bull gator looking for water will dig out a dried-up pond until he hits water.

Much of the Kissimmee River Valley was more water than land in the late 1800s when cattlemen first opened sprawling ranches in the low, flat marshlands and swamps. Massive dredging and canal digging spilled off lots and lots of that water. So, of course, Florida's skies turned cloudless. The state entered one of its many droughts. Water holes for cattle dried up.

Kissimmee's E.L. Lesley, who in the early 1900s had 15,000 head of cattle, wrote in his memoirs that at times he suffered as much from thirst "as anyone ever did lost on the desert."

Joe A. Akerman Jr. writes in his 1976 book *Florida Cowman*, "Florida cattlemen were perhaps the first people to recognize the importance of the alligator and the first to wage a war against the poachers hunting gator hides." Akerman quotes from Lesley's memoirs, "As long as we had plenty of alligators, men, cattle and horses never suffered for water. It made no difference how dry it got. In nearly every pond on the prairie you would find a gator cave and plenty of water." These days, state-licensed trappers called to rid a neighborhood of a troublesome

Gertrude Stanley poses with sons Jay and Roy on a cypress tree exposed during a drought when the lake level fell.

50

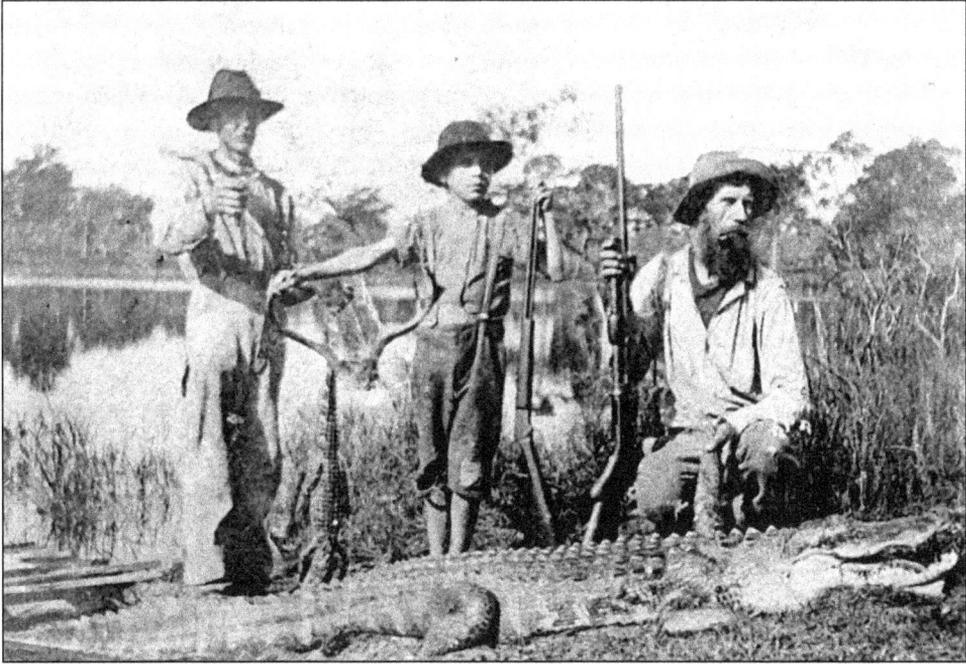

Jerrie Lafoley, center, is shown with alligators he helped hunt with his father and hunting partner Dolphus Hutchinson.

alligator usually kill the beast and sell the hide at state-regulated auctions and the meat to area restaurants.

By the late 1800s, many of Florida's biggest alligators had been hunted out of existence. Many had disappeared as Florida's wilderness became a favorite for Northern hunters. National magazines told stories of hunters who stood on the bows of steamboats along the St. Johns and Kissimmee Rivers and shot at alligators for sport, never attempting to retrieve the meat or hides.

Far more of the big gators, though, were hunted by early Cracker settlers and the Seminoles. "There were gators 15 feet and even longer, and they were plentiful," Kissimmee River Valley historian Albert DeVane writes in his journals. "In 1881, Maj. Phillip Dzialynski had a contract to supply 5,000 alligator hides to a leather firm in Paris, France."

So it was that in the winter of 1900, a self-described "Northern girl" set off on a hunt for a big bull gator. "A Northern Girl's Huntin' of a Gaitah" is included in *Tales of Old Florida*, a collection of century-old stories from a variety of writers. Marion Pryde Quay came to Florida with other Northeasterners "in search of tarpon and winter fishing." But she would decide to leave the coast and travel inland to the Seminole lands. Her guide was a man identified only as Clarence, a Cracker woodsman. He told her that finding a big gator was rare because alligator skins had become the Seminoles' primary barter at trading posts along the rivers. The steamer captains and trading posts paid 25¢ to $2.50 for alligator hides. As late

as the first decade of the 1900s, tanneries buying the Seminoles' alligator hides provided 75 percent of the tribal income.

But Quay wasn't hunting to barter. She wanted a trophy, an alligator big enough to silence the men who made jokes about women hunters. Of 20 Northeastern men who had gone alligator hunting over the prior two winters, only two had success. Her guide gave her two ways to find a big gator. They could row up one of the freshwater streams and hope to find an alligator or they could ride in a wagon along inland trails, then hike further into the wilds to several gator holes where her chance of landing a big one would improve. But the danger increased, too.

"An encounter with a gator becomes almost a hand-to-hand fight, as you are on foot and actually in the same water with him," she writes. "Altogether, at the holes, one needs [a] cooler head and good marksmanship is necessary. On the later score, fortunately, I had not much hesitation as I had shot more or less all my life, and knew that I could depend upon the accuracy of my aim."

The night before they set out for the hunt with her sister, "the house party . . . amused themselves for the remainder of the evening, launching at us dainty shafts of sarcasm and sparkling witticisms, which left us inwardly saddened, but outwardly, most valiant and bold." The next morning, they boarded a two-seated wagon pulled by a "one-time mustang" she writes. They brought along "a huge flask of whiskey" as an antidote for snakebites and two long poles and hooks to land an alligator. Quay carried a Winchester repeating rifle of the 1892 model with .38-caliber, long-distance cartridges.

They drove along a stream through the pine forest to what she called a "big swampy, grassy place with a circle of willows around their first 'alligator hole.' The name really refers to the holes the alligators tunnel out in the bottom of the pond, and into which they creep when startled," she writes.

Clarence, who brought along his brother, Aiden, shot two water moccasins, which Quay "stowed away" to show the others. But they found no gator. An hour deeper into the saw grass, they reached another hole where Clarence spotted a huge alligator. But he slid out of sight as soon as they approached. They waited and watched. "I was growing disheartened and weary before I finally saw an alligator. . . . I could just see his eyes, two bright spots, and could image his long, dark shape beneath the water."

Not sure if it was the big gator, she sent Clarence closer. But the gator sensed the movement and disappeared. Yes, the guide told her, he was big, 14 feet, maybe more. "I could have wept bitter tears of disappointment." Clarence used some of his best grunts trying to lure the gator back to the surface. Nothing for more than an hour. Then two more eyes appeared. Not wanting to miss her chance, Quay fired, "and he rolled his length over in the water, the inglorious length of three and a half feet!"

Back at the winter camp along the coast, Quay endured another night of jokes, including a visit from a Cracker neighbor who offered to allow her to shoot the roped alligator his children kept for a pet. That brought loud laughter from the

Two unidentified hunters hold the rattlesnake they killed in the palmetto scrubland.

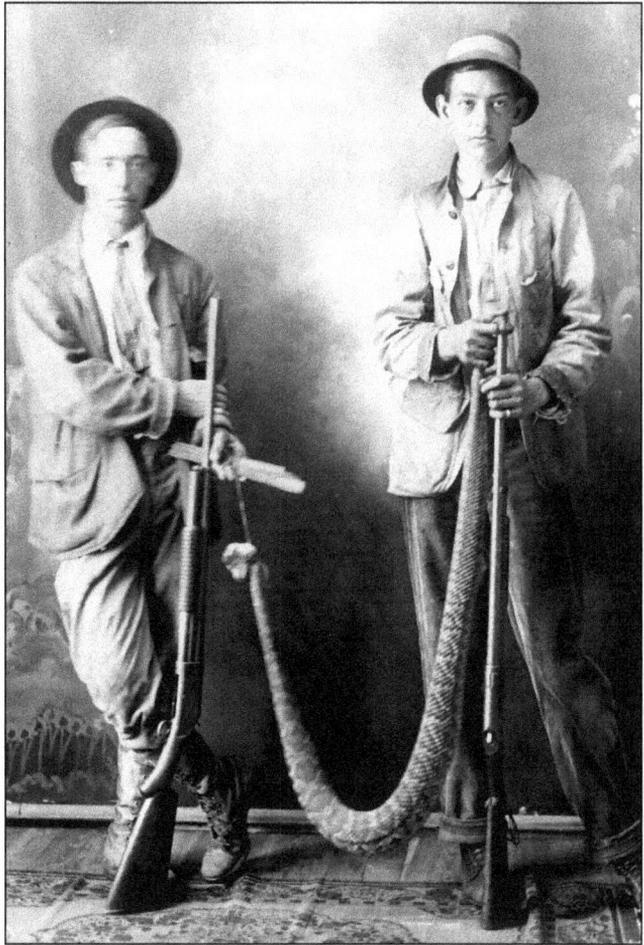

others. With morning, the hunter and guide set off for the farthest hole and that big gator.

Clarence dragged a spiked hook fastened to a long pole across the bottom, hoping to stir the big gator. "When the alligator is struck, he generally comes up with a headlong rush, which creates general havoc," Quay writes. Prepared to shoot, she waited for the alligator to surface, mean and ready to fight. Over and over, Clarence prodded the pond. Just as she was about to give up came the splash. The big gator "came out with his enormous mouth wide open—with a hiss, a jump and a snap, breaking the pole and scattered everything right and left! He looked tremendous! I fired, and he rolled over on the water dead."

She had hit the gator dead center between the eyes. "Oh, the rapture of it all! I laughed and shouted with delight! Then I stood off and surveyed his big bulk with feelings of pride and vain-glory." She fired salutes as Clarence drove that mustang back into camp. "We started North the next morning, and Clarence surprised and delighted me by appearing with the skin of my alligator, which he had taken off at

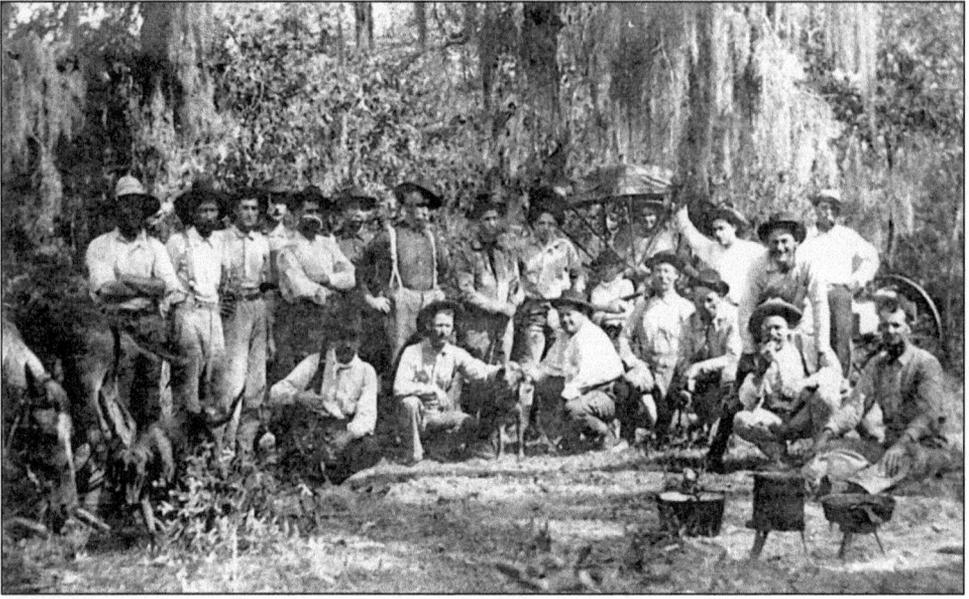

The center of attention for the hunters is the dog they used to track bears. The hunting party is shown in the late 1800s somewhere near Lake Okeechobee.

night that I might have it to take home with me. He brought me, too, the bullet I had used."

Along with big gators, the cattle history of Osceola County includes a few tall tales that have been retold through the generations. Two were captured by historical researcher Brenda Elliott in "Florida Cracker Cattle Lore: The Florida WPA Files," one of the chapters in *The Proceedings of the Florida Cattle Frontier Symposium.*

The first involved a kettle used to boil sugar cane juice into syrup, which was a popular sweetener at Florida Cracker tables. The legend holds that Burrell Yates, who lived on Canoe Creek, lent the kettle to Bill Stevens, who lived on Ox Pond. Three years passed before Yates started wondering if he would ever get his kettle back. He rode over to the Stevens' homestead in a horse and buggy.

As the Works Progress Administration (WPA) writer recorded the story: "Bill's wife warn't going ta let him have it, and when Burrell set in to take it anyhow she squawled and carried on sumpum turrible." Yates picked up a cypress shingle and "paddled her hard where she sat down and took his kettle with him," the WPA writers said.

When Stevens found out what had happened, he saddled up his horse and went after Yates with a shotgun. He found Yates on his porch. "Bill throwed up his gun and pulled the trigger and the load of shots deafened Burrell and cut a staple fork out of his right ear."

Hunting stray cattle a year later, a few of the Partin cattlemen came to the Ox Pond area. Elmer Johns, according to the tale, asked them what their mark looked

like. "The Partin boy said, 'Staple fork in the right ear.' Then Elmer said, 'They's a old deef white-headed bull with that mark, ranges up around Canoe Creek.'"

The second story involves another local legend, cattle king F.A. Hendry, who helped organize Polk and Lee Counties and served in the Legislature as representative of both counties. Hendry had worked as a guide for the U.S. Army during the Seminole Wars and then made friendships with Seminoles while amassing vast land and cattle holdings. With Kissimmee's Minnie Moore-Willson and her husband, J.M. Willson, Hendry tried to establish a state reservation for the Seminoles or buy land where they wanted to live. Their work eventually resulted in the Big Cypress, Brighton, and Hollywood reservations bordering Broward and Palm Beach Counties. The largest section became the Big Cypress reservation south of Hendry County.

Hendry wrote newspaper stories about his life of driving herds of what his family history calls "half-wild cattle." One of his stories about a vicious bull was retold to the WPA writers. The "cradle-headed" bull had a way of avoiding the cattlemen when they went into the prairie wetlands to pull out scrub cattle. The men called the aging bull "Old Frostysides" and "Old Frosty." One cattleman told the others of his encounter with the bull near sunset.

"Just as I was a-turnin' the point of the bayhead, Old Frosty come out of that swamp like a tornado, with a great load of vines around his horns. I spurred Jack and squared myself before him. Then I gave him a few right smart cracks with my drag, tryin' to turn him into the herd, but he kept comin' for me full tilt." Bogs

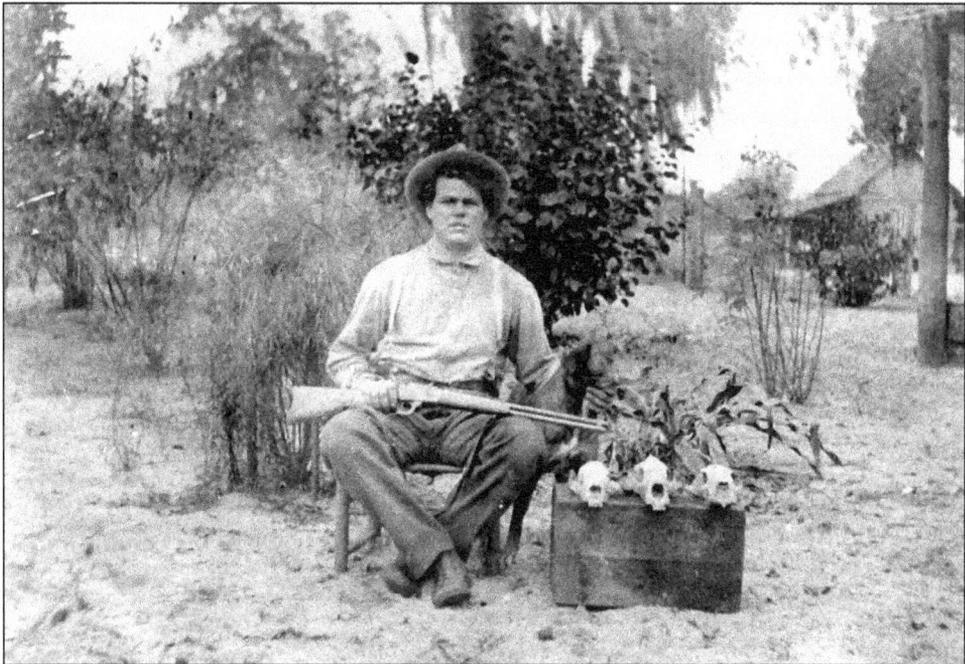

Marcus C. Norton Sr. poses with his rifle, hunting dog, and his trophies.

and sawgrass gave the cattleman nowhere to retreat. "The old fool steer by this time had his long horns very near Jack's kickin' end," the cattleman told his buddies. "Jack musta known it was boggy in that slough, cause he stopped sudden and fell to kickin'."

No amount of spurs to the horse's belly would make him move. That's when the saddle's girth snapped, sending the rider to the ground. "Me and Jack parted company quicker than lightnin'," the cattleman said. The horse took off, "and left me and Old Frosty to settle the dispute between ourselves." Struggling to his feet in the thick mud, the cattleman saw the bull. "Old Frosty's eyes lookin' green at me, his tongue out, with ropes of slobber streamin' from his mouth and nostrils."

The cattleman sensed trouble. "All this time my hat had stuck to my head like a leech. How I did it, I don't know, but I snatched it off and swung it at him. The point of one horn stuck right through the crown, and it rested square over Old Frosty's eyes so he couldn't see a thing. I guess it's there yet, and I hope it'll rot there."

Besides these tall tales, the archives of the Florida Historical Society have a salty side. In July 1863, Confederate Florida's trustees for state-owned lands stopped selling land within 2 miles of the coastline or salt marshes. The trustees feared

James W. Willson, a Kissimmee real estate broker, owned these shares in Kissimmee's Merchants and Farmers Bank. The shares were issued in 1921.

*James W. Willson, who with his
wife, Minnie Moore-Willson,
helped establish the Seminole
Tribe of Florida on its own
land, is shown with long-time
friend Billy Bowlegs III,
namesake of one of the last great
Seminole chiefs.*

speculators would buy all the land suitable for salt production. It's a reminder just
how primitive life was in frontier Florida. Salt was among the early settlers'
primary methods of preserving meat.

Families living between the St. Johns and Kissimmee River Valleys traveled to
New Smyrna to make salt. They used the large kettles at an old Spanish mission
to boil saltwater to extract salt for home use. Once the water evaporated, salt
crystals remained. They didn't have to go to the coast. Salt also could be extracted
from the roots of saw palmetto.

Salt ties up water molecules so bacteria does not grow and dries up the
microbes that create spoilage. It's not clear if the early Floridians understood the
science of salt, but they knew it worked. It took a lot of salt for what they needed.
Preserved meat or fish was up to 25 percent salt. The meat was packed in layers
of salt or a salt-molasses mixture, sometimes flavored with ale or spices. Often
barrels of salted pork, beef, venison, fish, and rabbit were sealed with layers of
lard. Jerky of venison and beef was made by putting the meat in salt or brine for
several days, then hanging strips of the meat on poles or the kitchen roof to dry in
the sun. Meat cured in salt was also hung in smokehouses, sometimes fired by

Minnie Moore-Willson and her husband, James W. Willson, take a buggy ride along the lakefront.

burning corncobs. Salt was in such short supply that some people boiled the dirt in their smokehouses to extract the salt.

Salted meat was scrubbed and soaked to wash out the salt and restore its water content before cooking. These meats could last more than a year, but spoilage and food poisoning were common. Cooks had various ways to disguise the taste and smell of tainted meat and fish and musty corn.

Salt was a "cash crop" that could be traded for other goods. Once, while settlers were returning from a salt-making trip to the coast, they encountered Union soldiers, trading a barrel of their salt for flour and coffee. Soldiers on both sides often carried their own food: endless meals of bacon or salt pork, hard bread, and black coffee. A soldier's filthy, blackened knapsack often oozed with grease, the fat of bacon. The soldier also would carry hardtack and soften it by soaking it in coffee or bacon.

Salt was valuable to both sides during the Civil War. Union troops patrolled Florida not only to capture smugglers trying to slip contraband through blockades but also to find and destroy salt-making operations. Some Union generals thought that stopping salt making in Florida was as important as cutting off the supply of Florida scrub cattle to the Confederacy. The Union stationed its navy along Florida's long coastline and along its rivers to chase blockade-runners who supplied cattle, hogs, salt, and other food to troops as far north as Virginia. Union

troops destroyed hundreds of salt-making sites, but salt-makers could easily move their kettles and boilers to other remote sites and set up their operation again.

The Florida salt plants grew in importance to the South when the war cut off supplies of salt from the North. The Union had successes bringing in ships to knock out some of the salt plants. Confederates occupied New Smyrna, a key port for blockade-runners and the site of salt plants. Confederate lookouts spotted six Union boats from the *Penguin* and the *Henry Andrews*, which were blocking Ponce Inlet, approaching the port on March 24, 1862. Florida's 3rd Regiment attacked, killing eight Union soldiers. The Union withdrew, temporarily, but responded by shelling the wharf and salt plants. The cannon fire also destroyed the 40-room Sheldon's Hotel, built just before the war near what today is downtown New Smyrna Beach.

Cutting off Confederate shipments of salt was one of the Union goals when they clashed at the bloodiest battles fought on Florida soil. At Ocean Pond and the pine woods at Olustee, on February 20, 1864, some 5,500 Union soldiers battled roughly the same number of Confederates. More than 2,000 federal troops and another 800 Confederates were killed or wounded before the Union withdrew and gave up on their goals of cutting off Confederate supply lines for salt and cattle, recruiting blacks on plantations to become soldiers, and rallying pro-Union Floridians to give Abe Lincoln their support for his re-election campaign. The South claimed victory. The files of the Florida Historical Society include dozens of other examples of Union forces destroying Confederate salt works.

The land that would become Osceola County remained mostly wilderness until the end of the Civil War. The decade afterward, many former Union and

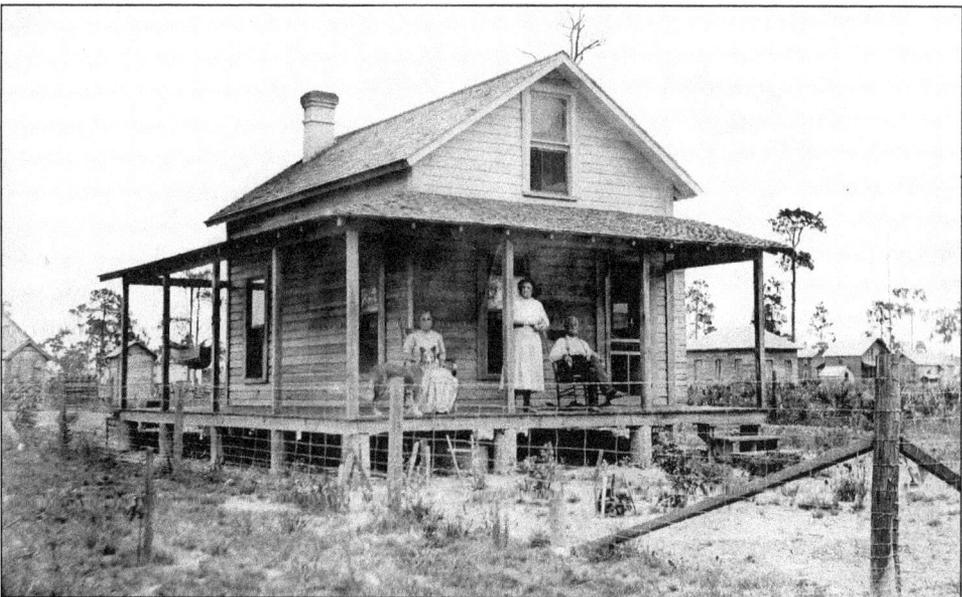

This unidentified family rests on the porch of what was a typical frontier Florida home in the late 1800s.

Confederate soldiers settled along the Kissimmee River and its lakes and tributaries. The early settlers discovered wild cattle that were descended from herds brought from Spain. Settlers also grew rice, sugar cane, vegetables, and fruit.

The federal government offered 160 acres and six months' worth of rations to anyone who would build a house, farm 5 acres, and agree to stay at least five years. Florida historian Richard Adicks calls the late 1860s and early 1870s the "seedling years," when pioneer families learned to do for themselves or do without. Their life was stark and demanding, and few could afford the luxuries of store-bought goods.

The land's tall pines became their walls and split cypresses their roofing shingles. In 1873, the pioneer settlement of Shingle Creek, home of a cypress mill, gained the first post office in the area. The mail routes from Fort Mellon (Sanford) and Fort Brooke (Tampa) crossed at the Shingle Creek settlement, where post riders exchanged pouches. Alma Hetherington, in her 1980 book *The River of the Long Water*, writes that the pioneers relied on the trading posts at Fort Mellon for staples. They hunted wild game from the woods and fished from the rivers and lakes. They cleared thick palmetto hammocks to plant cash crops or graze rangy cattle.

Many pioneers earned a livelihood hunting crane, egret, and other wading birds for their plumes. European designers of women's hats paid a high price for Florida feathers.

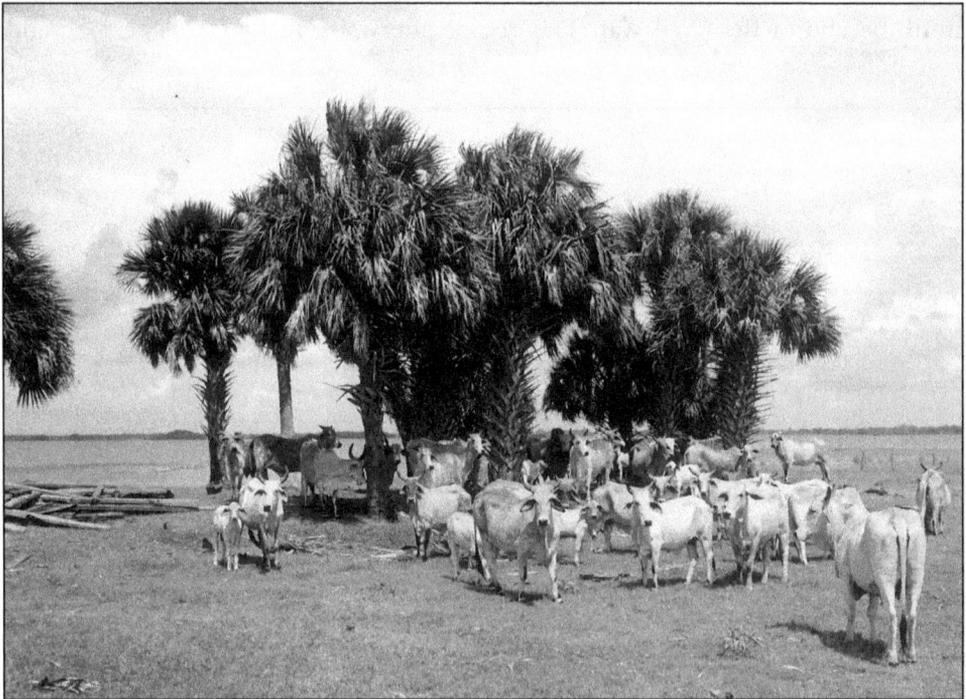

Ranchers improved their herds by importing purebred Brahma herds. This photo was taken in 1947.

The wild, untouched lands along the St. Johns and the Kissimmee Rivers were once overflowing with birds, fish, and wild game—all of which ended up on the tables of the rich and poor. Guests at the Titus Hotel at the head of the Indian River at Titusville were treated to oysters, clams, fish, shark steaks, sea turtle steaks, and soups and sampled the fruits and vegetables from nearby farms and groves.

Frederick de Bary, a transplanted New Jersey millionaire who made his fortune importing mineral water and champagne, built a steamboat resort on Lake Monroe at Enterprise in the 1870s. His guests enjoyed evenings of music and dancing and dinners of champagne, fresh game and fish, fruits, vegetables, and green-turtle soup. Railroad men Henry Plant and Henry Flagler, land baron Hamilton Disston, and other men of wealth relied on hunting guide Billy Bowlegs III, whose uncle of the same name was one of the last of the Seminole war chiefs. They almost certainly would have dined on "cooter," a freshwater soft-shelled turtle, as well as the gopher tortoise, sometimes called "scrub chicken."

Florida frontier storyteller Ed Winn writes in *My Florida Soul*, "Of all the river food, soft shell turtle was the favorite. . . . These prizes could be carried home in a gunnysack."

Pioneers also were fond of gopher turtles. "The only problem with these critters was that rattlesnakes often shared the gopher holes," Winn writes. "These turtles, once dug out of their holes, were docile. And it was pretty easy to dress one for the dinner meal and pen the others for another day." Add some heart of palm sliced out for swamp cabbage or diced up in a skillet with bacon fat and a few wild onions and potatoes and a dash of homemade salt and you have a pretty good start on a typical Cracker meal.

Day after day of salt pork (sometimes called "sawmill chicken"), grits, and cornbread could get boring. At least, that's what Seminole War–era army surgeon Nathan S. Jarvis writes in his journal. The doctor's diary went with him to frontier forts from Lake Monroe south to the Kissimmee River Valley. Soldiers, he writes, found Seminole cattle and butchered them. They used gopher turtles for a tasty soup.

Years later the freshest food served on board the steamboats that brought the first tourists to Central Florida was always fish, often caught just before the meal. Cooks placed traps along the river to catch turtles for soup. Steamer food was Florida Cracker food. Sweet potatoes and black-eyed peas came with every meal. Cornmeal was used in the batter of fried foods. Many Northern passengers sampled grits for the first time.

Florida's prairie also provided the Confederacy with a ready source of saw palmetto, used to treat lung disorders and bronchial problems. Just as during the Seminole Wars in Florida, far more Civil War soldiers died from disease than battle wounds. Florida's palmetto plants and trees had other uses in Confederate hospitals. Palmetto could be used as a substance to staunch the flow of blood. When ground to a powder, the dust can halt the free flow of blood—useful during operations to remove limbs or to stop blood from bullet wounds. Ground

Ranchers trained cattle dogs to help keep the cattle headed in the right direction.

palmetto berries were prescribed to combat constipation and for enlarged prostates, a practice that continues today.

Palmetto fronds were used as floor coverings, fans, brooms, and mops. After the Civil War, pioneers made hats from the palmetto fan-shaped fronds. The palmetto fibers from the tops—some measuring a yard across and weighing up to 60 pounds—were used to make brush and broom bristles. The Ox Fibre Brush Company had a processing plant reached by the Kissimmee River near Okeechobee. The company took its name from the oxblood color of the finished fiber brushes, which resembled the deep-red color of the Devon ox. The company canned the heart of palm on the site of its plants. Once the world's largest brush manufacturer with international markets, it went out of business in the 1970s. The berries are a cash crop in Florida, the main ingredient of herbal dietary supplements. Growing palmetto for medical uses is a $50 million-a-year crop for the state.

Cattle drives that began in Georgia and the St. Johns River area near Jacksonville meandered through what today is Kissimmee along trails leading to the Arcadia and Caloosahatchee River grazing lands. Pioneer "cowhunters"

needed thick skin and quick wits to thrive in the hardships of Central Florida's frontier wilderness. This is probably why the environment of long cattle drives and outdoor living on the range created a number of vivid personalities that Florida cattlemen today still talk about.

One such personality was Jessie Hope, who drove cattle in or near Orange County in the 1870s. It is claimed that during one grueling cattle drive from Valdosta, Georgia, to Tampa, he rode his horse for five full days without ever getting out of the saddle, napping occasionally as he rode. Joe A. Akerman Jr. recounts the tale in his book, *Florida Cowman*, though he cannot vouch for its authenticity.

As well known as Hope among nineteenth-century cattlemen was his pet black bear named Cubby, Akerman writes. Hope picked up the yearling bear from a tree in a thick hammock during one of his long cattle drives. But the animal didn't go quietly; it bit off part of Hope's finger. Cubby became well-known wherever cowmen gathered around campfires to swap stories after Hope trained him to do tricks. One of his favorites had Cubby drinking a bottle of beer and then stumbling around, pretending to be intoxicated. One night, however, some of Hope's companions got the bear really drunk, and he attacked Hope, ripping his coat and shirt to pieces.

Hope finally got rid of Cubby after "he violated the bounds of proper fireside etiquette even for bears," according to Hope's friend, George Dacy. Cubby had tipped over a 50-pound pail of lard in Hope's wife's kitchen and rolled around in it. To make even more of a mess, he ripped open a bag of sugar and flung what he

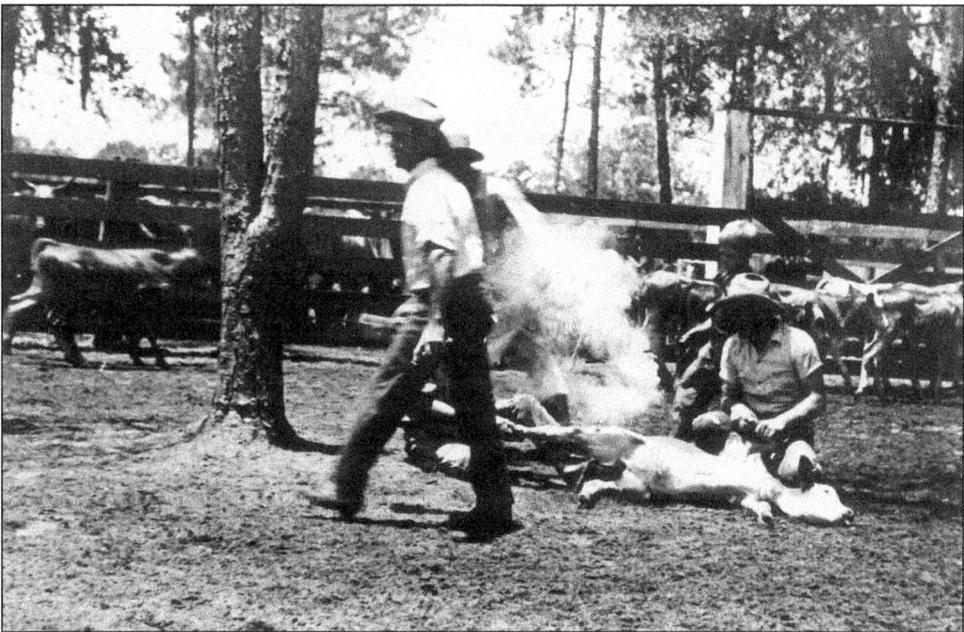

Ranchers brand cattle at the Sumner camp.

didn't eat throughout the house. When Hope came home and found the sugar-coated greasy bear curled up asleep in his bed, he decided it was time to give his pet away, Akerman writes.

The land where Hope called home had few established roads. For the most part, travel was by horse-drawn wagon and ox cart along narrow, sandy trails. Logging companies built their own crude roads, canals, and railroad spurs to the rivers.

Many travelers used the waterways. "Waterways have been significant since early man sat on a log and floated on a river," according to a 1997 study of Florida's early ferry services. Few bridges crossed the rivers. If they were lucky, settlers could find ferry boats to get across rivers and through marshes. A *Florida Historical Quarterly* article about Florida river crossings states that many ferries were in use long before roads opened. Even when Florida was still a territory, the government granted more than 100 permits for ferries.

The low land between what is now Kissimmee and St. Cloud was called Cross Prairie. Before the massive drainage work of the 1880s, the Cross Prairie ferry carried passengers across the marshy land between the pioneer settlement of Sunnyside on East Lake and Allendale (Kissimmee) on Lake Tohopekaliga. Travelers sometimes set signal fires to let the tender on the far side know that they were waiting. If several loads of wagon teams were waiting, a crossing could take all day. "Sometimes, where the ferryman was on the opposite shore, the traveler had to spend hours riding back and forth, gesticulating and shouting and even firing off a gun to attract his attention," according to the *Florida Historical Quarterly* article.

Myrtle Hilliard Crow includes several references to ferryboat services in *Old Tales and Trails of Florida*. One is about her parents' honeymoon trip to Narcoossee. Georgia-born James Hilliard, son of a Confederate soldier killed near the close of the war, went west to New Orleans and then to Texas, where he drove cattle to Colorado. Hilliard found his way to North Florida in 1877, where he learned the lumber business. He later ran a livery stable in Brooksville and owned a grove on Lake Eustis before settling on his island home near the upper western shore of East Lake Tohopekaliga.

Crow's mother, Emma Myrtle Hensley of Madison, Indiana, had moved with her family to Illinois as a child. Hensley's father, who had served in the Union Army, died when she was eight. Her family moved to the Lake City–Live Oak farming area of North Florida, where Hensley's mother married Emanuel Francis Masters of St. Augustine. Crow's mother would live briefly in Jacksonville before moving to Orlando.

Crow's father, too, would live for a time in Jacksonville. Lumber business would bring him to Kissimmee and Narcoossee, where he ran a sawmill supplying materials for the homes at the new English colony there. Her parents, who were introduced in Jacksonville, were married in Orlando.

Their wedding night took them to Narcoossee. "When they reached Cross Prairie, he fired his gun as a signal for the ferryboat operator," Crow writes. "What a picture it must have been to see this young 18-year-old bride, so full of youthful

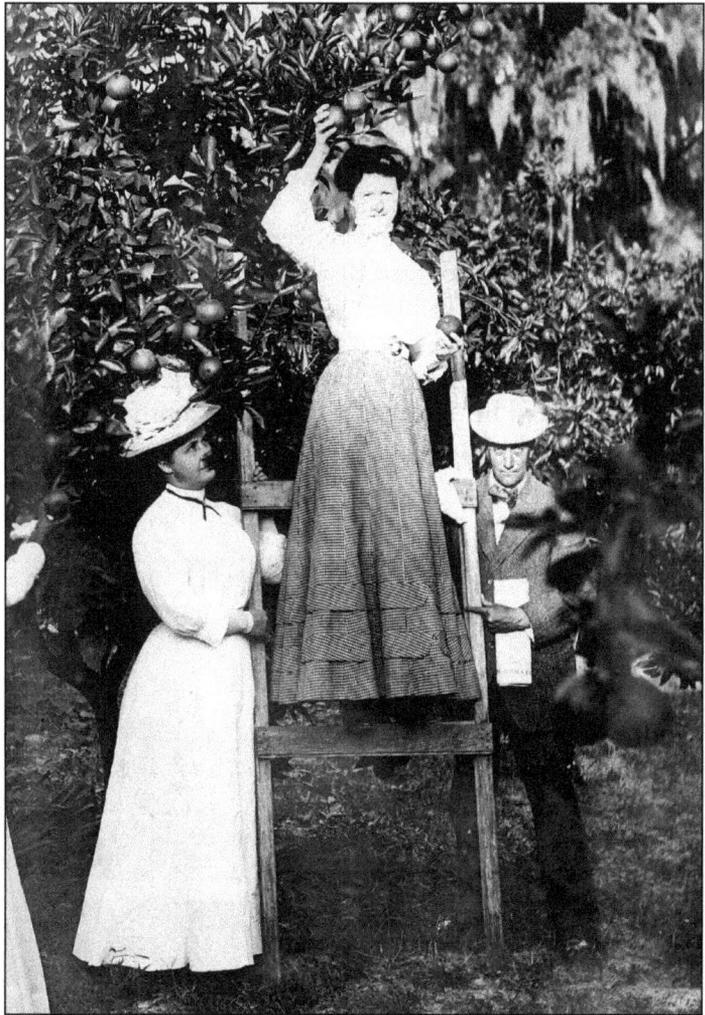

Three members of the Wright family pick oranges on Hilliard Island in October of 1903.

romance, boarding the ferry with her personal belongings. The following September they purchased and moved to the island to make their lifetime home." Hilliard later cut a path for a road across the marsh to what today is Boggy Creek Road. The county later took over maintenance of Hilliard Island Road.

Boggy Creek and the area at the northwestern shoreline of East Lake Tohopekaliga was marsh before the drainage work of the late 1800s. Even in the decades after the drainage, the Boggy Creek area remained thick with cypress trees. The land also was covered with large oaks, magnolias, tall cabbage palms, hickory, and sweet bays. The ground below the trees was thick with saw palmettos, ferns, and other plant life. Wildlife was plentiful. Wild hogs, wildcats, raccoons, opossums, skunks, squirrels, and all sorts of birds and snakes lived in and around Boggy Creek. Freshwater fish of all kinds and alligators filled the waterway.

Seminole legends told the first stories of the Monster of Boggy Creek, a huge creature with the giant head of an alligator that snorted and hissed and smelled foul. Years later, Osceola County's early pioneers told stories of men who went into the swamp and never came out.

Some trace the origin of the creek's name to fugitive cattleman Moses Edward Barber, who eluded a posse after Sheriff David Mizell was gunned down on February 21, 1870. No one was ever certain who fired the single shot that killed the sheriff, but few doubted that Moses Barber gave the order.

Barber and a few of his men "were almost overtaken at a creek . . . but the posse's horses bogged down in the marshes of a stream that has since been called Boggy Creek," writes Jim Bob Tinsley in *The Life and Times of Bone Mizell*, "and Moses and his kinsmen got away." Family lore holds that Moses and Jack Barber escaped by boat on the St. Johns River, then headed west and out of Florida forever.

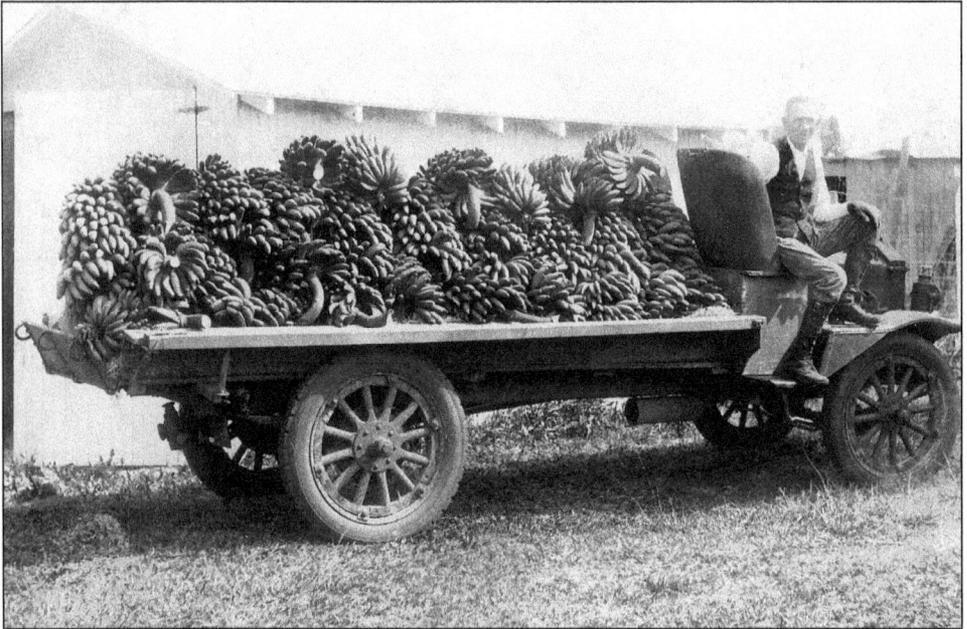

At a "coloring room" in Kissimmee, green Cavendish bananas grown in the early 1900s along the St. Cloud canal ripened for local sale.

6. Hamilton Disston Turns Frontier Allendale into the Gateway to the Kissimmee River Valley

Like many Florida communities, Kissimmee can trace the beginning of its commerce to its steamboat wharves. The southernmost point for the largest steamboats along the St. Johns River was Mellonville, "where civilization stopped," noted a newspaper writer in the 1850s. From Mellonville, which would become part of Sanford, settlers set off to establish homesteads in the vast swampland and prairies.

Some traveled overland, but many boarded smaller, flat-bottom steamers to venture farther south along the narrowing, shallow St. Johns. The Kissimmee River Valley steamboats, writes Florida Cracker historian Lawrence E. Will, were "always just one jump ahead of civilization."

Will describes the old stern-wheel steamers as "wet-tail" boats and "smoke" boats. When you couldn't get to where you were going on foot or on horseback, steamboating provided just about the only transportation. The steamers and their captains hauled people and their possessions into the wilderness from Lake Tohopekaliga to Lake Okeechobee at least 50 years before primitive trails would be widened and raised from the wetlands for roadbeds to carry trains and cars. Will writes:

> They'd helped to settle up the Kissimmee valley and the Caloosahatchee country as well, but when the water was drained off these Everglades, and folks had started to settle here, those wet-tail boats were the first to bring them in, across the lake down those new dug canals. Every settler had his skiff boat or launch and the red-skinned Seminoles used dugout canoes. We even had store boats and a church boat, too. There were no roads and blamed few trails, so if you didn't have a boat, you just plain stayed at home.

This November 17, 1897 issue of the Kissimmee Valley Gazette *includes an advertisement for the Clyde Line, one of the leading steamboat lines serving the St. Johns River.*

Will, who for a time owned two tugboats and a floating dredge, writes in his 1965 book *Okeechobee Boats and Skippers* that a fair number of the early arrivals were from the Midwest states and:

> a right good share had never farmed before. They were all naturally classed as Yankees. The hunters, the cow men on the Kissimmee prairie, the catfishers, and a goodly share of the boatmen, too, were native-born Florida or Georgia Crackers, a quite different breed of men, I'll have you know. They could be right at home with only a blanket and a mosquito bar for a roof, but they weren't really quite so wild as the Seminoles, although those Yankees seemed to think they were, and their Cracker dialect sounded right strange to Northern ears.

By the 1870s, steamboat lines were flourishing along the St. Johns River. Soon, though, dredging opened Florida's other shallow rivers, including the Kissimmee and its chain of lakes.

Historian Elizabeth Cantrell's book, *When Kissimmee Was Young*, recalls that in the early 1880s her uncle, L.A. Willson, arrived from Kentucky to a boomtown on Lake Tohopekaliga. Fifty houses were under construction and settlers were camped out waiting for lumber, keeping three new sawmills busy. J.H. Allen owned the largest. The former Confederate major had picked the shores of Lake Tohopekaliga to launch his career as a riverboat captain. His steamer, the *Mary Belle*, became the first cargo steamer on the Kissimmee River. He also opened a lumber mill and a general store. Soon pioneer settlers were skipping the ox cart trip to Sanford and buying their supplies in the settlement of Allendale.

The *Mary Belle*, built at a nearby shipyard, plied the waters between Fort Myers and Allen's wharf. Allen's first home was built on Paradise Island with logs cut on the mainland. He later built an addition to his store for a home. Allen, who would leave Florida for the Northwest and strike it rich in the Klondike River gold rush days of the 1890s, had seen his tiny settlement grow to become the gateway city to the Kissimmee River Valley.

Kissimmee City was born on a Saturday election day in 1883. That seems a fitting day for a town referendum; on Saturdays, just-paid cowhands were known to ride up to saloons in the pioneer settlement and order a whiskey without dismounting. The town that would become Kissimmee City earned a reputation in the 1870s as the home of the country's first bars that accommodated ranchers on horseback.

On March 24, 1883, 33 of 36 eligible voters said "aye," and Kissimmee was incorporated as a city. T.A. Bass was elected mayor. The vote reversed a January

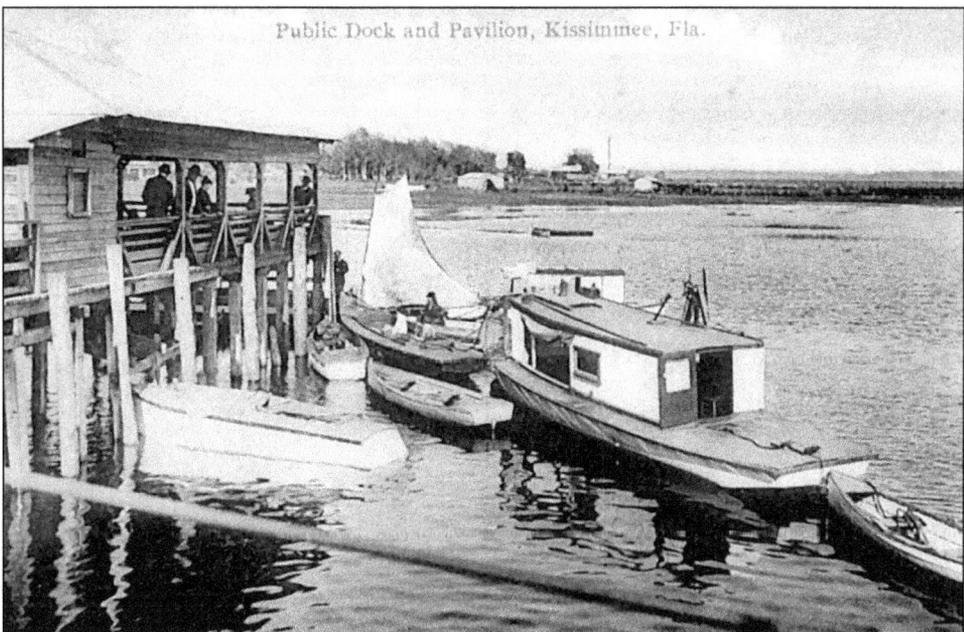

Steamboats and small sailboats provided transportation when early setters couldn't reach remote area on foot or by horse.

referendum that had been thrown out because 44 votes were cast. Only 36 voters were eligible.

Steamboat captain Rufus E. Rose, who had come to Florida from Louisiana to work for Disston, suggested the lakefront settlement should share the name of the river Disston's dredges were widening and deepening. Rose was the land agent for Disston's grand deal with the state to drain much of the swamps around Allendale and dredge a river highway from Lake Tohopekaliga to Fort Myers on the Gulf. Disston made the new city his headquarters for land sales and canal and drainage projects that opened steamboat commerce to the Gulf following the Kissimmee and Caloosahatchee Rivers. Disston, heir to his father's Philadelphia saw-manufacturing company, had made his dredging and draining deal when Florida was starved for cash. The deal Disston made with the state allowed him to keep half the land he drained. He contracted to drain land in the Kissimmee River Valley, the Lake Okeechobee area, and west from the lake to the Gulf of Mexico. He would clean out and deepen the Kissimmee River to Lake Okeechobee and open shipping lanes connecting lakes.

The state, though, needed cash to clear up title problems to a lot of the land because of debts on pre-Civil War railroad bonds. The bondholders were screaming for $1 million in interest payments, threatening to take control of 14 million acres of state land. Governor William Bloxham persuaded Disston to buy 4 million acres at 25¢ an acre. The deal in June 1881 made Disston the largest individual landowner in the United States.

By 1884, Disston had drained 2 million acres and his empire stretched from Kissimmee to Lake Okeechobee to the Gulf. That opened Florida's vast interior for farms, railroads, and real estate development. His land-sales campaigns

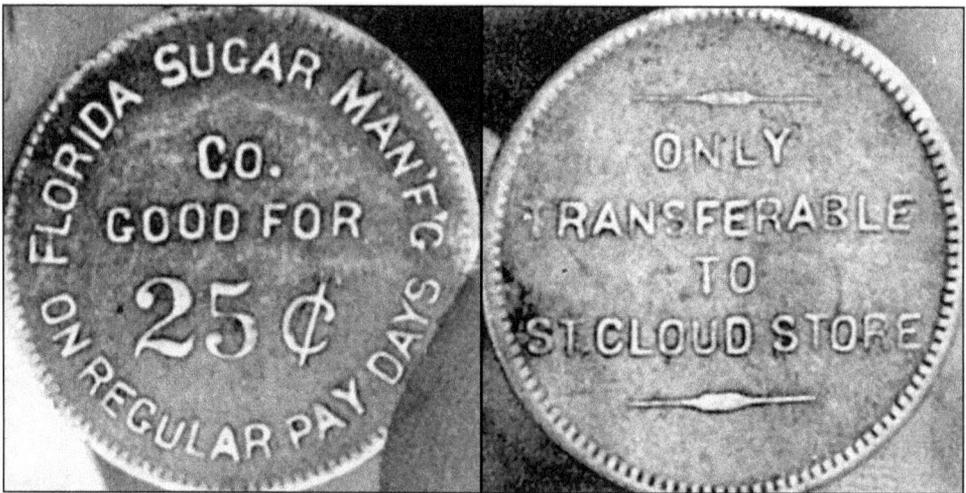

These photos show both sides of the coins issued to workers at Hamilton Disston's sugar cane plantation at St. Cloud. The former plantation commissary is now a private home on the banks of the St. Cloud Canal dug between East Lake Tohopekaliga and Lake Tohopekaliga.

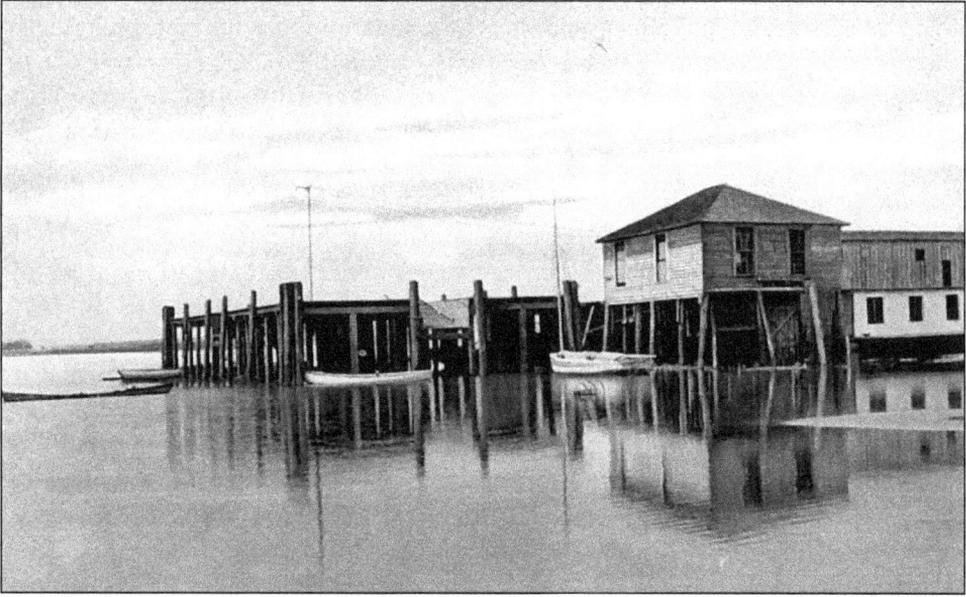

The wharf at Kissimmee's lakefront provided the commerce that made the city the gateway to the Kissimmee River Valley.

reached throughout the United States and Europe. Speculators came to take advantage of Disston's sprawling empire, and immigrant laborers settled nearby to work in the sugar and rice fields or operate the dredges draining the land and carving the canals.

By dredging the river and lakes, Disston and others brought business and industry to Kissimmee. The city became a bustling boat-building port as steamboats carried freight and passengers between Lake Tohopekaliga and the Gulf. Settlers found plenty of work building steamboats needed to carry dredges and laborers to remote areas being drained. From Kissimmee, flat-bottomed steamboats paddled up and down the lake chain, through the Kissimmee River and Lake Okeechobee to the ocean. Weekly shipments of groceries, clothing, equipment, and mail arrived for settlers scattered at 21 outposts from Kissimmee to Basinger.

The new territory attracted new settlers, including Barbados-born Scipio Lesesne, who came to Florida from South Carolina to work at Disston's sugar plantation. As a seaman, he traveled to many ports, learning new languages as he traveled. Lesesne (pronounced la-sane) drew on his language skills as foreman of the St. Cloud plantation, which employed black laborers from South Carolina and first-generation immigrants. Part of his role as foreman and interpreter was to recruit workers to come to Florida.

Juanita Lesesne, whose father is William Harleston "Buster" Lesesne, traced her father's name through family lore and historical documents led to the antebellum South Carolina plantation of a French Huguenot named Isaac Lesesne and Charleston lawyer William Harleston, who had a son by the same name.

71

Isaac Lesesne and his heirs owned several plantations and other farmland near Charleston, beginning in 1709 and continuing until 1808. Charleston was one of the leading cotton and slave auction ports during the English colonial years. Isaac Lesesne Jr. fought the British during the American Revolution and loaned money and goods to help other patriots during the British occupation of Charleston. The Lesesne family sold their South Carolina land in the early 1800s, resettling in Barbados, where colonists had established sugar cane plantations using slaves and indentured servants in the 1640s. "Many white people left Charleston during slave uprisings, taking those who were loyal amongst the enslaved Africans with them to Barbados," Juanita Lesesne said.

This is how she believes her grandfather's parents or grandparents came to Barbados. Scipio, a common name given the first-born males of slaves, was born on the island in 1859. "It is my understanding that my grandfather was not enslaved," but he grew up among former slaves, Lesesne said. The British ended the slave trade in 1808, the year the Lesesne family sold the South Carolina plantations and resettled in the West Indies. Slavery was abolished in the West Indies in 1833, more than two decades before Abraham Lincoln signed his Emancipation Proclamation during the Civil War.

"I recall being told that he stowed away on a ship leaving Barbados when he was quite young," she said. Life at sea gave the young man plenty of opportunities to learn new languages. Juanita Lesesne believes her grandfather eventually returned to Bridgetown, Barbados, and may have brought his parents to Charleston. It was there that Scipio Lesesne met lawyer William Harleston, who was an investor in Philadelphia saw and tool manufacturer Hamilton Disston's Florida ventures to drain swampland and grow sugar cane.

"William Harleston had been involved in the development of a sugar cane plantation in St. Cloud," Juanita Lesesne said. "This gentleman, the father and/or his son, I'm uncertain of which, was the friend of my grandfather whose name was given to my father."

The Lesesne family has marriage ties to another of Osceola County's legendary African-American families. Malinda and Buster Lesesne, the youngest of Scipio Lesesne's children, were married on May 28, 1938. (More about Buster Lesesne is in chapter nine.) Malinda Lesesne's Aunt Sara was the wife of rancher Lawrence Silas, a legend among Florida cattlemen. During Florida's segregation era, Silas owned 3,000 acres along the St. Johns River, building on his father's ranching reputation and traditions of square dealing and treating those who worked for him as he expected to be treated. Lawrence Silas's father, Tom Silas, had come to the Florida frontier just after the Civil War. Born into slavery, Tom Silas set out on his own into the lawless Florida interior where cowtowns like Kissimmee were full of men who had fought the Seminoles and the Union. Tom Silas started his own ranch in Whittier (now Kenansville). He never learned to read, but he made sure his wife hired tutors for his children.

In a late 1940s interview with a reporter for the *Tampa Tribune*, cattleman Lawrence Silas said his father died in the late 1800s "after doing what he could to

see that his children received good educations," which included learning to judge the value of cattle and friendships. Silas built his herd at a time when cowhands earned $1.50 a day to drive cattle to the gulf ports but cattle barons shipped tens of thousands of head of Florida's wild scrub herds to Cuba for Spanish gold. The Silas ranch would grow to 2,000 acres. He bought and sold cattle, grazing some on land he owned, some on land he leased.

After his death, his family moved to Kissimmee. Tom Silas left several thousand cattle and a sprawling ranch, but these assets slipped away from his wife. Lawrence, born in Kenansville in 1891, worked for other ranchers and built on his father's buying and trading talents. He eventually owned 3,000 acres along the St. Johns. He succeeded by following his father's teaching of square-dealing with partners and workers. "I eat what they eat; I sleep where they sleep," Silas told the *Tribune* reporter.

Folklorist Zora Neale Hurston profiled Silas in her 1942 article in *Saturday Evening Post*, "Lawrence of the River." She writes, "Lawrence Silas represents the men who could plan and do, the generations who were willing to undertake the hard job—to accept the challenge of the frontiers."

Among these challenges when Kissimmee was still a frontier town was getting the mail. In the years before storeowner W.A. Patrick opened the first post office on May 22, 1882, in his general store at Emmett Street and Stewart Avenue, delivering the mail was one of the tasks of R.E. Rose. About once a week, R.E. Rose put aside his duties as riverboat captain and superintendent for shipbuilding and dredging crews to make a mail run to Orlando. When he returned to the

Hamilton Disston's dredges dug a river highway from Lake Tohopekaliga down the Kissimmee River Valley.

Okeechobee Land and Drainage Company's log store under twin oaks at Vernon Avenue and Hughes Street, Rose stood in the shade to call out the names of company workers. The town had only a few scattered families, and they often gathered to see if any of the mail in Rose's pouch carried newspapers or family letters from afar. This was before a post office opened in Kissimmee in May 1882.

Rose, who laid out many of the first streets, had come to the lakefront settlement of Allendale as an engineer for Disston. The former New Orleans riverboat captain's job description was as wide open as the countryside. As superintendent of Disston's operations along the Kissimmee River, Rose also watched over the shipyard, its foundry, and machine shop. The shipyard built barges, dredges, dredge tenders, and steamboats, everything except the boilers, which were bought in Orlando.

His duties grew after he bought 420 acres and built a home for his family on East Lake Tohopekaliga. Nearby, with Pennsylvanian Sam Lupfer Sr. as his partner, he raised sugar cane and built a small open-kettle mill. With Disston as his partner, he expanded his sugar planting into a 1,800-acre plantation, boasting what was at the time the biggest sugar mill in the South. The land around the sugar plantation became St. Cloud.

Rose's brother-in-law, another riverboat captain named Clay Johnson, also came from Louisiana when Disston offered him the job of foreman of his shipyard. The sugarcane Johnson planted in 1883 on 20 acres of muckland at the southern tip of Lake Tohopekaliga won honors for quality and yield in 1885 at the New Orleans

Cattle graze on the low land near the Disston Sugar Mill. The pasture is in front of cypress trees and the houses where Disston workers lived.

Cotton Centennial. In Louisiana, Rose had been a chemist and Mississippi riverboat captain. Disston had learned of Rose from his work with the Louisiana Reclamation Company, which dredged up peat and muck from the Mississippi Delta.

Rose almost became Kissimmee's first mayor. In January 1883, when Kissimmee held its first election to incorporate as a city, Rose was the leading candidate for mayor. That vote was challenged. In a second election three months later, Tom Bass, another steamer captain, became the city's first mayor. Competition between Bass and Rose wasn't limited to the ballot. When the canal was finished between Lake Tohopekaliga and East Lake Tohopekaliga, both wanted to make the first trip. Alma Hetherington, in her 1980 book *The River of the Long Water*, writes that her father, riverboat captain Paul Gibson, also wanted to get through the channel first.

Rose had dammed the canal with logs, but the two other captains, Bass and Gibson, took a buggy at night to try to free a passageway so their steamers could slip through before Rose. They failed, and Rose took the honor the next day.

Rose later regained political influence. On May 12, 1887, Osceola County was formed by the state legislature from portions of Orange and Brevard Counties. He was soon elected as first chairman of the County Commission. Also, Rose went on to land an appointment as the state's agricultural chemist, a post he kept until his death in 1931.

The duties of a Kissimmee River steamer captain sometimes took a twist. As a ship's captain, Clay Johnson had the authority to perform marriages for pioneer couples. At the request of one bride, the captain secured a marriage license and prepared for the wedding. The bride, though, showed up without her groom. It seems the woman had called off the first wedding, and now asked the steamer captain to arrange for a marriage license with the name of her new beau.

Johnson, who came to Osceola County from New Orleans in 1883 to work for Disston, would find many other challenges along the river. He owned a fleet of steamboats from the 1880s to the 1920s. The Louisiana riverboat captain dredged the Southport Canal, leaving a small section for a grand opening ceremony attended by President Chester Arthur.

Johnson's first steamer was the *Mamie Lown*, which burned kerosene to heat its steam engine. The small side-wheeler was used to tow barges across Lake Tohopekaliga, through the St. Cloud canal to East Lake Tohopekaliga, and deliver machinery in 1888 to Disston's sugar plantation and massive mill.

Johnson's small side-wheeler, though, couldn't get up enough steam to haul the heavy machinery without help from a Cross Prairie ox team. William White hitched his oxen to the steamer and, walking along the shoreline, they pulled the steamer along. Johnson would also haul bricks for the houses of the English at Narcoossee and teach the newcomers about farming in Florida.

Johnson and his family lived aboard the steamer *Okeechobee* when they first arrived. They later lived in a log cabin near the shipyards and the Okeechobee Land Company bunkhouse for its workers. After he moved his family into a one-and-a-half-story Queen Anne–style house with a big wraparound porch on

This undated photo shows Rufus Edwards Rose, the steamboat captain and Disston agent who suggested the name Kissimmee City for the new town on the lake Disston's dredges were opening as the gateway to the Kissimmee River Valley.

Vernon Avenue in 1895, Johnson entertained family and friends with tunes on the fiddle, fife, or flute.

Cracker historian Lawrence E. Will, who knew Johnson in his later years, described the riverboat captain in this way:

> Hit were when I was a-boatin' on the big lake that I got to know some of them old Kissimmee River steamboats and their crews and especially Cap'n Clay Johnson, the most famous one of all. He were the last man to run a steamboat in the State of Fluridy. . . . And, if'n you'd had told him he was the dead spit of old Mark T'wain, he'd a-been your friend for life. Clay Johnson steamboated whar thar wasn't neither buoys nor beacons nor dredged-out channels, and he had no searchlight to pick up his marks at night, nor ship-to-shore telephone to let his missus know he'd be an hour late in gettin' home, but he could read the face of the water like a parson readin' scripture.

For his homesite, the captain had hauled barge loads of dirt to fill in the low land. He and his son, Amory, designed the house and supervised the shipyard

carpenters who built it with heart of pine lumber milled nearby. Steamers landed near Johnson's private landing not far from his Kissimmee house.

Family names found their way onto his steamers. He named the cabin boat *Lillie* for his wife, Lillie Augusta Rose Johnson. Passengers boarded the *Lillie* for a four-day trip from Kissimmee to Fort Myers. The *Lillie* had staterooms on the upper deck. Johnson bought the *Cincinnati*, salvaged its boiler and engine and rebuilt it as the *Roseada*, named for his daughters, Albina Rose and Ada Roberta. Family lore has it the *Roseada* could float on a heavy dew. The *Roseada*, like the *Lillie*, ferried prospective land buyers down the rivers to Fort Myers.

Johnson's working boat, the *Osceola*, was built in 1910. Fully loaded with 1,000 boxes of oranges, the nearly 75-foot steamer could still make 12 mph upstream. Merchants paid Johnson a percentage of their sales to deliver grain, groceries, and other goods to settlers along the river and return with oranges, hides, resin, turpentine, and other products for trade.

When railroads took over the Kissimmee River cargo runs, Johnson moved the *Lillie* and the *Osceola* to Lake Okeechobee to haul road-building materials for new highways. He converted the *Lillie* to a work boat, removing the staterooms and upper deck to give it more stability. The *Lillie* ended up as a houseboat in the Keys. The *Osceola* sank after hitting a tree during the time the Army Corps of Engineers was working on the Kissimmee River channel.

Johnson, who retired to Kissimmee in 1926 and died in 1931, outlived the *Roseada*. He had given it to his son-in-law George Steffee, who continued operating it on the Kissimmee. The *Roseada*, the last of the Lake Tohopekaliga steamers, was damaged by a 1926 hurricane. A 1928 storm ended any thought of repairs.

Disston's canal system was never big enough for another boat, the *Bertha Lee*. Riverboat Captain Benjamin Hall took 53 days to maneuver the *Bertha Lee* from

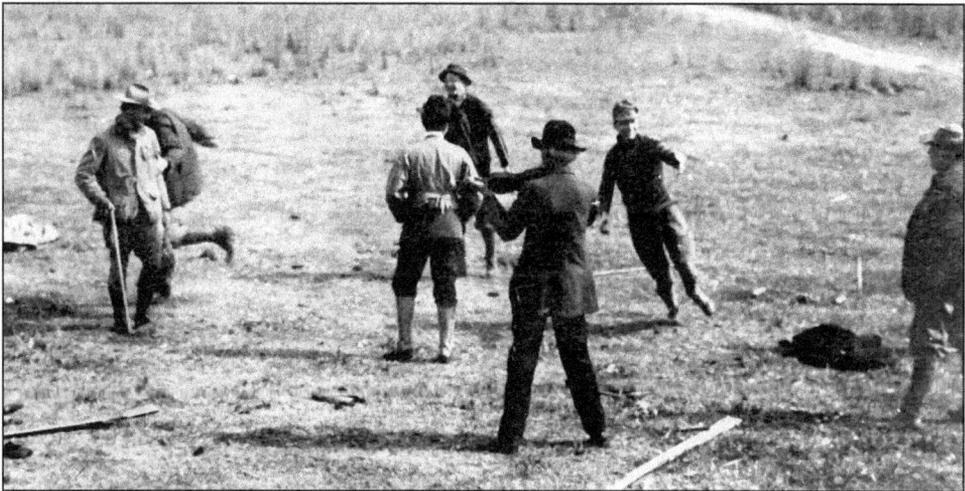

Steamer Captain Clay Johnson entertains family and friends with tunes on the fiddle, fife, or flute. Here he is shown playing for a square dance on the lakefront near his home.

Fort Myers, through the narrow Caloosahatchee River, Lake Okeechobee, and the Kissimmee River to the Tropical Hotel on Lake Tohopekaliga. Hall, who had been 12 when he signed on as a cabin boy on his first ship, accepted the challenge after another riverboat skipper passed on the challenge offered in 1883 by resort hotel owner Ed Douglas.

Most of the stern paddlewheel steamers of the mid-to late 1800s were compact and flat-bottomed because of Florida's shallow, twisting rivers. Not the *Bertha Lee*. It had two decks, with freight and machinery confined to the lower deck and cabins for passengers on the upper. It was 130 feet long with nearly 4 feet of draft—big enough and pretty enough to show off to the growing winter tourist trade. Or so the resort hotel owner planned.

The *Bertha Lee*'s voyage began September 20, and ended at the Kissimmee docks nearly two months later, writes Osceola County historian Alma Hetherington, whose father, Paul Gibson, was another of the early riverboat captains on the Kissimmee River.

Getting the boat around sharp bends often required the skillful pilot to chart a zig-zag course, running the bow and then the stern into the riverbanks before steaming ahead. Other times, Hall sent his crew ashore to tie a rope to riverfront trees to help guide the steamer. Just before reaching Lake Okeechobee, the river narrowed to a point where the banks were right up against the ship's side guards.

Steamer Captain Clay Johnson moved his family into this 1.5-story Queen Anne-style house with a big wraparound porch on Vernon Avenue in 1895.

Captain Clay Johnson named the Roseada, *shown here loading lumber, for his daughters, Albina Rose and Ada Roberta.*

The captain cranked up the stern wheel's boiler, but the ship didn't move. The crew used lumber from the ship's lower decks to build a dam to raise the water in the channel enough to float the wedged-in ship.

That's about the time they ran out of fuel to heat the steamer's boiler. Hall sent the crew to cut more wood. Ahead was the Kissimmee River, a long marshy prairie of frustrating channels leading nowhere and clogged by water plants, which often got caught in the paddle wheel. Navigating was made more difficult because the winding river had almost no current to help the captain find the main channel. The captain and crew, though, beat the river and chugged into Lake Tohopekaliga on November 12.

The resort hotel owner had bought the steamer after seeing the advantages of having a riverboat for his guests. For a while, guests enjoyed night cruises with the lakefront's trees and branches illuminated by firelights from pine burning in a large iron box on top of the pilothouse. Soon, though, Douglas decided the boat was too big to use for the few moonlight excursions and picnics offered to guests. He made a deal to unload the ship, and hired Hall to return the ship to Fort Myers. When he reached the Gulf town, though, the *Bertha Lee* was impounded to pay the debts owed to the crew. The largest share of the debt was due Hall, whose bid won at an auction. The ship would find work hauling cotton, but it later sank when the crew ran it aground and it capsized on the Chattahoochee River near Bristol, Georgia. That was the end of the *Bertha Lee*.

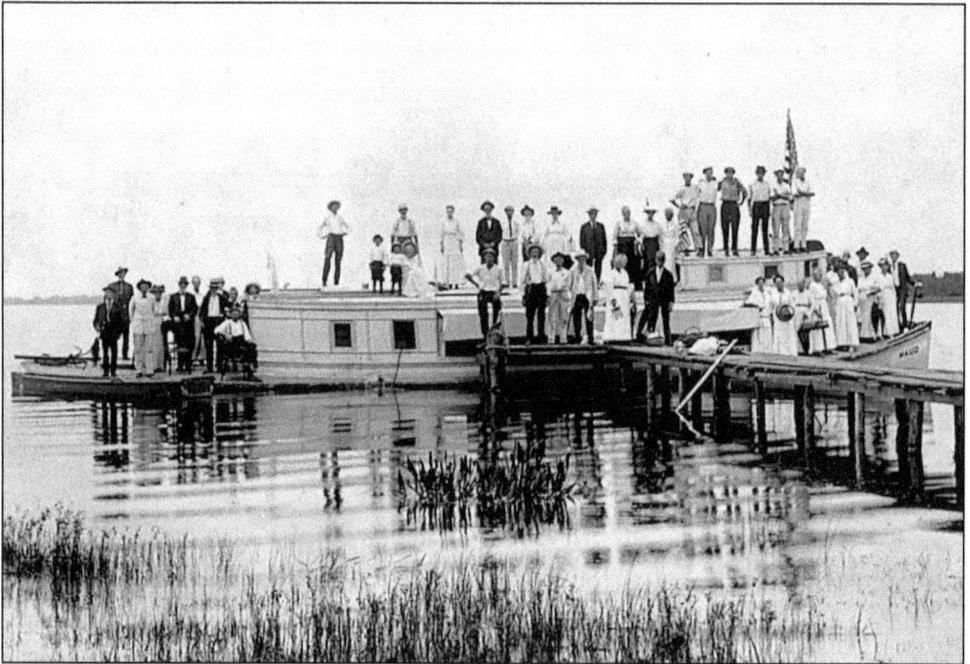

This 1916 scene shows some of the English settlers who founded Narcoossee in the late 1800s during a picnic trip on the Maud.

Hall's bet on the *Bertha Lee* was just part of the gamble of life in early Osceola County. It's a pretty good bet that a fair share of all that Spanish gold for cattle drives was put on a horse's nose. Kissimmee had its own horse track with bleachers. The crowds filled the stadium seats to watch local riders race ponies owned by ranchers. The owner of the winning horse could take home $25. The rider got a silver dollar.

The stories of Osceola County's early years include tales of local boys and their horse races along Lake Tohopekaliga. Stories are also told of horse races along the dirt streets of St. Cloud. Horse racing was a big part of a lot of early Osceola County celebrations. Cantrell writes that horse races took place on what is now a state-owned island in Lake Tohopekaliga. A Fourth of July celebration in 1884 on the island, then called Brack's Island for W.J. Brack, included horse races around barrels on land and boat races on the lake. Brack, who had been Orlando's first mayor and later became one of the early Osceola County commissioners, provided the racing and a feast for more than 350 people from as far away as Tampa Bay, the Brevard coast, and Sanford. The racing was followed by a "bountiful and magnificent spread of good things of every description; and with such a multitude it did not take long for the beef and venison barbecued in the morning, to disappear, washed down with delicious lemonade and watermelons."

Gambling and politics were one and the same in early Osceola County. Kenansville, when its was still called Whittier, was one of the Florida settlements

that kept the nation waiting during the 1876 disputed election of Republican Rutherford B. Hayes over Democrat Samuel Tilden. Aldus M. Cody and Robert S. Cody's *Osceola: The First 100 Years* included the story behind the decision-making votes cast at Whittier.

Almost 125 years after the Hayes election, Florida helped George W. Bush move into the White House as the fourth president—and the first in the twentieth century—elected without winning the popular vote. Before Bush, the last president elected who lost the popular vote was Benjamin Harrison, who wasn't the choice of the people but won the 1888 Electoral College vote. The same constitutional quirk put John Quincy Adams in office in 1824 and Hayes in 1876. The Bush-Gore election dispute was a lot like the situation in 1876. Bush sent former Secretary of State James Baker to Florida to watch over the recount. Al Gore's interests were overseen by former Secretary of State Warren Christopher. National statesmen from both parties rushed to Tallahassee after the disputed contest between Hayes and Tilden. "They were joined by curious observers and several companies of U.S. soldiers and literally overran Florida's small capital city," writes Jerrell H. Shofner in *The New History of Florida*.

The road that would lead Hayes to the White House began at a crude frontier courthouse west of Whittier at a spot called Court House Pond. Back then, the government house where people in the area came to vote was part of Brevard County. (Osceola County was made from sections of Brevard and Orange Counties in 1887.) "Few persons today think of the most famous election contest in American history as having been decided by the election returns from a wayside voting precinct in Osceola County," writes Minnie Moore-Willson in *History of Osceola*.

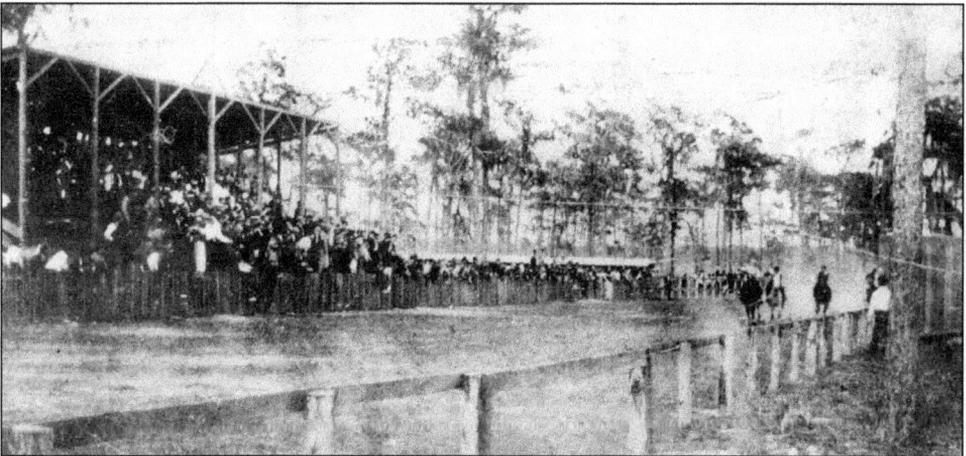

Kissimmee had its own horse track with bleachers. The crowds filled the stadium seats to watch local riders race ponies owned by ranchers. The owner of the winning horse could take home $25. The rider got a silver dollar. The Kissimmee Race Track opened in 1912 on Pleasant Hill Road.

Weeks after the election, the results were still in dispute as the political parties argued about ballot fraud in Florida, Louisiana, and South Carolina. Kissimmee River Valley historian Albert Devane later wrote that at least one of the Court House Pond offenders was "prosecuted, found guilty and sentenced to prison." The delayed vote count from Whittier swung Florida's electoral vote to the Republicans and gave the presidential election to Hayes, even though Tilden had won 51 percent of the popular vote. After most of the states were counted, Tilden had 184 electoral votes, one short of the number he needed. Still in doubt, though, were Louisiana, South Carolina, and Florida.

Democrats were close to retaking the presidency for the first time since 1856. But Florida was dominated by Republicans, who came into office following the Civil War. A GOP-controlled board took a month to review challenges to the result and then named Hayes the winner. Democrats balked, sending their own tally to Washington. Voting along party lines, eight Republicans on a 15-member commission gave all three states and the election to Hayes. It was a brokered deal. Hayes and the Republicans agreed to withdraw the last federal troops from the

The brick ruins of Disston's sugar cane mill have survived the years near the St. Cloud Canal.

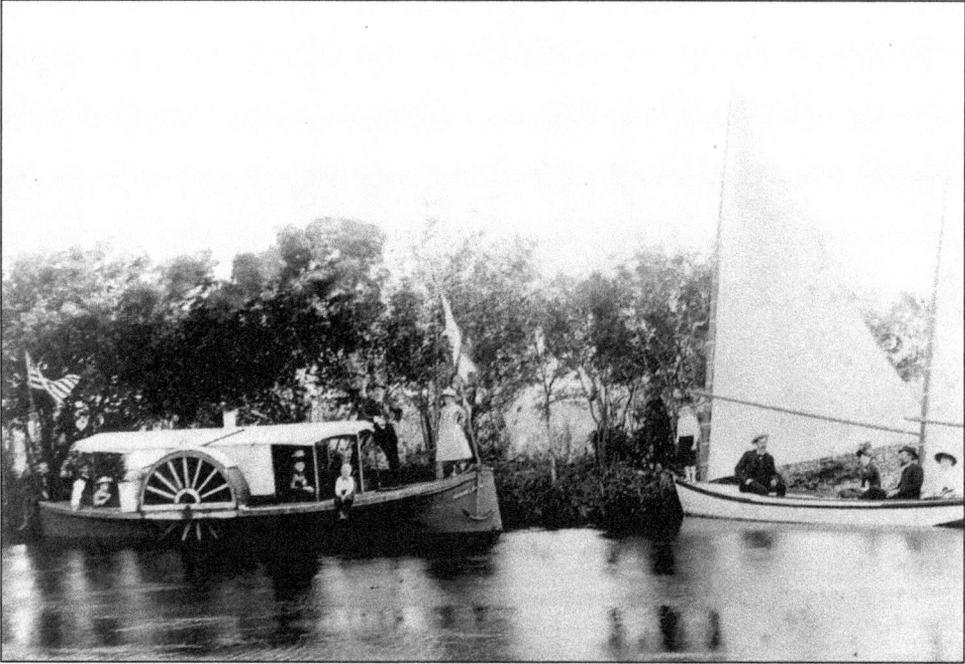

Not all the boats on the Kissimmee River were used for work. These two boats are out for a pleasure ride.

South and provide more federal money to rebuild the South. All the bickering, though, had kept the nation—and the candidates—waiting. Hayes did not find out he was the new President until March 2, 1877.

Florida's role in that election was just one of the many reports Will Wallace Harney wrote about in this frontier state. The former Kentucky teacher, lawyer, and newspaper editor came to Florida in 1869 on the leading edge of the era when Florida offered its vast interior to just about anyone willing to tame its wilderness. His "Florida Letter" dispatches to the *Cincinnati Commercial* lured many others to join his frontier adventures. For 14 years, he wrote for national magazines and Northern newspapers, often datelining his stories from Pine Castle, his 160-acre pine-lumber estate on the west side of Lake Conway. Long after his estate burned, the community kept the name.

Harney, who had been editor of the *Louisville Democrat* before moving to Florida, acquired *The Florida* in 1883. He renamed it *The Bitter Sweet*, a reference to the sour bite of wild oranges from the old Spanish groves, and opened a newsroom over the Kissimmee Land Company.

T.M. Shackleford, who would become a Florida Supreme Court justice, was a correspondent for the *Louisville Courier Journal* when he befriended Harney. The editor, a short, thin man, was dressed in a blue flannel shirt with the sleeves rolled up. Seated at a table, Harney was "dashing off copy for his paper. . . . Before I left, he had me completely under his magic power."

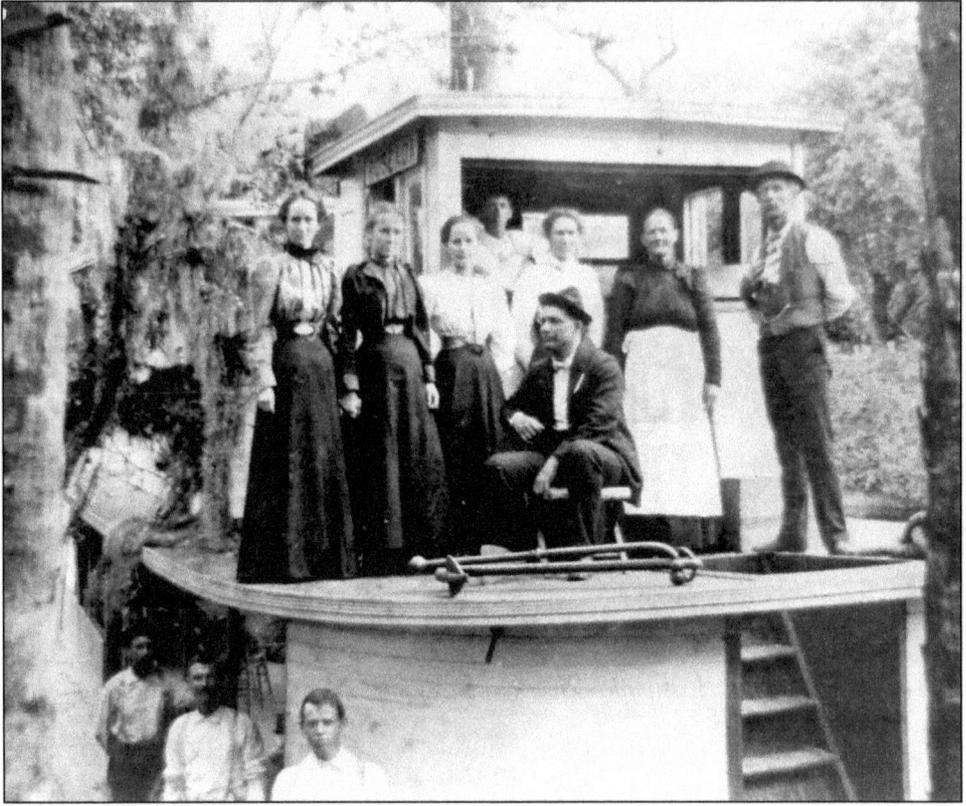

Clay Johnson, far right, stands on the desk of the Roseada *with his wife, Lillie, and other family and friends.*

Shackleford wasn't alone. Harney's writings were responsible for enticing many Northern farmers and tradesmen of modest means to move here, buy a small plot, and make a good living raising vegetables or citrus. Many of those he wrote about had cleared land, built their houses, and grown their own crops. They planted orange trees, tended their cattle, and made clothes for themselves and their children. The editor recommended sugar cane or citrus as a cash crop. Citrus trees needed five years to bear fruit, so growers needed other crops until his trees matured. He suggested sugar cane. "Sugar cane is a more profitable crop [than cotton] in skillful hands . . . but it requires care and experience," he wrote.

The right harvest and careful attention when making the syrup would be rewarded. "You may clear a hundred dollars an acre on your land, or not more than twenty," he cautioned.

Celebrations were planned around cane grinding after the harvest. The bottom of the boiling kettles provided candy for children. Everyone could chew raw cane or wait for biscuits sweetened with hot cane syrup. The men fermented their own potent cane beer.

Not all of Harney's writings were sweet. He warned his readers of storeowners who exploited farmers with inflated prices for goods, steep interest on loans, and low-ball rates for crops. He called these merchants the "curse of the South" and "bloodless, cold-natured, ignorant vampires." His reporting also uncovered fraud at state and federal agencies when thousands of homesteaders could not get titles to land because others claimed the land. He found thieves at state land offices had taken money from settlers but never recorded land claims.

Still, he wrote, Central Florida had the right climate, clear water, and opportunities for a prosperous life. For one of his 1877 columns, he described one small business owner. "Mr. Crutchfield, a house carpenter, came here four years ago, with very little capital, I expect, beyond his tool chest. He has built a number of houses; built the Courthouse, the finest building of the kind in Florida; our church on Lake Jessamine, and is a thrifty, enterprising man," Harney wrote. But Harney cautioned that success "depends not on the country, but the individual."

Another tradesman "got quarrelsome." He had the skills, but his business failed. "I cite these to show that it depends on the man." He continued, "If you have a weak spot in you, don't go to a new country." He cautioned the young, too. "If he is but 25 years of age, there are older workmen, but not better, who have the confidence of the community, and confidence is as much a value as mechanical skill," he wrote. "Such a man ought to pack his tool chest and go to a

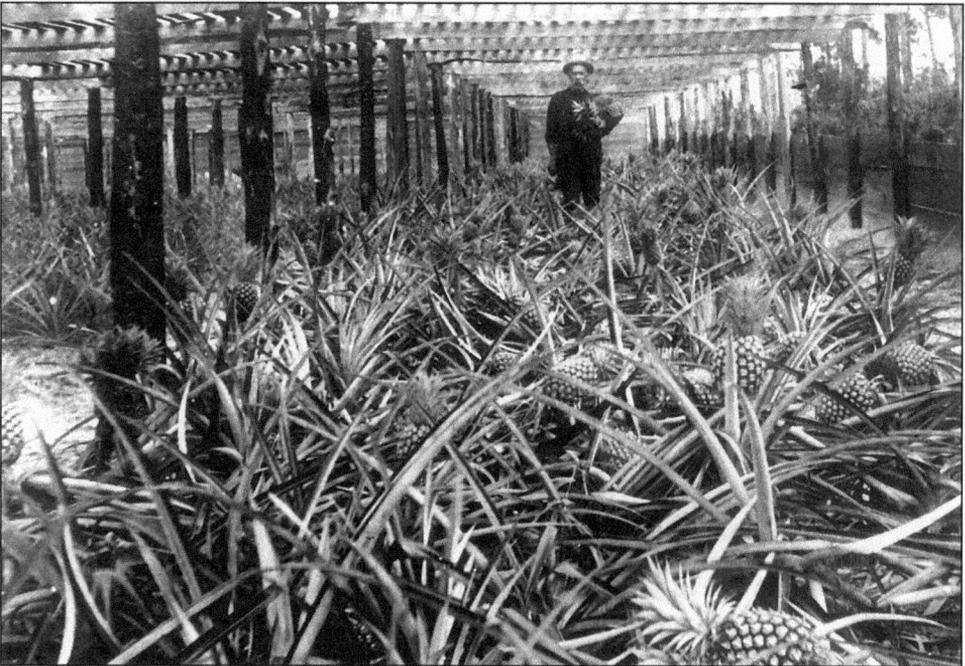

An unidentified man stands under the shade as pineapples ripen. Pineapples grown along the St. Cloud canal were shipped from Kissimmee to markets in New York.

new country. There he finds a scarcity makes him valuable. . . . He can, with a little prudence in management, command his own price."

In another dispatch, he writes, "Of course, as in all human enterprises, there is a great deal of absurdity, whimsicality, failure, but I like that cheerful, sanguine, risky, go-ahead spirit that plunges in often imprudently, and yet which, after all, gets what the timid creature on the bank never can—the satisfaction of having made a good fight for it."

7. The South Florida Railroad and Opening the Florida Interior

The steamboats plied the waterways of Osceola County until the 1920s. The city's role as a center of commerce was aided when the railroad from Sanford reached Kissimmee in 1882 and Tampa in 1885. The extensions of Henry Plant and Henry Flagler's railroads, however, ended the steamboat heydays and steered commerce away from the wharves.

By running his railroad down Florida's east coast, Flagler, who made millions as John D. Rockefeller's partner in Standard Oil, sparked town after coastal town. About the same time, railroad baron Plant gobbled up the nearly bankrupt South Florida Railroad route between Lake Monroe, Orlando, and Kissimmee—and vast stretches of land—as his railroad empire chugged its way to Tampa and south along Florida's west coast.

Before Plant and Flagler's railroads, Florida's only rail tracks were the ones linking Jacksonville with Pensacola and west to Mobile, Alabama, as well as David Levy Yulee's Atlantic-to-the-Gulf railroad. Moses Elias Levy amassed tens of thousands of acres of Florida's wilds as Spanish land grants before Spain surrendered Florida to the United States in 1821. Levy made his fortune in lumbering and trade with Spain. His land stretched from Gainesville, south along the St. Johns River, and west to Tampa in the 1820s. His son became one of the state's first two U.S. senators and took office as David Levy Yulee, restoring the traditional Jewish name lost after the family was expelled from Spain in the 1400s. Yulee made it possible for at least 1,200 ordinary men to homestead more than 200,000 acres of federal land in the mid-1840s and secured 10 million acres of federal swamp land for the state to give to railroad promoters, including his own line from Fernandina to Cedar Key.

The late 1880s brought the South Florida Railroad, linking Sanford to Maitland, Winter Park, Orlando, and Kissimmee, and the Orange Belt, linking Sanford, Longwood, Oakland, and west to what became St. Petersburg. Flagler's Florida East Coast Railroad stretched along the Atlantic coast from

Jacksonville to Palm Beach and Miami. Everywhere the railroads went, new communities followed.

Before the railroads, the vast inland territory south of Sanford was nothing but nothing, open land of pine, palmetto, and potential. Some people had lived in that open territory for decades, but not many. Without river access, the land between the north-flowing St. Johns and the trickles of Shingle and Reedy Creeks, which form the beginnings of the south-flowing Kissimmee River, remained remote settlements.

The pounding of metal on metal as the first nails were driven for the South Florida Railroad began in Sanford in early January 1880. Soon, the sharp sounds of hammering those rails into place reached the outskirts of Allen's little village on Lake Tohopekaliga. Henry Plant's railroad was coming, and the new Kissimmee City, county seat for the residents of the new Osceola County, would open up to the world. No longer reachable only by steamer and ox-cart trails, Kissimmee would become a cattle capital of the Kissimmee River Valley and headquarters for land-sales offices for the vast territory opened to the south that only a few years earlier had been a wilderness. The largest resort hotel south of Jacksonville would be built along Kissimmee's lakefront and opened to Northern tourists.

By the time Plant was building train tracks south to Kissimmee, Hamilton Disston had made his deal with the state to drain much of the swamps of the Kissimmee River and dredge a river highway from Lake Toho to Fort Myers on

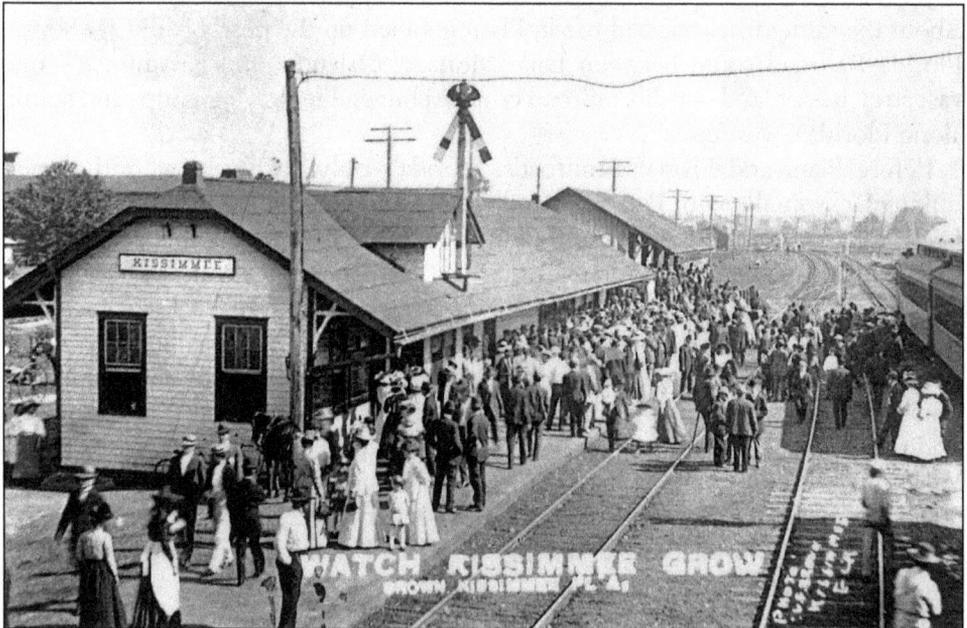

This is the Atlantic Coast Line railroad depot in Kissimmee, shown in the early 1900s. The line was part of the original South Florida Railroad, built in the 1880s from Sanford through Orlando and Kissimmee to Tampa Bay.

Henry Plant's South Florida Railroad would bring new residents to Kissimmee City.

the Gulf. Meanwhile, Florida and its 270,000 residents were still suffering the aftershocks of the Civil War while the United States, heavily influenced by isolationists, adopted tariffs to protect its trade positions. The Spanish-American War loomed along with the United States' desire to flex its muscle as a power on its side of the world.

In Kissimmee, the railroads were beginning to challenge riverboats for cargo and passengers. The railroad depot was at Drury and Broadway. For a few years, downtown Kissimmee would be the end of the line for the South Florida Railroad. The tracks stretched to Tampa by 1885. When the passengers boarded at the Kissimmee depot for the first ride to Plant City, Lakeland, and Tampa, many presented the conductor with complimentary tickets from James E. Ingraham.

J.E. Ingraham became right-hand man to some of Florida's most influential men of the late 1800s. Ingraham came to Florida in 1875 from Ohio, hoping the climate would cure his tuberculosis. Henry Sanford, a wealthy diplomat who in 1870 bought 23 square miles south of Lake Monroe, hired Ingraham as his land agent and often left him in charge of his Florida investments when he traveled to Europe, Africa, and Latin America.

Ingraham helped Sanford select land to donate for the South Florida Railroad from Lake Monroe's steamboat wharves, through Orlando and on to Kissimmee. The state granted charters and the rights to vast open lands to railroad investors, including Sanford, Longwood founder Edward W. Henck, and their Boston

James E. Ingraham became the right-hand man to some of Florida's most influential men of the late 1800s: Henry Sanford, Henry Plant, and Henry Flagler.

friends, who formed the South Florida Railroad Company in 1879. Soon after the railroad reached Orlando, it contracted with Joseph Samuel Oliver to build the line to Kissimmee. Oliver brought his wife from Georgia to Maitland. He used a handcar riding over his tracks to the end of the line, where he showed her Kissimmee. She quickly adopted it as her home.

Historian Minnie Moore-Willson later wrote of her first railroad trip to Kissimmee: "Arriving on a belated train, no porters, no conveyances were in evidence; yet from the oil street lamps the little city, now numbering about 1,000 inhabitants, presented a picture of tropical beauty. From the depot a boardwalk led to the large and commodious hotel. 'The Tropical,' the most spacious as well as the most expansive hotel south of Jacksonville." In Florida's boom days of the late 1800s when railroads opened up the state's vast interior, every pioneer town looking to lure investors or tap into the growing number of winter visitors from the North offered travelers the simple (sometimes crude) comforts of inns and rooming houses. Only a few, though, had real resort hotels.

It may not have rivaled the fabled grand hotels of railroad tycoons Flagler and Plant, but Kissimmee's Tropical Hotel had plenty to offer. The state had already long been a mecca for people with health problems making winter pilgrimages

when the Tropical was built in the early 1880s in the style of Florida's rambling resort hotels. Loggers cut nearby pines and cypress for the lumber used to build the sprawling three-and-a-half-story hotel and its 700 feet of wide, open verandas. The hotel provided side trips on trains to a St. Cloud sugar plantation. The hotel's steamer took more adventurous guests bass fishing and hunting for turkey, deer, quail, and alligators. Later, they posed for trophy photographs before dressing for elegant dining and dancing or a night at the nearby opera house.

The Tropical, at Broadway and Monument Avenue, was open from October to May. John Jacob Astor, who made a fortune in the fur business and then became one of the richest Americans of his time by buying property on Manhattan Island, brought his bride to The Tropical on their honeymoon. The guest register during The Tropical's heydays included the Vanderbilt family, inventor Thomas Edison, and President Chester A. Arthur.

The coming years would bring smaller railroads, including the Midland built in 1886 from Kissimmee to Windermere, and the Sugar Belt Railroad, which connected Kissimmee's steamboat wharves and railroad depot with the sugar plantations near St. Cloud and settlements near Narcoossee.

By the early 1880s, Ingraham had joined railroad baron Henry Plant, who, like Sanford, was a Connecticut-born Yankee, as president of the railroad that would link Tampa's port with Kissimmee, Orlando, and Sanford. Henry Sanford was one of the principal stockholders who backed Plant's shrewd gamble to buy up many of the South's bankrupt railroads at the close of the Civil War. Sanford was also president of Boston's Adams Express Company, where Plant, as southern agent for the rail and steamer transport company during the war, had managed to

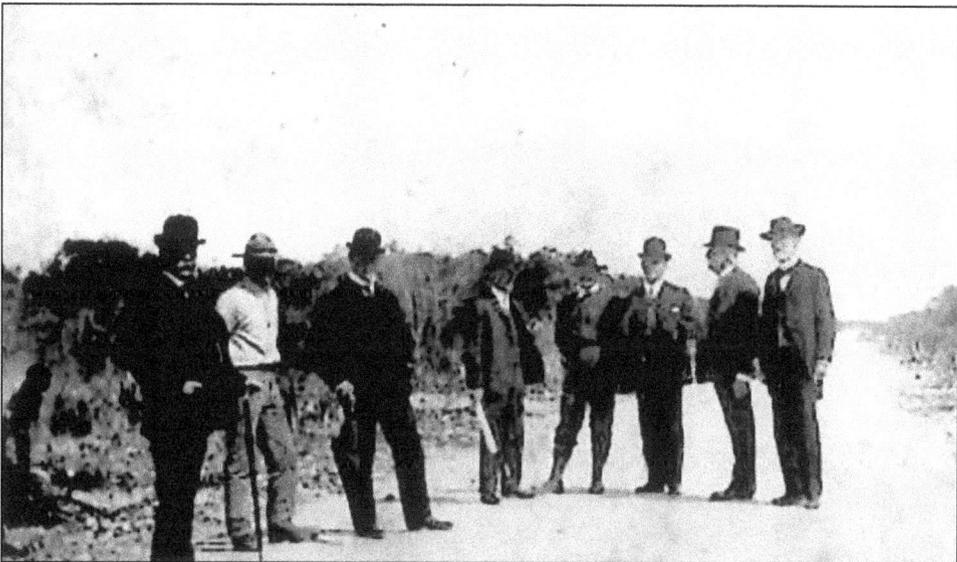

Standing at Stock Island in 1906 is J.E. Ingraham, far left, with other executives of the Florida East Coast Railroad, including Henry Flagler, second from right.

help the company prosper by hauling goods and money for the Confederate government. Plant's railroad gobbled up vast stretches of land as it chugged its way south from Tampa.

Linking Kissimmee with Tampa proved to be a major victory for the South Florida Railroad, which had been close to bankruptcy. With Ingraham as president, Plant's Kissimmee-to-Tampa route took advantage of a state grant of 13,840 acres for each mile of track completed. Regular trains ran between Tampa, Kissimmee, and Sanford, covering the 115 miles in four-and-a-half hours.

The railroads had challenged riverboats for their cargo and passengers, and the downtown Kissimmee street in front of the depot (now Drury) was named Ingraham Avenue, honoring the land agent and railroad planner. At the same time Plant was running his railroad through Central Florida and down Florida's west coast, Flagler was pushing his tracks south along the east coast.

Ingraham would help engineer Flagler's railroad entry into Miami, triggering a land boom that lured settlers away from Kissimmee. Ingraham's successes with Plant's railroad had attracted the attention of Flagler, who tapped him to run his St. Augustine-based land company.

When hard times arrived in the mid- to late 1890s, Ingraham, the man who helped forge the railroad link to Osceola County, played a key role in persuading many Kissimmee pioneers to seek better opportunities to the south. Miami founder Julia Tuttle urged Ingraham, an old friend from Cleveland, to persuade

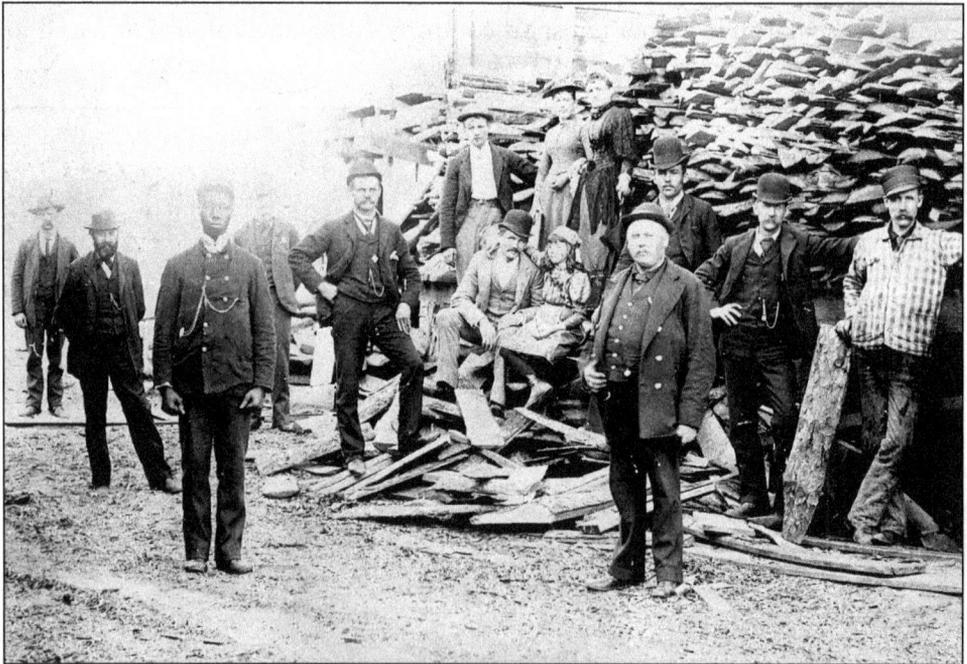

A Midland railroad crew and their families, shown in Kissimmee in 1890, stand near the pile of pine bark used to fire the steam engines.

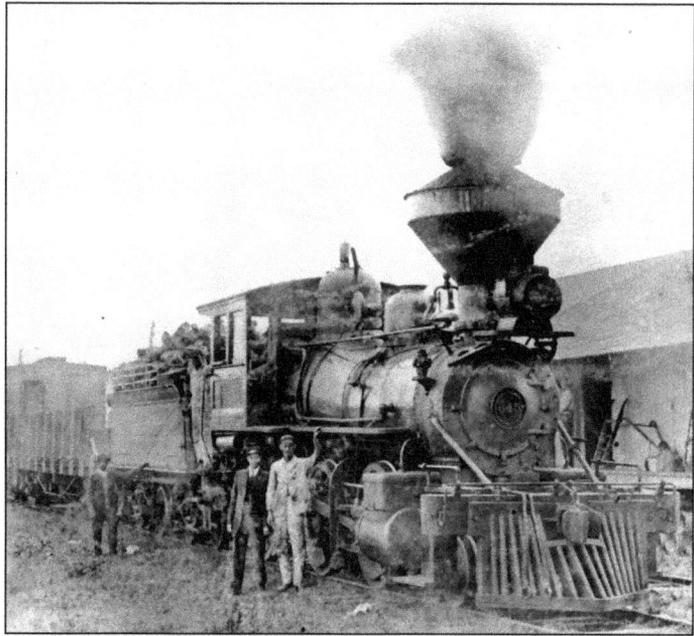

Railroad engineer Ira Bass, center, is shown in the early 1900s. Bass had helped survey the route of the Sugar Belt Railroad that served Narcoossee, St. Cloud, and Kissimmee.

Plant to build a railroad south through the Everglades to her trading settlement on Biscayne Bay at what had been Fort Dallas. Plant agreed in 1892 to send Ingraham to lead surveyors to find a route through the Everglades.

The journey was a disaster. Ingraham ignored Tuttle's advice to use the flat-bottomed Seminole canoes and pole through the glades. Instead, his heavy rowboats bogged down in the tall reeds. He also tried to carry enough rations, rather than fish and hunt along the way as suggested. The trip was supposed to take a few days to a week. Worried when Ingraham was three weeks overdue, Tuttle asked a Seminole friend named Matlo to find him. Matlo found Ingraham hungry and frustrated but unhurt.

Ingraham's experience led to Plant's decision to abandon plans for a railroad from Tampa to Tuttle's settlement. The doomed journey into the Everglades was followed by two disasters that Ingraham had no control over, one created by men, the other by nature.

The first came in 1893, when the national economy sunk into its worst depression to date. The Panic of '93 was caused by unsound bank debt and speculation that resulted in a stock market crash. It came at a time of over-development and investment in Florida agriculture and real estate. The panic ruined Disston, who had made Kissimmee the headquarters of the swamp-draining empire. Hundreds of settlers who had come to Kissimmee during the boom times lost their jobs and farms.

Then, in the winter of 1894–1895, back-to-back hard freezes all but wiped out Central Florida's citrus trees and other agriculture. By the time the Great Freeze brought financial ruin statewide, Ingraham had left Plant to join Flagler as

Smoke rises from stacks of this South Florida Railroad train on its run from Jacksonville to cities to the south.

president and a minor stockholder in the oil and railroad robber baron's Model Land Company. Flagler biographer David Leon Chandler said Ingraham published booklets, pamphlets, and a magazine, *The Homeseeker*, to advertise Flagler's land for $1.50 to $5 an acre and lure settlers to the east coast towns along the railroads. Special deals were made for large tracts if groups would agree to colonize. Ingraham, who had become an expert on Florida crops and soils while working with Sanford, hired railroad agents to sell land and provide reliable agricultural advice.

When the freeze hit, many of those who bought land from Flagler faced ruin. Flagler, though, authorized Ingraham to give away free seeds for replanting and to arrange rail delivery of free fertilizer and other supplies. Flagler also gave Ingraham free rein for low-interest loans to farmers and gave them as long as they wanted to repay.

The freeze also would spawn two versions of the inspiration for Miami's railroad boom era. Magazine and newspaper writers of the time told the story of how Julia Tuttle wrapped fresh stems of choice flowers in damp cotton and sent

a bouquet of orange blossoms to Flagler in St. Augustine as proof that her land had survived the bitter cold. That, the legend goes, persuaded Flagler to extend his railroad and sign the deal to develop Tuttle's land into what became Miami.

Flagler did receive the flower and blossoms, and he did sign a deal with Tuttle. That much is fact. Ingraham arranged the meeting in April 1895.

Over dinner in Cleveland soon after Flagler completed his railroad to Palm Beach, Tuttle began lobbying Ingraham to talk Flagler into continuing his rail tracks to her land.

After the freeze, Ingraham, fearing he might be fired, needed something to inspire Flagler's confidence that the land deals Ingraham arranged eventually would prove to be sound. Ingraham found it in orange, lemon, and lime trees in South Florida that had survived the cold. "I gathered up a lot of blooms from these various trees, put them in damp cloth and . . . hurried to St. Augustine," Ingraham later wrote. Soon afterward, Flagler traveled to Tuttle's home and signed the deal that brought the railroad's land boom to Miami.

Kissimmee historian Alma Hetherington says the lure of a better life persuaded many prominent families to abandon the shores of Lake Tohopekaliga for South Florida. Citrus growers looking for land free of frost led the southward march of settlers. With them went "families of the highest culture," Hetherington writes in *The River of the Long Water*. Among them was Judge Martin L. Mershon. The Florida statesman's son, Luther, would become one of Miami's leading lawyers. Dentist R.E. Chafer moved his practice to Miami.

Two sons of Dr. Jeremiah W. Sewell, a pioneer Kissimmee physician, established Miami's first clothing store for men. John Sewell later served four

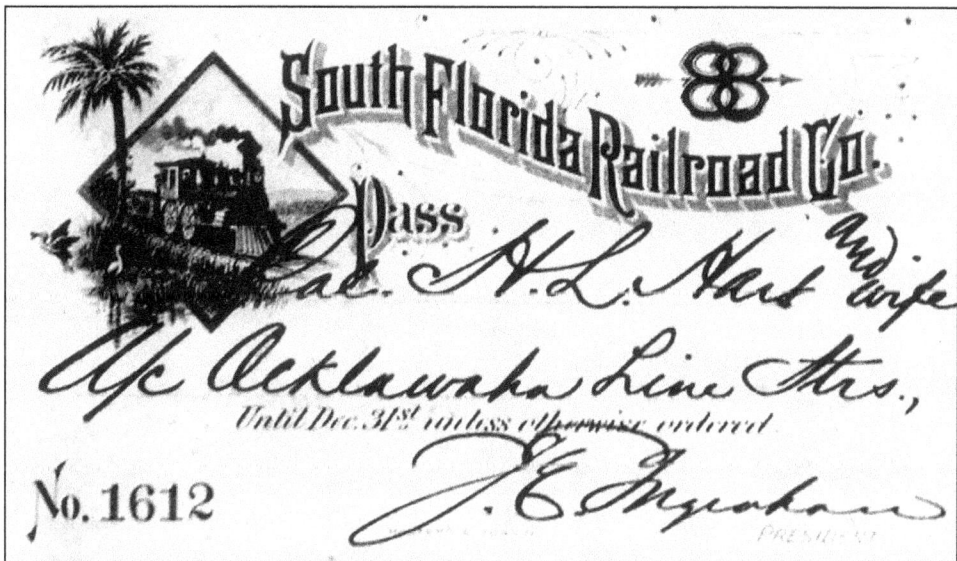

J.E. Ingraham signed this South Florida Railroad Company pass issued to Colonel H.L. Hart, who owned a steamboat line.

terms as Miami's mayor, and his brother Everest started his political career as president of the chamber of commerce and later served several terms as mayor-commissioner. J.E. Jaudon left Kissimmee to open a produce business in Miami and later became Dade County tax collector. He also helped develop the Tamiami Trail.

Ingraham, who had helped Henry Sanford create a city on Lake Monroe as the "gateway to South Florida," later wrote that his last conversation with Henry Flagler, just before Flagler's death in 1913, was about Miami, described by Flagler as an "eternal city." The pioneer settlement of Whittier in southeast Osceola County would never have become Kenansville without Henry Flagler. After he made a bundle helping John Rockefeller build the Standard Oil empire, Flagler "founded" Florida, according to biographer David Leon Chandler. Flagler made his first trip to Florida in the late 1870s. Doctors said his invalid wife might enjoy a winter in a warmer climate.

Florida's swamps and Jacksonville's hotels didn't impress Flagler, Chandler writes in his 1986 biography, *Henry Flagler, The Astonishing Life and Times of the Visionary Robber Baron Who Founded Florida*. Once back in Ohio, he plunged back into his growing oil empire and ignored a family doctor's advice to continue spending his winters in Florida for his wife's sake. After the death of Mary Harkness Flagler, the robber baron blamed himself. Chandler says Flagler

The sawmill and turpentine community of Whittier would become Kenansville when Henry Flagler donated 5 acres and $6,000 to built a brick schoolhouse with an auditorium. The community adopted the new name to honor the hometown of Flagler's third wife, the former Mary Lily Kenan of Kenansville, North Carolina.

The tracks of Flagler's railroad are in the foreground of this view down one of Kenanville's main streets (now Canoe Creek Road) in the early 1900s.

changed his life by doing what his wife had wanted—he left Standard Oil and invested vast sums in a chain of winter resorts and a railroad system along Florida's east coast. He was determined to build railroads to open up Florida's vast interior to citrus growers, cattle ranchers, and farmers.

Back then the tiny settlement of Whittier was still part of Brevard County. (The Legislature created Osceola County in 1887 by slicing off parts of Brevard and Orange Counties.) Its first settlers arrived in 1878—stark, demanding times to try to provide for a family in the wilds of the Kissimmee River prairie. In the early 1900s, the circuit-riding judge, Minor S. Jones, traveled twice a year by horseback from Titusville to a crude frontier courthouse west of Whittier. He packed his saddlebags with law books and cornbread, dried meat, and coffee, according to Alma Hetherington's 1980 history of Osceola County.

Flagler's Florida East Coast Railway Company began construction of a 90-mile route between New Smyrna and Okeechobee in 1911. The railroad would pass about 1.5 miles east of the sawmill and turpentine community of Whittier. A railroad station sparked a new community and a new name when Flagler donated 5 acres and $6,000 to build a brick schoolhouse with an auditorium to replace the small wood-frame school at Whittier. The community adopted the new name to honor the hometown of Flagler's third wife, the former Mary Lily Kenan of Kenansville, North Carolina.

After his first wife's death, Flagler had married Ida Alice Shourds, who was later committed for insanity. Flagler's decade-long affair with Mary Lily Kenan and his bribery and political deals to win a Florida divorce caused the tabloid-style scandal of his time.

Henry Flagler's Florida East Coast Railroad stretched along the Atlantic coast from Jacksonville to Palm Beach and Miami and to the Florida Keys.

Mary Lily Kenan, the daughter of a former Confederate captain well-known in Raleigh who later served as attorney general and clerk of the North Carolina Supreme Court, met Flagler in 1891. She was compassionate, intelligent, beautiful, and decades younger than Flagler. He enjoyed listening to her sing and play piano. She enjoyed mixing bourbon and opium, a surprisingly common diversion for ladies of her day.

Flagler, still married, gave Mary Lily an engagement gift of a necklace of Oriental pearls with a huge diamond clasp and a matching diamond bracelet. Together, they were valued at $1 million. To show her family that he would provide for her future, divorce or not, he told his architects to build her a Cuban-style Palm Beach home. It became the community's first mansion. He also gave her $1 million in Standard Oil stock. (Later, his wedding gifts to Mary Lily and her family would soar into many more millions.)

Flagler, at the time, was a resident of New York, where the only legal reason he could cite for divorce was to accuse his wife of adultery. She was institutionalized at

the time. His convoluted divorce scheme started when he established Florida residency, then won a New York court ruling that his wife was insane. Florida's divorce law was similar to New York's, but its politicians were more . . . cooperative. A few well-placed contributions later, the Florida Legislature passed and the governor signed a new law allowing a divorce when a spouse was incurably insane.

Two months later, a Dade County court granted Flagler a divorce. He married Mary Lily ten days after the court ruled. (Seventy years later, researchers proved that Flagler's railroad spent $125,000 with key politicians and attorneys to gain the divorce.) Chandler writes that an elaborate ceremony was staged in Kenansville, North Carolina at the Kenan family estate. Mary Lily, Chandler writes, became the love of Flagler's life, sharing his vision for Florida's future. She was at his bedside when he died May 20, 1913.

The Flaglers were not the only national celebrities lured to the region. The April 10, 1883, *New York Daily Tribune* included a telegraphed story datelined "KISSIMMEE CITY, Fla." from its reporter traveling on President Chester Arthur's private train. "White civilization ends here," the New York reporter wrote of what a few years later became the county seat of Osceola County. "The lower part of the state being in possession of a cowboy race known as Crackers, who herd cattle extensively over the prairie lands, and of a remnant of a race of Seminole Indians who hunt, fish and raise crops in the Everglades."

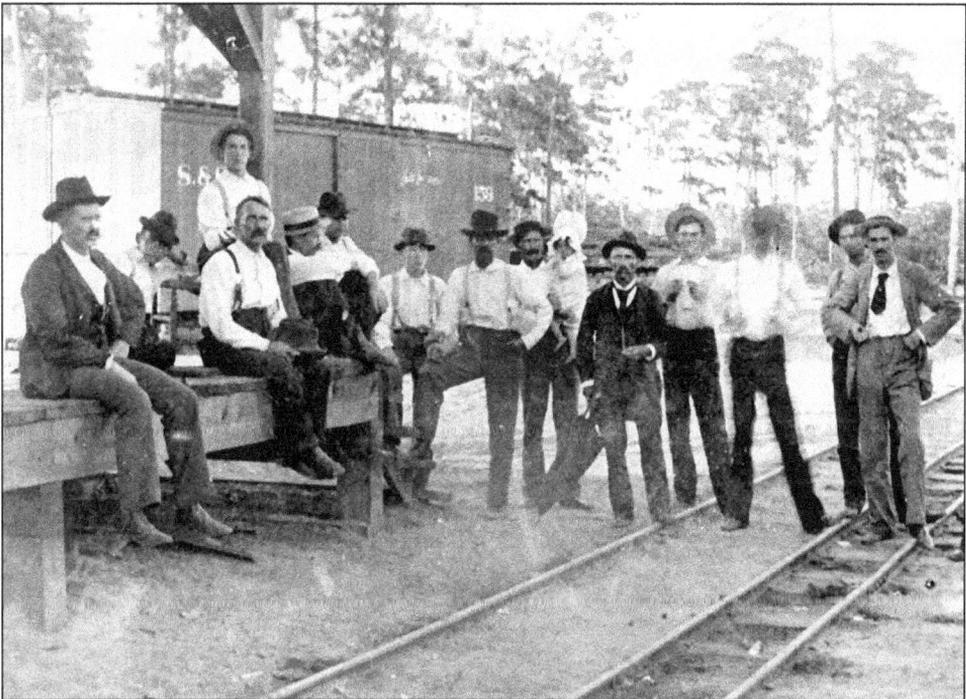

Men gather at the Peghorn Station on the northeast shore of Lake Tohopekaliga when crews switched tracks from short-gauge to standard gauge.

Midway through his term in the White House that began when James Garfield was assassinated, Arthur was battling Congress over his call for lower tariffs. He also was championing reform of federal civil service appointments to overcome criticism that he repaid political supporters with government jobs and keeping secret his incurable kidney disease with the approach of his re-election campaign. (He would not get his party's nomination, but he carried his secret to his death in New York less than two years after he left office.)

With the winter of Washington politics behind him, a hunting and fishing vacation in Florida seemed just the diversion Arthur needed. Myrtle Hilliard Crow writes in *Old Tales and Trails of Florida* that her father, J.K. Hilliard, was among the guests to cruise the Kissimmee River on the President's boat. He also stayed at The Tropical during the President's visit to the Kissimmee lakefront resort hotel.

Arthur's sour moods during his Florida trip, though, frustrated many Floridians hoping to see the President. He disappointed guests at the Sanford House on Lake Monroe by demanding a private dining room for lunch and dinner. A train ride from Sanford to Kissimmee, where he was to board a steamer for a tour of Lake Tohopekaliga and a freshly dredged canal to the Kissimmee River, took three hours. Along the way, the President's special rail car stopped briefly for Arthur to take a carriage tour of two Maitland orange groves. He made a second short stop in Winter Park. But the President snubbed Orlando.

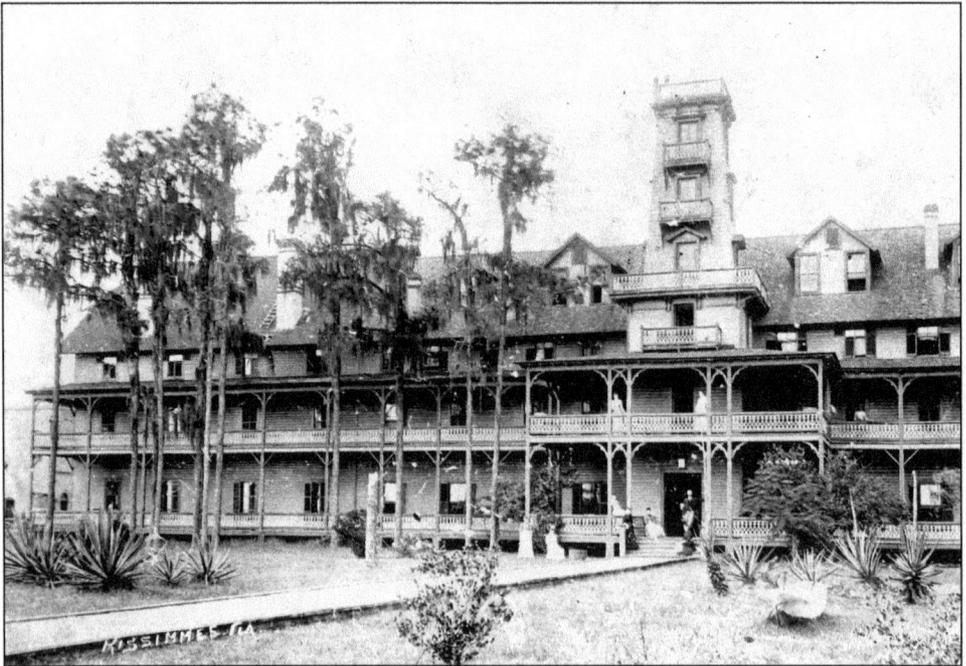

The Tropical Hotel, the largest railroad-built hotel south of Jacksonville during its time, drew guests from throughout the nation.

100

Julius Schweikart, shown on the left, built one of the first homes at Fowler Park for his family after the early railroads opened the interior for settlement.

Orlando had made extensive preparations for the President to attend a reception and picnic, according to the *Tribune* report. When he left Winter Park, though, Arthur told the railroad crew to pass the stop in Orlando. He ordered the crew only to slow down. He would stand on the rear platform and bow to the gathering at the depot. The railroad superintendent warned the President that changing the schedule would disrupt other trains. The *Tribune* reporter said the President replied, "This is my train, and if you don't do as I say, I'll go back."

A telegraph of the President's demand landed on the desk of James E. Ingraham, president of the railroad and a man familiar with the demands of some of Florida's most influential men of the late 1800s. Realizing another train was on the same track, Ingraham ordered the train to stop in Orlando, "preferring to risk the president's displeasure than the president's life," the *Tribune* reported. "The president stepped out on the back platform," the newspaper said, "made a salaam to the outskirts of the crowd, and when the train suddenly stopped he swiftly entered the car, dropping in a chair on the side of the car away from the station so that not one-third of the people assembled there could see him."

Eve Bacon writes in *Orlando: A Centennial History* that when Arthur's train reached Kissimmee, Colonel A.B. Linderman greeted the President and announced, "We flatter ourselves that we have among us not only the president, but the next president." Arthur, in no mood to make a political address, answered, "We are not here to look after the next president. We are here for rest and quiet," Bacon writes.

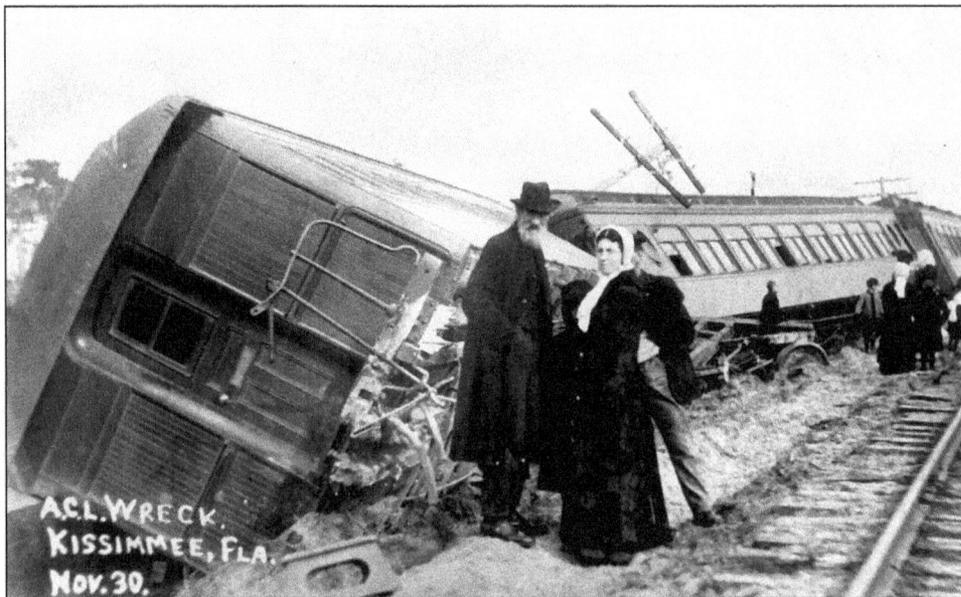

People gather after a train wreck near Kissimmee on November 30, 1911.

With that, the President's riverboat moored at a Lake Tohopekaliga pier steamed away "for the regions of alligators and flying ants up the Kissimmee River, with a fair prospect of passing the night on a mud bank," the *Tribune* reported. "It has not been settled how long the president may remain hereabouts," the newspaper reported, speculating that he might have ventured into the Everglades. "It is likely that the insects will drive him back in a few days."

Joining railroad barons Flagler and Plant, a Russian nobleman started his railroad enterprise after the failed efforts of two Yankees to link Lake Monroe with Lake Apopka. When the Orange Belt Railroad couldn't pay a bill for $9,400 worth of crossties, Peter Demens, then in his mid-30s, became a railroad magnate. Demens—the only son of a Russian nobleman who had been an officer of the czar's elite guard, and a country squire whose populist writings put him on the fringe of political turmoil in his homeland—migrated to the United States in 1881.

"Personally, I had no luck (in Russia)," he later wrote. "I don't know what the trouble was, whether I was not suited for anything or the circumstances did not work out well for me. I think it was a combination of both factors." Lured to Florida by a Jacksonville relative, the expatriate bought an 80-acre orange grove in Longwood and a one-third interest in a nearby sawmill, according to his biographer Albert Parry in *Full Steam Ahead!*

Not long afterward, he bought out his sawmill partners. P.A. Demens & Company's profits provided its owner with money to move his family from a two-room pine cabin to a fine two-story residence in Longwood and allowed Demens to branch off into other enterprises. By the mid-1800s, his logging, sawmill, and woodworking and contracting enterprises employed 300 craftsmen

and 3,000 other laborers across the state. He built 21 buildings throughout Florida, including a church at St. Augustine, a hotel in Sarasota, and a hotel and college at Winter Park.

Not all of his clients were pleased with his work. Frederick W. Lyman, Rollins College's first president, wrote many letters complaining about Demens's materials and workers. Parry said the Lyman letters and others point out how much Demens overextended himself and exaggerated his accomplishments. Still, Parry and other historians said, Demens demonstrated ingenuity and energy to complete his railroad and balance the demands of investors and workers.

Parry claims Demens resolved to take his "haphazard logging railroad and push it on a straighter course to the gulf coast and make the settlement at Paul's Landing on Pinellas Bay an international port." He bought old rolling stock from other railroads and settled for lightweight rails. He wrangled landowners to donate huge parcels for the railroad to cross their land. His headquarters was on 200 acres on Lake Apopka donated by Judge J.G. Speer. Demens wanted the town on the lakeshore named for his St. Petersburg homeland. The judge and others, though, picked the name Oakland. The Orange Belt Railroad tracks reached Oakland in 1886. The town's celebration on November 15, 1886, became its official birthday, Parry said.

Demens would have to wait until his railroad tracks reached the sandy shores of the gulf for his hometown to gain a Florida namesake and a fabled tradition of

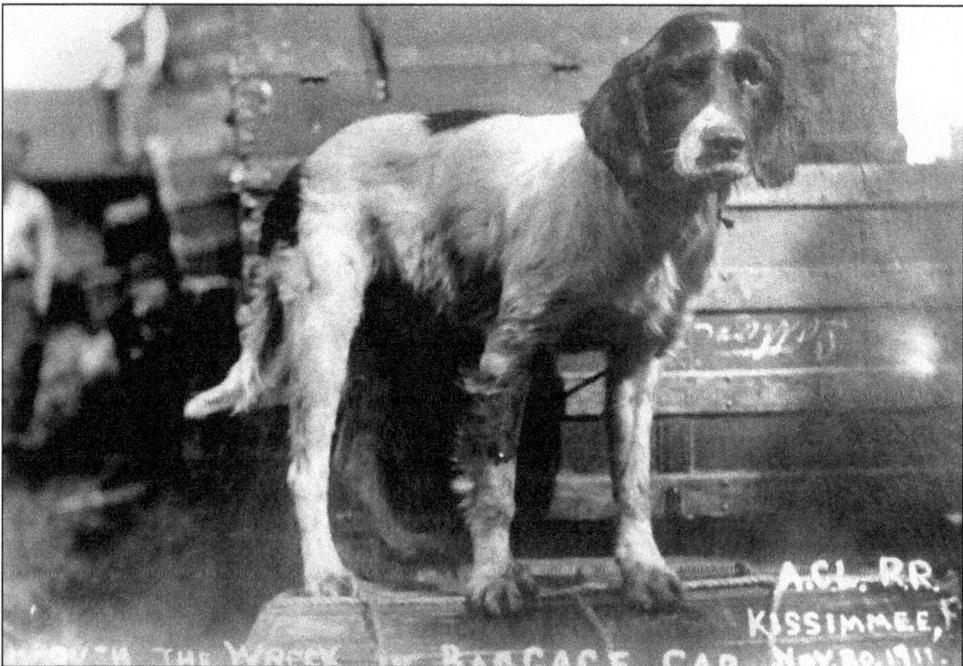

This hound that was in the baggage car survived the 1911 wreck of an Atlantic Coast Line train.

its naming. Reaching the gulf—120 miles away—would require more investors and a $700,000 bond issue. New York brokers, though, did not share his enthusiasm for the profits to be made in the sands of Florida.

Help arrived unannounced on December 1, 1886. Hamilton Disston left his Kissimmee land-sales and swamp-draining headquarters to pitch a deal to the struggling railroad entrepreneur. Like Demens, Disston had inherited wealth but was carving his own place in history through the frontier of Florida. Disston was the oldest son of an English immigrant who had tooled his factory apprentice's knowledge of how to heat-treat steel to hold a blade's sharp edge into a saw-manufacturing fortune. In the 1880s, Disston tapped his father's wealth and influence from Philadelphia to Tallahassee to make a deal with the state to drain millions of acres of Florida swamps and dredge rivers for steamboat commerce.

The extensions of railroads, though, were steering commerce away from the wharves and sparking wilderness and coastal towns. Railroad baron Henry Plant was gobbling up the nearly bankrupt South Florida Railroad route between Lake Monroe, Orlando, and Kissimmee—and vast stretches of land—as his railroad empire chugged its way to Tampa and south along Florida's west coast.

Disston wanted to shift railroad interests to his gulf settlement of Disston City. He wanted to make it a major port to rival Plant's Tampa. To do so he needed to make a deal with Demens, who was scrambling to finance his fledgling Orange

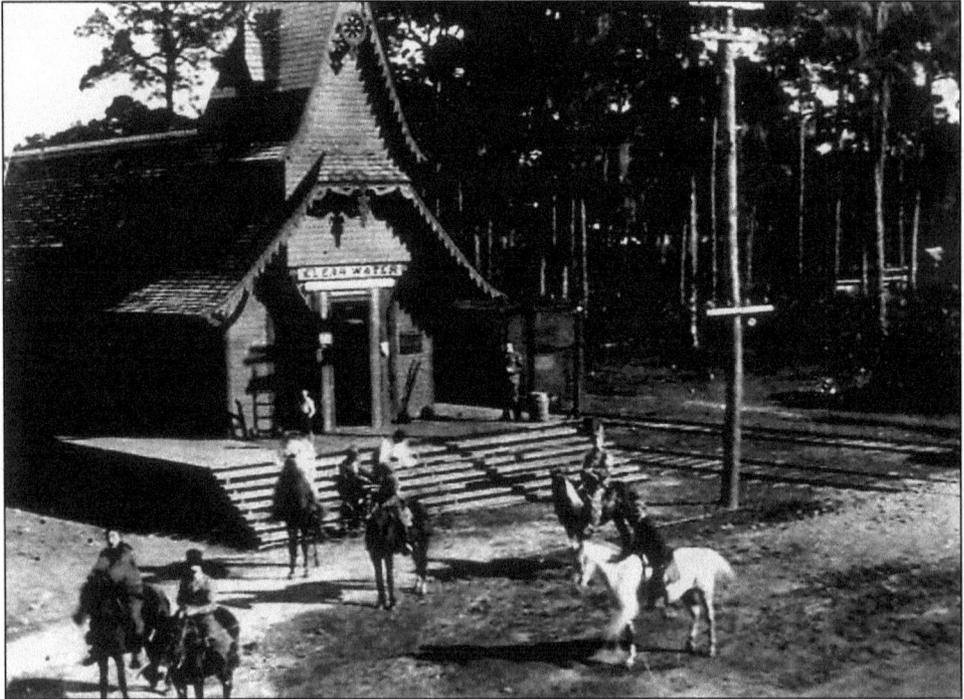

Peter Demens of the Orange Belt Railway Company used Russian-style architecture on the depots along the line. This is Clearwater's first depot.

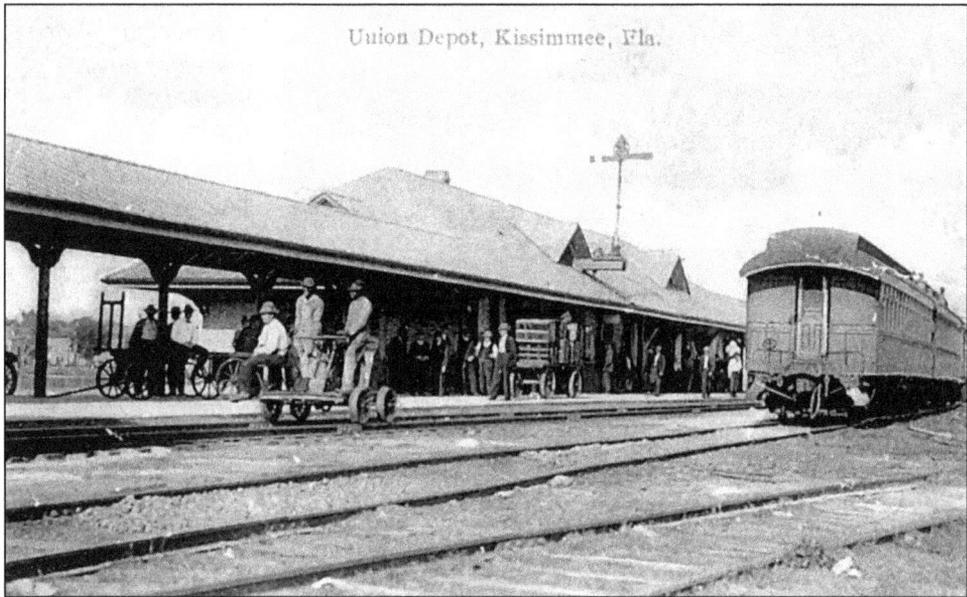

Kissimmee's Union Depot is shown in the early 1900s.

Belt Railroad, Parry records. Demens was desperate for cash to fend off unpaid laborers and creditors when Disston paid him a visit. Disston, one of the greatest wheeler-dealer entrepreneurs of his day and friend to the tycoons and robber barons of his age, came to Demens with an offer to invest in his railroad. He would give Demens 60,000 acres and use his influence in Tallahassee to gain state land grants. In return, Demens was to route his railroad tracks to Disston City, today's Gulfport but then a near-empty dream town.

The deal fell through when Demens asked for 50,000 acres more land for causeways and bridges to link Disston City with the edge of the main shipping channel into and out of Tampa Bay. Disston tried but failed to persuade his investors and board of directors in Philadelphia to agree to the deal. Instead of routing his railroad to Disston's gulf town, Demens focused his sights on the 1,600 acres owned by the son of the richest man in Michigan. John Constantine Williams, son of Detroit's first mayor, had bought his Pinellas Peninsula land in 1875.

Still, Disston did not abandon Demens. Instead, he introduced Demens to his wealthy buddies who regularly made trips to Florida to get away from the Northern winter and the public eye. Northern millionaires enjoyed hunting, fishing, card games, and hard drinking. Through Disston, Demens met Chicago philanthropist Philip Danforth Armour, whose brother ran the family meatpacking fortune, and several financiers. To hawk his bonds, Demens ordered his crews to shuttle trains up and down the line to fake great commerce near the hunting lodge where Armour was staying. At one point, Parry writes, Armour "jumped out of his bed in his nightshirt to shout, 'I'd have to buy this damned Russian's railroad if only to stop the noise and have some peace.'"

A guest at the lakefront resort after it was renamed Hotel Kissimmee poses with his catch of the day.

Demens also had a porter interrupt a poker game with Armour to announce that his private car had arrived to carry him off to some urgent business. Finally, Demens took Armour on a ride on his line. "It was rumored at the time that the speed and smoothness achieved on that trip had not been exceeded on the Orange Belt either before or for a long while after," Parry writes. While waiting for money, Demens dodged bill collectors from the hat-maker millionaire George W. Stetson, who wanted $30,000 for steel rails, and another railroad's demand for $10,000 for rolling stock. Banks in Sanford and Orlando demanded their money. Once payday had come and gone for his railroad laborers, he talked his way out of a lynching. On another day, one of his investors, a Canadian, dropped dead when creditors chained the wheels of locomotives to the rails.

On February 15, 1887, Parry says, Demens traveled to New York, where he borrowed $100,000 from H.O. Armour and Company backed by railroad bonds and mortgages on all his Orange Belt property. He later borrowed $200,000 more, enabling Demens to finish his railroad to the Gulf. On June 8, 1888, the first "wobbly train" chugged to a steamy halt at a platform near a general store and a "sorry collection of shacks and a handful of settlers" at Paul's Landing. Florida folklore includes a fanciful explanation that Demens and Williams drew straws or

flipped a coin. The winner would name the town; the loser would name the hotel. St. Pete's first hotel would be The Detroit, but that's where fable varies from fact, Parry said. Demens, never shy about his successes, avoids mentioning a coin flip or drawing of straws in any of his writings.

Instead, Parry said, Ella E. Ward, the wife of the storekeeper at Paul's Landing, went to Oakland to find out what name the railroad headquarters wanted for the new town. Joseph Henschen was the only partner there at the time. He figured no one would ever remember how to spell it if he named the town for himself, so he selected a name he knew Demens would appreciate. Paul's Landing became St. Petersburg. Henschen said he never gave it much thought, adding, "It will never amount to anything anyway, so its name won't make any difference. . . . I signed a petition, got four or five others to sign it, and we sent it to Washington where it was approved by the post office department."

Demens's railroad, though, did not bring immediate prosperity. Too few customers were available to keep up with the demands of creditors. He owned vast acreage but couldn't sell it. Demens, who had completed the Orange Belt knowing it would never turn a profit for him, recognized the trouble facing those who had invested in Florida. In early 1889, Demens traveled to Philadelphia to meet with his creditors and surrender his railroad.

Demens hated the "sharks" of real estate agents flooding the Northeast and Europe with flamboyant brochures about easy money to be made in Florida. Inflated land prices and over speculation foreshadowed a major disaster. Actually, he managed to make a few dollars—$14,400—in Florida before the

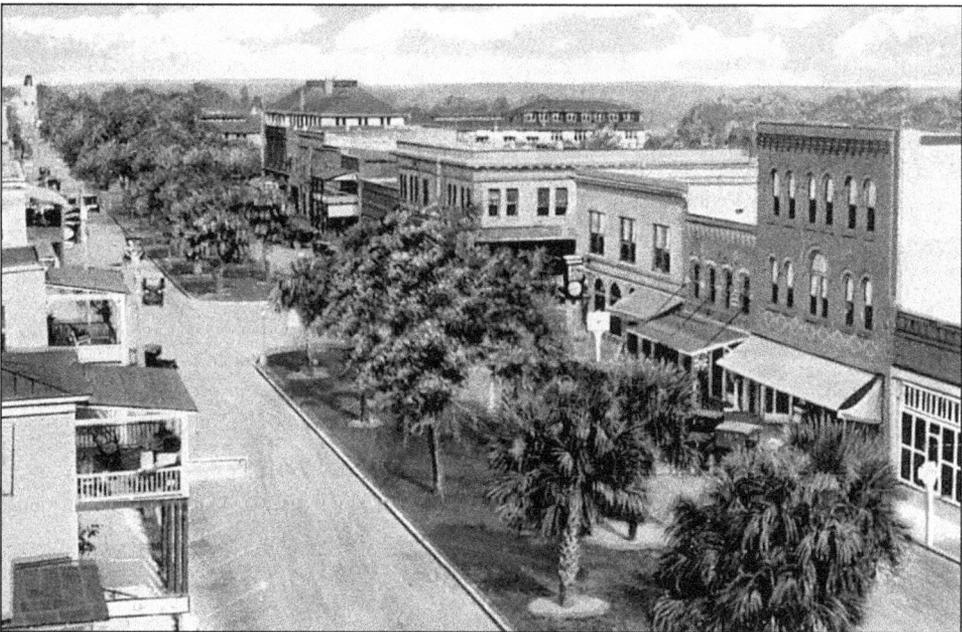

This bird's eye view shows Kissimmee's Broadway, looking north.

land boom busted. He resettled his family in Asheville, North Carolina and later Los Angeles.

Disston, once the largest landowner in America, lost his fortune when his Florida investments soured with a nationwide depression and stock market crash of 1893. In 1896, he sat in his bathtub and put a bullet through his head.

The Orange Belt Railroad and the South Florida Railroad gradually merged into the Plant network of Florida's railways that are now owned by CSX.

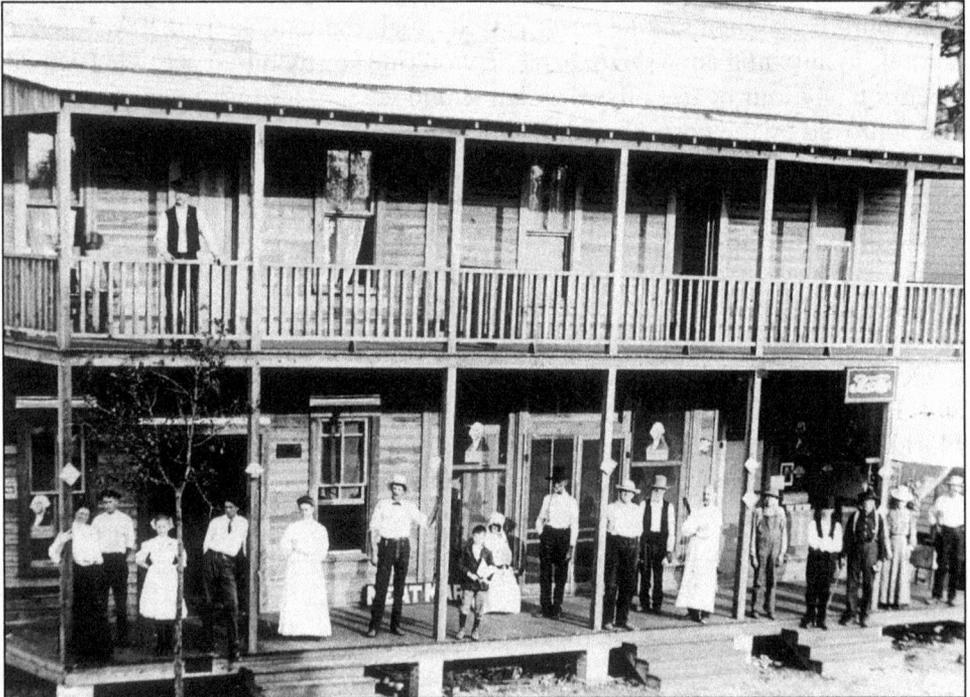

This is the Broadway Hotel. The site is now the city library.

8. THE STATE CARVES OUT OSCEOLA COUNTY WITH KISSIMMEE AS COUNTY SEAT

Four years after the townspeople of Allendale voted to incorporate as Kissimmee City, the first Osceola County commissioners were elected. The Florida Legislature in 1887 had carved off the southern portion of Orange County and the western edge of Brevard County to create the new county. The wild days were coming to a close. Kissimmee would be the new county seat for Osceola, Florida's 40th county.

The first Osceola County government records were kept at the home of J.H. Allen. Allen offered free use of his house along the tracks of the South Florida Railroad for government offices from August until November, when the new Opera House was to be completed. That gave county commissioners time to sign a lease with the Brandow brothers for use of their Opera House on Broadway (roughly the site of Makinson Hardware). For $450 a year, the county could use the ground-floor auditorium and stage for court sessions and the upper floor for county offices. The building also housed some city offices. Seating was on wooden benches. The only ventilation came through windows and double doors. Kerosene lamps with tin reflectors and candles on brackets brightened the auditorium. The auditorium could seat 300 people. The entire county in 1887 had 815 residents. By the time the first courthouse was finished, the county's population had nearly tripled.

Kissimmee City had been named the temporary county seat, but a countywide vote was necessary to pick a permanent spot for the new courthouse. Voters in Runnymede lobbied for their town to become the county seat. Like Narcoossee, English colonists settled Runnymede. About 1885, the English built a three-story wooden hotel about a mile west of Narcoossee on Lake Runnymede. Hotel owner John L. Hall offered the county two sites in his town for the courthouse. Runnymede won favor among 30 voters at the February 6, 1888 election, but Kissimmee City won the day with 421 votes.

On March 23, 1889, voters narrowly approved a referendum for a three-story red brick courthouse. Osceola County commissioners, including chairman

Rufus E. Rose, who managed Disston's land company, later paid $2,000 for D.B. Stewart's oak-shaded land for a courthouse. The contractor was George H. Frost of Massachusetts. Reuben D. Libby, who since 1883 had spent his winters in St. Cloud and his summers in Maine, was among the first in line to pay his tax bill to start paying off the 20-year bonds voters approved to raise $30,000 to build the courthouse. The building included a jail on the first floor. The courthouse had a pen where cattle that wandered off nearby pastures were kept until claimed.

Minnie Moore-Willson's 1935 *History of Osceola County* describes free-roaming cattle along Broadway. Homeowners near downtown had to fence their yards to keep the cattle out. From the mid-1860s Kissimmee had been a livestock center. Ranchers brought their cattle to Kissimmee's holding pens for shipment to Cuba.

The new voters of Osceola County approved a referendum for this three-story red brick courthouse.

William Burroughs (W.B.) Makinson is shown in 1884. He arrived from Maryland in 1883 and invested $1,000 in his brother Carroll's business. W.B. Makinson eventually took over the business and in 1884 opened his hardware store.

Even more than with cattle, Osceola County would build its place in Florida history with locally made red bricks. The Romanesque Revival courthouse has served the county ever since, earning its listing on the National Register of Historic Places in 1977. County leaders dedicated it on May 6, 1890 and have used it ever since. That makes it the state's oldest courthouse still in use for the purpose it was built. Only Clay County has an older courthouse, but that one in Green Cove Springs is now a museum.

The historic courthouse was the site of many executions. Charles F. Prevatt, sheriff from 1897 to 1905 and again from 1908 to 1913, was in charge on the scaffold for Osceola's last courthouse hanging, January 19, 1912. A photograph published in Myrtle Hilliard Crow's *Old Tales and Trails of Florida* shows a large crowd gathering on the north side of the courthouse. Men in Sunday-best suits, most with grim expressions, stand arms crossed, waiting and watching. Huddled around the condemned man—dressed in a suit and bow tie—are 12 other men, including one man resting his hand on the shoulder of condemned inmate Eddie Broome. The knotted noose looms in the background.

An *Osceola Journal* reporter wrote that when Broome, spelled "Broom" in some historical accounts, was given a chance to speak he told the crowd his parents had raised him better but he had "fallen into evil ways and had led a wicked and

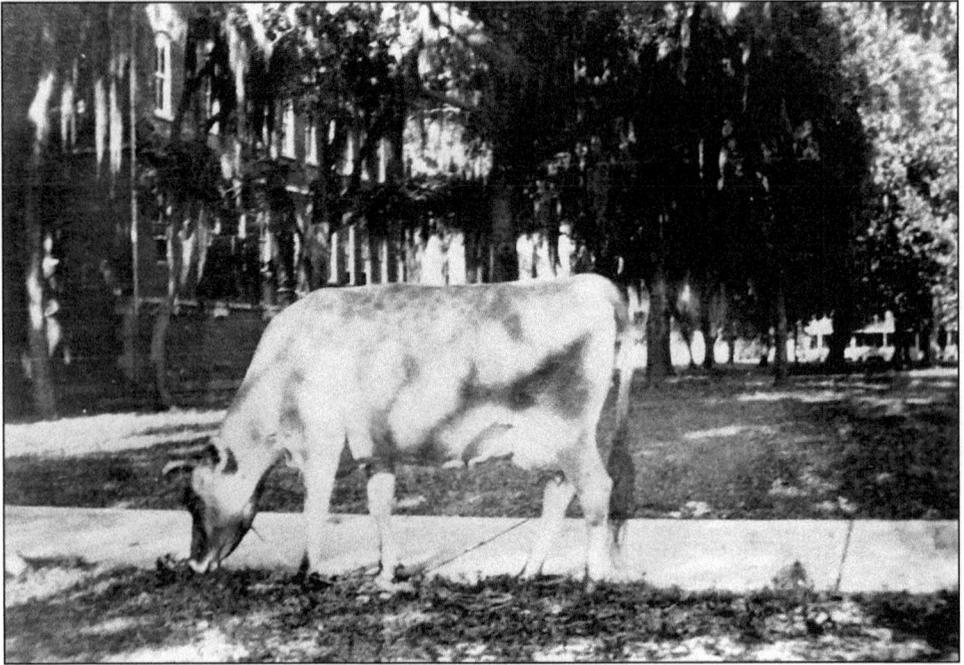

Maude, shown here in 1923 with the oak-shaded courthouse in the background, munches on grass. She also learned to climb the courthouse steps. Maude was the courthouse's "official" grounds maintenance crew, but the county had a pen where cattle that wandered off nearby pastures were kept until claimed.

reckless life." Broome cautioned those assembled not to play cards or engage in other vices and to read the Bible.

The *Orlando Reporter-Star* reported that after praying, Broome asked all those who would meet him in heaven to raise their hands. "Eight men raised their hands," the newspaper account quoted Orange County Deputy Frank Gordon. "Then Sheriff Prevatt advanced with the rope. When the noose fell over [Broome's] neck, he fainted. He came to, and began to yell, and the noise he made beat anything you ever heard. It excited the prisoners in the jail, who began to yell. . . . It was a great time."

Broome, who sometimes used the name Jim Rose, was tried, found guilty, sentenced, and put to death in less than two months, but his crime had occurred more than a year earlier. Broome shot and killed Samuel Boatwright in late 1910 in what he said was self-defense. He said Boatwright attacked him with a knife. His attorneys were never able to locate two witnesses, a man from Tampa and another from Miami, who could have testified for him.

Osceola was still a young county, just beginning to establish its own place in state politics when Florida became the staging area for the U.S. invasion of Cuba and later Puerto Rico. On February 15, 1898, more than 250 men were killed and some 50 wounded when the USS *Maine* exploded in Havana Harbor. The

explosion set off the Spanish-American War. Osceola County cattlemen rounded up wild cattle for the army, driving herds to Tampa Bay, port of embarkment for the Cuban Expeditionary Force. The war brought boom spending. Workers from interior Florida raced to build new buildings and military depots at Tampa, Jacksonville, and Miami.

More than 250,000 soldiers enlisted to fight in Cuba. Almost all of them embarked from Florida from April to July 1898, arriving by rail and traveling from Jacksonville, through Sanford and Kissimmee, and on to Tampa Bay. Some of those veterans were among the first to buy lots at a military retirement community that would become St. Cloud.

Many Floridians had lobbied to avoid a war, fearing that a U.S.-run Cuba would threaten Florida's agricultural and tourism industries. Congress passed a declaration of war that said Cuba would not become an American territory. Congress, though, didn't mention Puerto Rico. After victory in Cuba, U.S. troops easily took the island, ending four centuries of Spanish rule. Since 1952, the island

This scene shows the dedication of the new courthouse on May 6, 1890.

has been governed as a commonwealth of the United States. The goal of taking Cuba had been regime change. Even before the outbreak of war, one of the future governors of Florida smuggled guns to Cuban revolutionaries.

Napoleon Bonaparte Broward, Florida's swamp-draining governor of the early 1900s, was a gun smuggler in the years just before war broke out. In mid–October 1896, Broward was aboard the *Dauntless* when it supplied arms and ammunition to Cuban revolutionaries who met the steamer tug along the island's coast. Broward was born in Duval County, birthplace of a Florida-based plan to seize Cuba from Spain.

Antonio Rafael de la Cova writes about the Florida gunrunners in "Cuban Filibustering in Jacksonville in 1851," published in the fall 1996 issue of the *Northeast Florida History Journal*. (Filibustering, in this usage, means someone who carries out warfare against a country with which his own country is at peace.) "During the last half of the nineteenth century, most of the clandestine filibuster expeditions to liberate Cuba from Spanish colonialism were launched from Florida," he writes, adding that the first adventurers embarked from Jacksonville with plans to overthrow the Spanish in Cuba in the 1850s. They planned to

The courthouse was the site of many executions. Charles F. Prevatt, sheriff from 1897 to 1905 and again from 1908 to 1913, was in charge on the scaffold for the execution of Eddie Broome, Osceola's last courthouse hanging, January 19, 1912.

Osceola Johnston, shown here at 5 months old, was the first child born after the creation of Osceola County. He was born January 6, 1888.

"obtain Cuban independence with American volunteers, weapons and funds, and later petition for admission into the Union," he writes. Texans had done just that by establishing their own republic after defeating Mexico and then winning admission as a state in 1845, the same year Florida became a state.

Refugees came to Florida during the decade of fighting that began in 1868 with Cuba's first major drive for independence from Spain. Many settled in Key West. About the same time, Cuban cigar makers moved to Key West and later to Tampa.

By 1869, Broward was a 12-year-old orphan forced to make his own way after the deaths of both parents. He worked at the St. Johns River logging camps and farms. He hired on to work on a rivership, later becoming a steamer pilot. He would become one of many Floridians and other American adventurers who provided Cuban rebels with clandestine weapons. Broward learned how to be a smuggler from the skipper of the *Dauntless*, the legendary Johnny "Dynamite" O'Brien.

With his brother, Montcalm Broward, and their friend George DeCottes, Broward raised $40,000 to build the steamer *Three Friends* with plenty of power and a design to meet the sea-challenges of the route from Jacksonville to Nassau. Instead, writes maritime historian Edward Mueller, the *Three Friends* would make at least eight secret missions to Cuba. Broward and his partners pocketed $10,000–12,000 for each trip. They paid their crews double wages and bonuses. Once he tied up a port official in a game of poker while his crew loaded up high-powered cargo labeled "groceries" and "tomato juice."

Besides guns, Broward ferried patriots, food, and medical supplies to Cuba. Broward and the other owners were accused of the crime of supplying ammunition and manpower to a foreign nation. But all charges were dropped in the spring of 1898. Congress declared war on Spain that same year after the USS *Maine*, dispatched to Cuba by President William McKinley, blew up in Havana Harbor.

Historians credit Broward's notorious exploits as a gunrunner in the years before the Spanish-American War for at least part of the name recognition that made him Florida's governor in 1905. As governor, Broward opened more land on Florida's frontier to the south by supporting the draining of the Everglades. After his four years as governor, Broward won election to the U.S. Senate in 1910, but he died October 1 before taking office.

Some of the Kissimmee men who worked the steamers of the Disston era would be recruited for the next war. The army on April 27, 1918, drafted James Harry McGruder, who had at 13 gone to work as a cook's helper on Clay Johnson's Kissimmee River steamboat *Osceola*. In 1918 he was 19 and had earned his license as a steam engineer, but the army put him to work training mules in Virginia at $11 a month. He was discharged in early 1919, returning to Kissimmee.

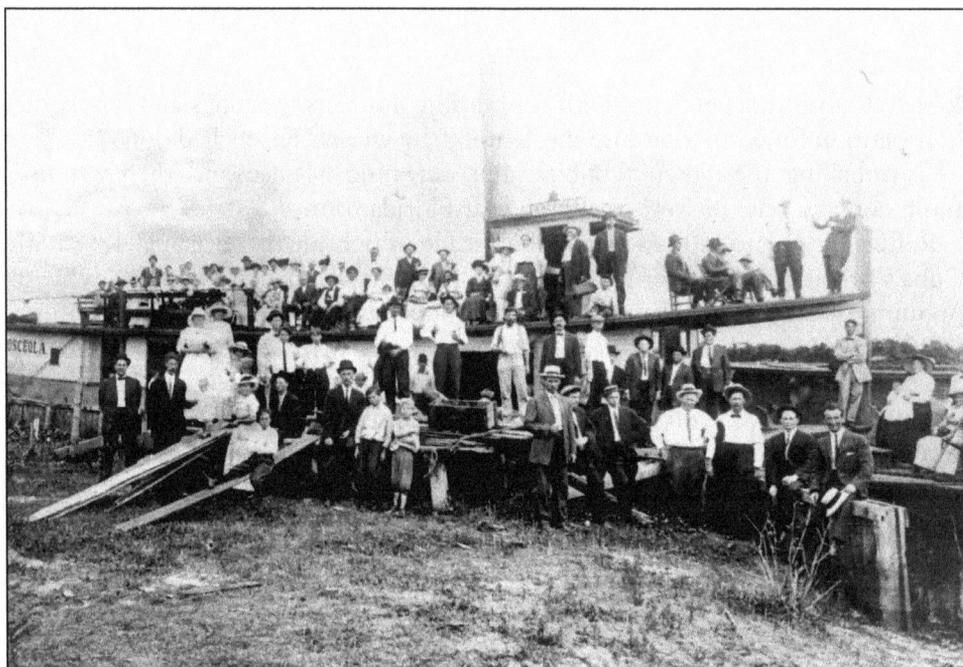

The Osceola *was one of Clay Johnson's steamers on the Kissimmee River.*

9. Florida's Land Boom and the Great Depression

Downtown Kissimmee businesses had other ways to attract attention, from building its version of big-city flat-iron structures to massive community picnics and even a life-size checkerboard game. New York has one of the first flat-iron buildings. Chicago and Seattle have theirs, too. And Asheville, North Carolina, Atlanta, and Fort Worth, Texas. Even Kissimmee can boast such a structure.

New York's Flatiron Building, which looks a lot like the rounded triangle shape of an old iron, is at Broadway and Fifth Avenue. When it opened in 1902, it was New York City's first steel-frame building. With architecture inspired by Ecole des Beaux-Arts in Paris, it stands today as the Big Apple's oldest surviving skyscraper. Kissimmee's triangle-shaped landmark, the Jordan-Norris Building at 113 N. Stewart Avenue near City Hall, started out as the home of the *Kissimmee Valley Gazette*. Bill Bauer, a St. Cloud architect, included the old newspaper office as one of Kissimmee's landmarks for a statewide historic guide by the American Institute of Architects. *Guide to Florida's Historic Architecture* lists the 1912 Jordan-Norris Building and its link to the pioneer-era newspaper, which is older than the building.

In mid-November 1897, the *Kissimmee Valley Gazette* published its first edition after a merger of two other papers. *The Kissimmee Valley* newspaper, founded in 1894, merged with the *Osceola Journal* in 1897 as the *Kissimmee Valley Gazette*. In 1910, S.J. Triplett, editor of the *Gazette* and a former writer for the Hearst newspapers in New York, was the first president of the Kissimmee Board of Trade, which predated the chamber of commerce.

The two-story brick building in the shape of a flatiron and fronting where Mabbette, Stewart, and Church Streets meet was completed in 1912, replacing the newspaper's previous wood-frame office. The name W.B. Harris and the date 1912 appear just above one of the doorways. Harris and his brother, N.S. Harris, owned the newspaper at the time. The newspaper offices and printing operation were on the ground floor, but the upstairs was designed for three apartments. The newspaper played a key role in promoting the city. The Board of Trade, with hopes of luring "sturdy and progressive tillers of the soil," sent free subscriptions

Members of Kissimmee's first Board of Trade pose on the courthouse steps in 1910.

of the *Gazette* to Northern and Western cities and invited reporters from across the country to visit Kissimmee.

During the Florida land boom era, a downtown Kissimmee event in January 1927 showed the lengths to which Broadway merchants went to attract attention. The promotion was an open-air community dinner around a 900-foot table. An estimated 2,500 to 3,300 people gathered in downtown Kissimmee. Downtown merchants served up 600 sandwiches, 75 gallons of coffee, 700 bottles of soda, 500 buns, 500 pounds of salad, 73 bottles of pickles and olives, 2,000 oranges, 1,800 bananas, 150 large cakes, 980 pounds of sliced ham, and 36 cases of minced ham.

Other social events rivaled even this grand picnic. On a Saturday afternoon in 1927 crowds began to gather around a checkerboard at the intersection of Broadway and Darlington Avenue. This was no ordinary checkerboard. And this was no ordinary Saturday in downtown Kissimmee. Community pride was at stake, and Kissimmee and St. Cloud folks were there to rally support for their towns and to prove their checkerboard champs were up to the challenge.

The big match-up needed a big-scaled venue with a view, so a huge checkerboard was painted on the downtown street corner. Just before the match began, the 24 "checkers" walked to their starting marks—12 Kissimmee women dressed in white and 12 St. Cloud women dressed in red. Off to the side, the competitors played on a regular-sized board and their moves were announced to the gathering crowd encircling the roped-off, oversized board. Some stood on nearby roofs and sidewalk overhangs. The Osceola County Historical Society's records don't include which city won that first match, but another was held the following Saturday in St. Cloud. Each city is said to have won one game.

That's the way they did things in the boom years—on a big scale. Not long after that, though, Florida's land boom busted, and the Great Depression cast its dark shadow over the nation. Downtown merchants struggled through the challenges of the Depression and the war years that followed.

Historical researcher Brenda Elliott sifted through the records of writers paid by the federal government during the Great Depression to document life in the United States during the time of the nation's worst economic crisis. The Florida Writers' Project, funded by the Works Progress Administration (WPA), not only provided employment for writers during those tough years, it proved to be a "fascinating and rich source on the Florida Cracker's life," Elliott writes.

Elliott compiled her research into the old records as "Florida Cracker Cattle Lore: The Florida WPA Files," published in 1995 in *The Proceedings of the Florida Cattle Frontier Symposium*. A substantial portion of the document is from interviews conducted in the 1930s with Osceola County residents, including the story about the Cracker salutation. "The common greeting in this section . . . throughout the Florida cattle country is 'Hey!' pronounced with a certain explosive quality which used to startle [people when they] first came here," the WPA writers said. "It takes the place of 'Good Day,' of the various contractions of 'How do you do,' of the north. The appropriate response seems to be another 'Hey.' "

Two stories from the files helped spread the folklore that Crackers were, well, lazy. In the first, a farmer trying to hire a Cracker to work on his farm was told,

The Kissimmee Valley *and the* Kissimmee Valley Gazette *in the late 1890s carried the news of the world to the new residents of Osceola County. N.S. and W.B. Harris published both papers. One of the stories on July 28, 1897 told of thousands of people leaving for the Klondike gold fields.*

"What for should I work? Hit don't cost but $35 a year to live, and I've got $40."
In the second, a Cracker hired to clean up a front yard asked how much he would
be paid. The owner told him to get to work and he'd pay him whatever he was
worth. That brought this response: "I can't afford to work for that little."

Many Cracker families couldn't afford to shop in the cities. The files included
this description of the plain clothing an Osceola County housewife made from
old cotton feed sacks. "These bags are carefully saved by frugal families, bleached
in the laundry and converted into all kinds of garments," including dresses,
pajamas, coarse underwear for girls, work aprons for women, and shirts for men
as well as table covers and bed sheets.

"When I called on a woman who has a considerable chicken ranch 10 miles
from Kissimmee, I found her wearing sackcloth made into a coarse work dress
or smock," an anonymous author writes, "and not all the printing has been
faded out, so that a-thwart her ample person she bore in faded pink letters the
legend, 'The Perfect Form . . .' The 'u-l-a' had been clipped from the last word."
The same author also wrote that Kissimmee did not have a modern laundry.
Instead, just about every house had a "blackened kettle resting in an iron tripod

*On a Saturday afternoon in 1927, crowds watched this life-sized checkers competition
at the intersection of Broadway and Darlington Avenue between teams from Kissimmee
and St. Cloud.*

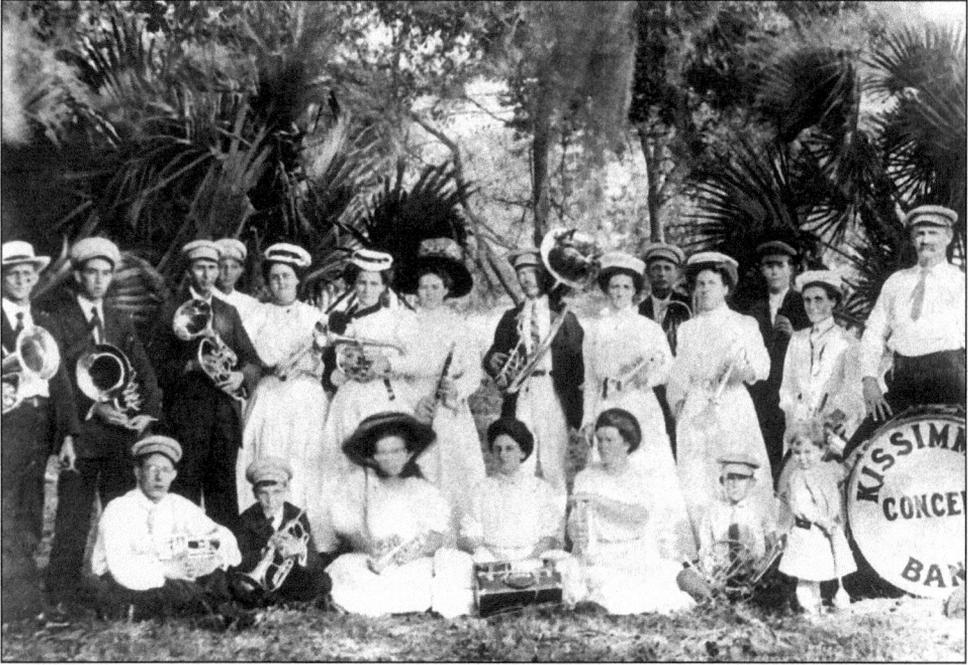

The Kissimmee Concert Band is shown in the early 1900s.

or a tottering support of broken bricks where the family laundry is done. . . . Where there is no help, the women of the family wash in the same way, boiling the clothing in the kettle. This is not the place, up to this date, for the electric washer salesman."

The WPA writers were not impressed with most of the simple Cracker houses, schools, and churches, but they liked the Crackers' food and customs. They dined on "bankin' 'taters"—newly dug sweet potatoes sweetened by being buried in Florida sand for several weeks. They also sampled "Hoppin' John," a pork-flavored blend of lima beans, rice, and corn or black-eyed peas. And they had "long sweetenin' " (molasses) or "short sweetenin' " (cane sugar). The writers also note, "The Cracker's dislike for 'store-boughts' is clearly reflected in his lumping all prepared foods—such as breakfast cereal—and any food prepared by Yankees—anyone north or west of Alabama and Georgia—into the category of 'Monkey food'."

Cracker wives cooked most of their meals outdoors, sometimes very early in the morning. They often prepared the full day's meals before dawn to avoid the cooking chores in the heat of the day. Food prepared, set out, and covered with a tablecloth after breakfast dishes were cleared away might be eaten throughout the day. And the hospitality of the table was opened to visitors and even strangers passing that way.

The WPA files include one tale attributed to Osceola cattleman Henry Partin, who told a story about one of his uncles whose second wife was from Vermont.

The uncle warned his nephew about Yankee women: "You kill one of your prettiest calves and take her the best lot of steak you could want," the old man said. "You wake up in the morning, expecting to have some of that steak, with maybe a couple eggs and a lot of rich gravy to go over your grits. And that damn Yankee woman sets you down to some toast and jelly."

Neighbors took care of neighbors during the Great Depression. The Lesesne and Silas families were neighbors. Sara Silas was one of many Kissimmee women who looked out for young Buster Lesesne. "She partly raised me," said Buster Lesesne, who would grow up to become a political leader in Kissimmee's black community.

His mother, Nancy Wheeler Lesesne, died when he was a toddler. His father, Scipio, found ways to provide for nine other children. After working for many years at the sugar-cane plantation and mill in St. Cloud, his father farmed potatoes and ran a movie theater on the first floor of the family home in Kissimmee. Raising Buster, it seems, took more than a houseful of older siblings and a hardworking father. It took the whole town.

Some of the help came from historian Minnie Moore Willson, who founded Friends of the Seminoles. She had been a frequent visitor to the Lesesne home and promised Buster's mother she would provide for them. "And she did," Buster said. "She brought a loaf of bread almost every day," he recalled.

Hard luck hit the family during the Hoover presidency. They lost the family homestead to a mortgage foreclosure. Three brothers and two sisters moved to New York and later sent for Buster. Even while he was living in Harlem and

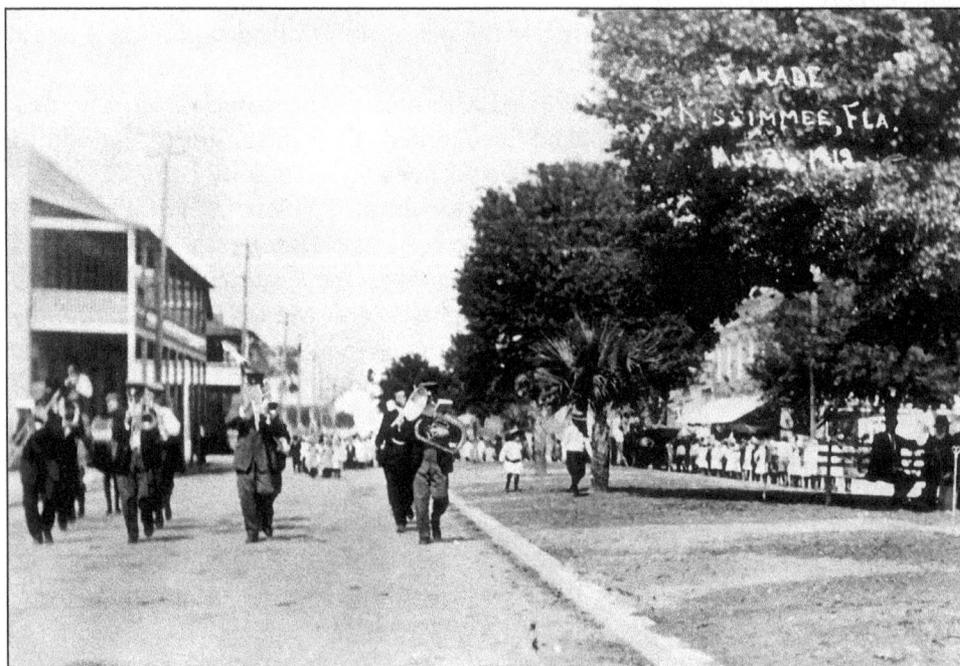

A city's band leads a parade on Broadway in 1919.

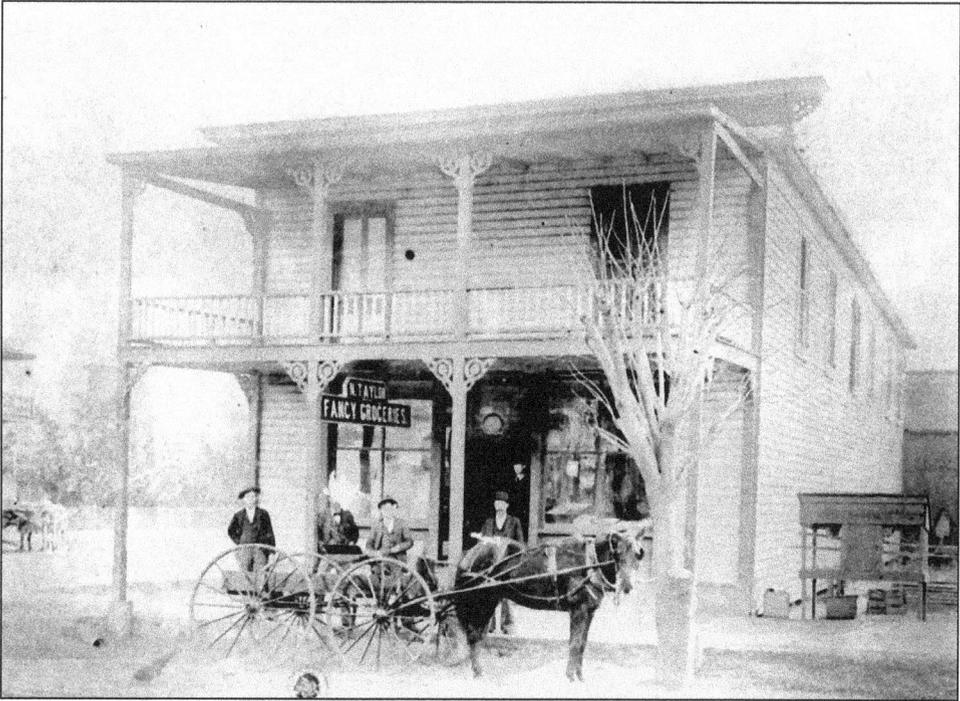

Newt Taylor ran this grocery on Broadway in 1889. Isaac. M. Mabbette's home is on the left in the distance.

driving a cab without a city permit, Buster had a friend. Willson spent her summers in New York City.

Buster was a Republican when he first moved to Harlem. He had tried for five years to get a cab license when a friend told him to go to Tammany Hall, where political bosses doled out favors in return for support at election time. He walked in about noon and walked out three hours later with his license. "I've been a Democrat ever since," he says.

Buster's political interests led him to a six-week elections class at New York University, lessons that served him well when he returned to Kissimmee as the owner of the first licensed taxicab company in Osceola County. And, when he returned, he started returning favors. Delivering flowers was part of the cab business he started with a borrowed Hupmobile when he worked as a bellhop at the Arcade Hotel, which later became the Brahman Hotel, in downtown Kissimmee. When the bus company had too many riders, it hired Lesesne's cabs. He even drove his cab as a part of a rodeo show. He kept his jobs at the hotel, cooking and washing dishes. Other times, he worked the front desk. He also owned the lobby shoeshine stand.

By the early 1940s, he had a new Plymouth, and Malinda dispatched cab calls from their home, where they also ran a notary business. The officers and soldiers stationed at the airfield kept his cabs in business. During the years he ran Buster's

Cab—1937 to 1983—he often stopped to check up on older people. "I'd find sick people and help. And I'd make sure they were getting their meals." Sometimes, they just needed a talk with a friend. "People say I helped them, but really, they helped me."

His cab provided transportation when he and his wife started Kissimmee's first employment office. White employers trusted Buster to provide good workers, and his company made a little money hauling people around. Buster drank coffee with the white men at segregated lunch counters. "All people are nice to me," he said. "They respect me because I respected them. . . . I was never integrated into Kissimmee." It wasn't necessary. Buster Lesesne was invited. Along the way, he became a celebrity, recognized from Kissimmee to Tallahassee.

A front-page story on Christmas Eve 1985 told readers of *The Orlando Sentinel* that Buster would be delivering boxes of food to the needy. ABC's *Good Morning America* show asked for an interview, and the *Sentinel*'s story appeared the following day on the front of *The Atlanta Constitution*, where his sisters in Georgia read about their younger brother.

Buster doesn't drive his cab anymore, but he's still looking out for people. He puts flowers on the graves at the once-forgotten Pine Ridge Cemetery. The widening of U.S. Highway 441 cut a path through the cemetery during the late 1920s or early 1930s. By the 1980s, palmettos and weeds had taken over when a judge appointed Buster and four other men as trustees to lead the cleanup. The trustees put up their own money for the work, and from time to time, Buster and the others still pay for burials.

Maybe he's just paying people back for the help they gave him. He told a story of a white woman who had been a lifelong friend. She once told him to wait for her outside a church before a funeral, so they could walk in together. She introduced him, saying, "This is my brother. He was born at night. I was born during the day. That made the difference." When she died, she left him $10,000 in her will. "I put flowers on her grave every Easter," he said.

Buster Lesesne celebrates August 28 as his birthday, but the year of his birth is a mystery. He believes he was born between 1908 and 1911. "That's a good mess. They lost the records in a house fire," he said. "I have a lot of birthdays!"

And he has lots of honors. Lesesne may well be the most recognized cabbie in Osceola County politics. In the spring of 1992, presidential hopeful Bill Clinton's campaign made a swing by the Osceola County Stadium where the Houston Astros were about to take on the Boston Red Sox. Lesesne told the Arkansas governor that he and his wife would make sure Clinton got Osceola's vote. "Bless you," Clinton replied.

Buster, whose wife has been clerk for Precinct 25 for 30 years, is a political insider and civic activist. He was invited to Bob Graham's second inauguration as governor and has been recognized by organizations ranging from the Florida Sheriffs Association to St. Luke Missionary Baptist Church. He worked on the campaigns of three Democratic governors. Former Governor Leroy Collins appointed Buster as deputy hotel commissioner.

Cattleman Henry O. Partin told some of his family stories to WPA writers. One story was about his uncle whose second wife was from Vermont. The uncle warned his nephew about Yankee women. "You kill one of your prettiest calves and take her the best lot of steak you could want," the old man said. "You wake up in the morning, expecting to have some of that steak, with maybe a couple eggs and a lot of rich gravy to go over your grits. And that damn Yankee woman sets you down to some toast and jelly."

Novelist and folklore historian Zora Neale Hurston stayed overnight at his house on Kissimmee's Brack Street in the 1940s. Buster was named an honorary pall bearer at the funeral of boxer Joe Louis at Arlington National Cemetery. They met when Lesesne's sister-in-law was Louis's nurse. Louis willed Lesesne a cap, which hangs on a wall in his home.

The walls of his front room are filled with plaques, framed pictures of Presidents and governors, letters of thanks, honors, and newspaper clippings. When he ran out of wall space, he started making piles on his desk, filing cabinets, and the floor. The piles keep growing. A signed photograph from Al and Tipper Gore is at the bottom of one stack. There's even a fund-raising request from then-presidential candidate George Wallace. Buster has fun with that one. Things like that happen when you are a longtime member of the Osceola County Democratic Executive Committee and Kissimmee's favorite son.

F. Bailey, left, and an unidentified man stand next to Bailey's Ford bus, which ran between Kissimmee and St. Cloud in the early 1900s.

Another of Kissimmee's favorite sons, Frank O. King, creator of the "Gasoline Alley" cartoon strip, lived between Kissimmee and St. Cloud for more than 20 years. King's Highway runs south from Neptune Road to the more than 230 acres that included the cartoonist's Folly Farm estate on the northeast shore of Lake Tohopekaliga.

The cartoon's banker, a Mr. Enray, was a caricature of one of King's neighbors, N. Ray Carroll, president of what then was the First National Bank of Kissimmee. Carroll—and Mr. Enray—gave out saving advice as well as loans. Carroll, writes Catherine W. Beauchamp in *Look What's Happened in Osceola County*, would give each first-grader who came into the bank a new saving account book and a crisp $1 bill. "Many of these children kept their savings accounts active to and through adulthood," she writes.

Mr. Enray's financial advice helped any number of people make a better life for themselves, which is a pretty good epitaph for a community banker. The comic strip banker guided the strip's main character, Skeezix Wallet, as he ran his fix-it shop, named Wallet and Bobble. In the real world, Carroll counseled some of his bank customers to buy land, instead of letting their savings sit in his Kissimmee bank. Sometimes he set up the loans to help them buy land.

That's how Buster Lesesne, a black entrepreneur during the segregation era, turned his taxicab profits into real-estate investments. "I was trying to save money, always trying to put it in the bank," Lesesne told the *Orlando Sentinel* a few years back. "But Mr. N. Ray Carroll . . . told me that I couldn't save a lot of money, so I ought to buy land instead. He said, 'If you get $2,500 or $3,000, buy land. If you don't have it, I'll give it to you, but you've got to pay it back.' So I did."

Former Osceola County Commissioner Mike Bast, who describes himself as Mr. Enray's grandson, said King put Carroll in the comic strip, and Carroll put King on the road. Carroll was state senator when he persuaded the Legislature to name King's Highway for the cartoon creator.

Carroll did a lot more for Osceola County. He was one of the founders of the Florida Cattlemen's Association, established in Kissimmee in 1934. All of the founders were from Osceola County. Carroll also stepped up when the federal government was planning the route for a highway from Melbourne to Kissimmee in the 1940s. The banker made sure that an Osceola County road would be used for what today is U.S. Highway 192, which puts Kissimmee and St. Cloud right in the middle between the Atlantic beaches and the Disney theme parks. Carroll was around to introduce U.S. Senator Claude Pepper at the 1943 dedication of lakefront Kissimmee's Monument of States. Bressler Pettis created the downtown landmark at Monument Avenue and Johnston Street from stones from each of the states. Carroll has been described as Kissimmee's first real power broker in Tallahassee. Some even wanted him to run for governor in the early 1940s.

Bast, who has lived on King's Highway since 1948, has an original of King's comic strip drawing of Mr. Enray. It was a gift to his grandfather from King. Others in the community found their likeness on the pages of the newspaper comics.

Local lore holds that during the mid-1930s King would park his car along Kissimmee's Broadway and watch the high-school students going into Johnny Schmidt's pharmacy. Similar looking teenagers would show up in the strip. Also, a courthouse that looked a lot like the Osceola County landmark provided the backdrop for the 1940s scenes when Gasoline Alley's leading characters, Uncle Walt's adopted son, Skeezix, and Nina, picked up their marriage license. The couple had done their courting at a soda fountain counter identified on a window sign as "Tress," another downtown Kissimmee landmark. The old Tress News Stand on Broadway had been a telegraph office during the cattle town's early days. Sebastian Tress built his Broadway storefront in 1899 for his brother Anthony. The newsstand, with its soda fountain and candy counter, was a community social gathering spot until it closed in the 1980s.

King, who lived in Osceola County from the mid-1920s until he moved to Winter Park in the 1950s, was born in Cashton, Wisconsin, in 1883, the same year the former settlement of Allendale on Lake Tohopekaliga became Kissimmee City. The *Lambiek Comiclopedia*'s biography for King states that he started his career as a cartoonist at the *Minneapolis Times* in 1901. Later, he worked at the *Chicago American*, then the *Examiner*. King was working for the *Chicago Tribune* in 1910. Five years later while still at the *Tribune*, King had his first hit with the comic "Bobby Make-Believe."

That comic led to creation of the ever-growing Wallet Family and the others who made up the cast of characters for "Gasoline Alley," which took its name from the street where Walt Wallet and three other men worked on their cars, beginning in late 1918. Newspaper syndication began in the 1920s. The family's

story line begins with bachelor Walt discovering a foundling, Skeezix, and taking on responsibility of rearing the child. Walt marries Phyllis, and through the generations, the Wallet family continues to entertain a nation. What set King's comic characters apart from others is that the Wallets, their children, and grandchildren aged in real time.

The comic provided King with a comfortable living, enough to allow him to keep homes near Kissimmee and Chicago. By the early 1950s, he handed over the Sunday strip to his associate, Dick Moores, who also lived in Florida. Readers continued following the fictional lives that looked a lot like real-life families in small-town America. To help Osceola County celebrate its 100th anniversary in 1987, Jim Scancarelli, the cartoonist who continued the strip after Moores retired, drew a cartoon showing Uncle Walt and his great-grandson, Rover, outside the courthouse.

King gave Rollins College 276 of his "Gasoline Alley" strips in the 1960s. They are part of the archives at the Winter Park college's Olin Library. King was 86 when he died in Winter Park in 1969. Tribune Media Services still syndicates "Gasoline Alley."

Newspapers weren't only full of such lighthearted items. They also carried the stories of the crimes of the Ashley gang. A photograph shows a young couple embracing in the early 1900s in the pine forest. They are not young lovers on a Florida vacation, newlyweds still on their honeymoon, nor new arrivals with plans

Frank O. King, creator of the "Gasoline Alley" cartoon strip, lived at his Folly Farm estate between Kissimmee and St. Cloud and often used local people in his strip.

to raise a family in the wilds of Florida and raise a family. He's a bank-robbing gang leader, and she's Florida's notorious "Queen of the Everglades."

John Ashley made his legend as a criminal who could hide from the law in the wilds of Florida. Historian Gene M. Burnett, author of three volumes of stories under the title *Florida's Past*, describes Laura Upthegrove as Ashley's "bawdy mistress." "She often carried a .38 revolver strapped to her hip while directing bootleg loads," Burnett writes. The two were, he claims, "as devoted as a couple of newlyweds." Ashley, though, had a cruel, jealous streak when it came to Upthegrove.

Osceola County legends about the two—ringleaders of the Ashley Gang in the same criminal vein as Bonnie and Clyde and Ma Barker—include the story about Ashley's rage when he heard his sweetheart was making time with another gang member. The story goes that Joe Tracy, born in St. Cloud but more often mentioned with ties to Holopaw, had joined Ashley's gang, got caught, and was tossed into the county jail in Kissimmee. Upthegrove, whose talents included finding easy banks to rob and driving the getaway cars, was spending way too much time visiting Tracy in jail.

Ashley, so the story goes, rounded up the other gang members and told them of his plan to break into jail and grab Tracy. But Upthegrove found out that Ashley's plan all along was to get Tracy out of jail to kill him. She tipped off the cops.

The cartoon's banker, a Mr. Enray, was a caricature of one of King's neighbors, N. Ray Carroll, president of what then was the First National Bank of Kissimmee. Carroll—and Mr. Enray—gave out saving advice as well as loans.

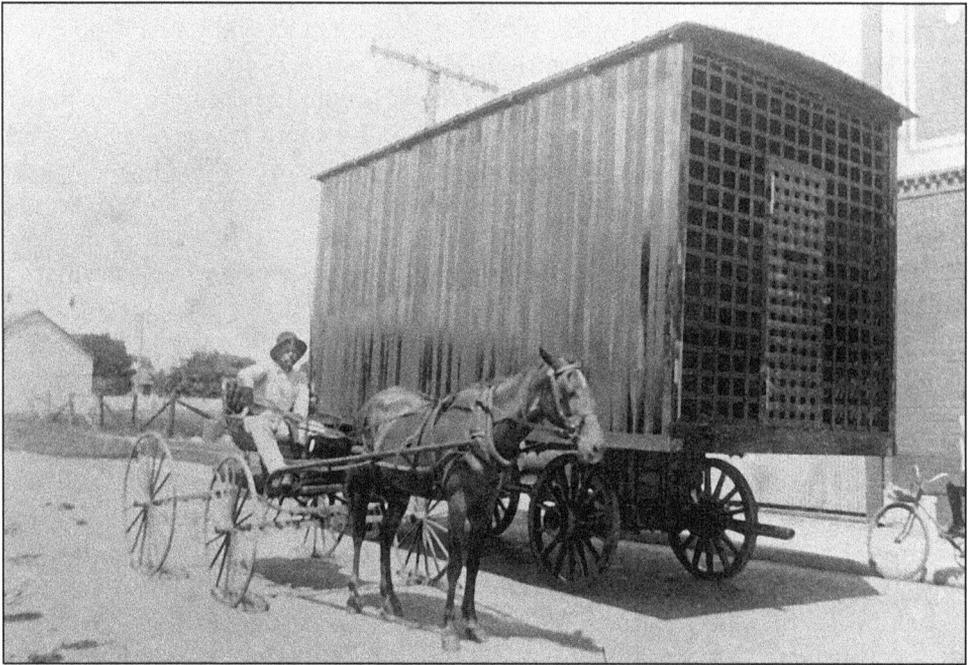

With progress comes a need for a jail. This was Kissimmee's first jail.

Ashley and three other gang members were headed to Kissimmee, but they only got as far at the Sebastian River Bridge at the southern tip of Brevard County, where a posse was waiting. Deputies had stretched a chain across the bridge and placed a red lantern there to stop the gang's car. When Ashley and the others got out of their car, deputies rushed in and cuffed them. During struggles, the posse gunned down every one of the gang, including Ashley. John Ashley had started out as one of five brothers whose parents had started the crime ring. Hearing about the killings of her son and the others, Ma Ashley arranged for a Salvation Army minister from Miami to perform the funeral service.

Burnett writes that Tracy and Ashley started out as pals in the sawmill town of Holopaw. They were childhood buddies, hunting, fishing, and drinking together. Tracy, described by those who knew him from his Holopaw days as an outgoing guy with a generous nature and perpetual smile, fell in with the Ashley family's gang in a spree of bank robberies, shootouts, hijackings, and rum running. Tracy was tied to his share of killings, including his arrest on a train in Kenansville as the prime suspect in the 1924 murder of a Lokosee man who ran a turpentine business. The case was weak, and Tracy's popularity kept the state attorney from getting an indictment.

Tracy rejoined the gang, robbing a Pompano bank. Tracy's partner in the killing of a taxi driver near Fort Christmas turned him in. That's when Tracy decided to marry Upthegrove, a key witness expected to testify against him. The marriage, on April 17, 1925, kept her off the stand.

Alma Hetherington writes in *The River of the Long Water* that Judge J.W. Oliver performed the marriage as Tracy "stood by the back steps inside the jail enclosure in Kissimmee and his girlfriend, Lola Upthegrove, stood outside. . . ." That's as close as they got, Hetherington adds. "History has it that the new Mrs. Tracy was more than a little disappointed by the deletion of the traditional post-marriage ceremonies." Upthegrove died a year later, a suicide by poisoning.

Later, from his cell in state prison at Raiford, Tracy agreed to show law officers where the gang had stashed $31,000 in stolen cash, gold jewelry, and bonds. Tracy took them to a St. Cloud house in July 1926, where he escaped through a back window. After he was recaptured, Tracy's monthlong adventure won him a sentence of 15 years to life in state prison. Years later, he won a pardon and set up a saddle shop in Gainesville. Legend holds that he returned to a life of crime. He was a suspect in at least one more bank robbery, this one in Williston. He died in 1968 at Florida State Prison near Starke.

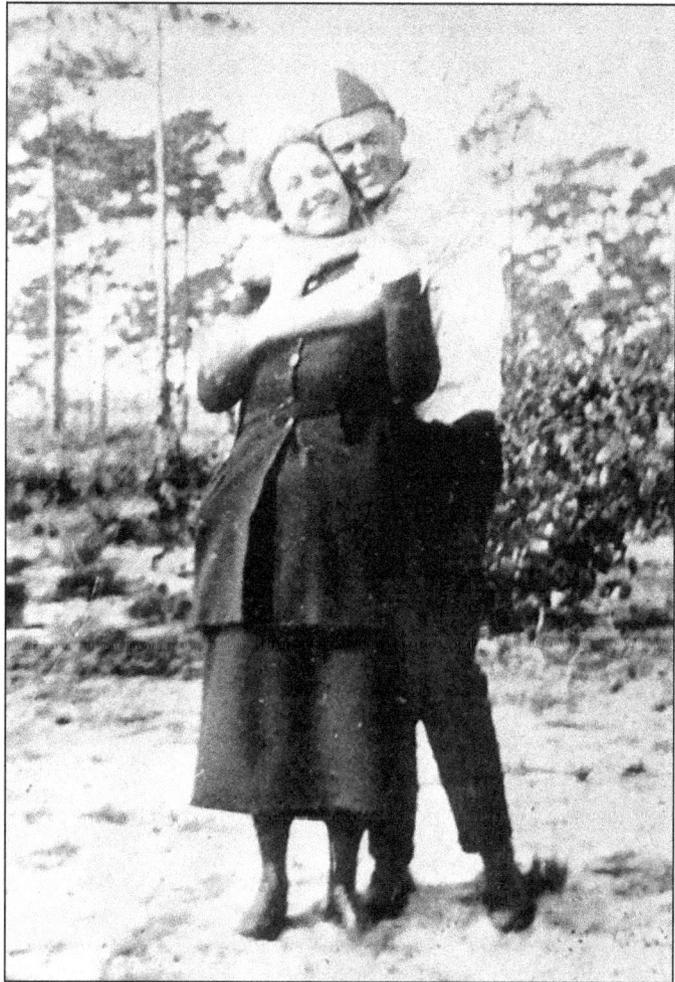

John Ashley, who led the Ashley Gang on a crime spree through Central Florida, poses here with Laura Upthegrove.

The Ashley Gang had faded just as Florida was entering the Great Depression and building its first paved roads. "We who have experienced the deep sand ruts know how to appreciate fully the modern highways," wrote Myrtle Hilliard Crow in the 1940s.

Crow followed the old trails through Central Florida in the 1930s and 1940s to gather stories for her book *Old Tales and Trails of Florida*. Throughout most of her book, Crow writes about the early years of travel along Central Florida's old trails used by the U.S. Army during the Seminole Wars of the 1830s through the 1850s. Parts of today's U.S. Highways 17, 92, and 441 follow roads that the army laid out for mule teams to haul supplies to soldiers at a string of forts stretching from Sanford to Tampa. Even sections of Florida's Turnpike follow the old military trails.

Late in her book, Crow writes about the coming of the automobile:

> When the automobile first came into use, we were handicapped by bad roads. The winding roads used by the teams [of horse- or oxen-drawn wagons] were unsatisfactory, often having stumps in them. When cars were driven through the ponds, the engines could get drowned out, and many were the times that the nearest neighbor would be called upon to pull the cars out of the muddy places with a team of horses.

Dry spells made the sand loose, and many cars got stuck in shifting sand. Early motorists learned to bring along a shovel to dig narrow wheels out of the

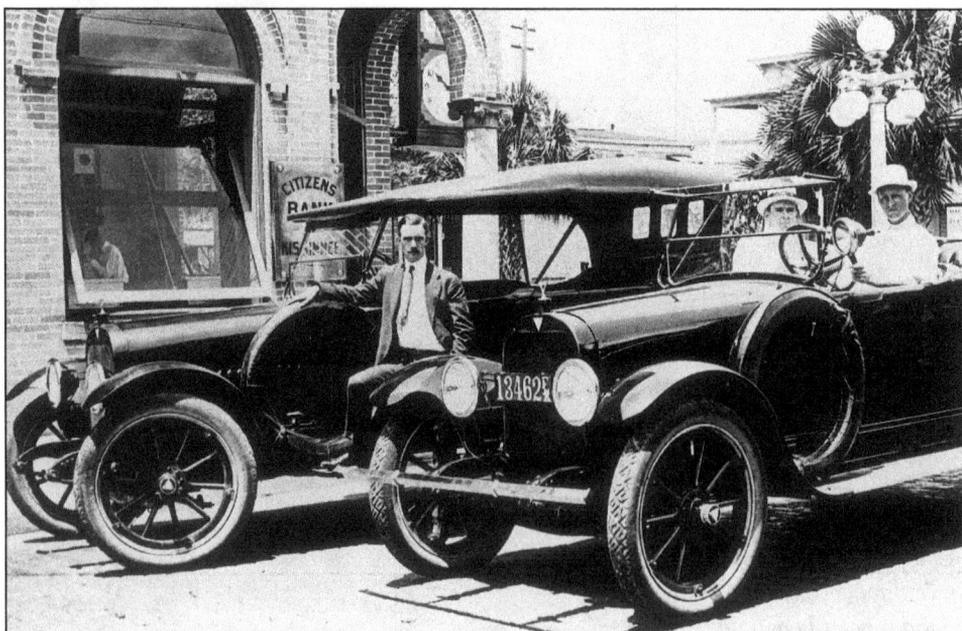

Two proud owners pose with their cars outside the Citizens Bank in Kissimmee in 1924.

Driving in the prairie, shown here in 1919 near Whittier, required (left to right) F.E. Brandon, Dr. A.J. Holt, and J.M. Willson Jr. to put their backs to work.

sand and an ax to chop up downed trees blocking the road. Some of the sand trails were covered with pine needles to help the tires get some traction. People would go through the woods and rake the pine straw and drag it into piles. Crews in wagons would come along and pick it up and scatter it along the roads. And sometimes, corduroy roads were built over marshlands using logs laid crosswise.

By 1915 advocates were promoting construction of the Dixie Highway, a paved two-lane road that would link Florida with the North and bring the first wave of tourists of the automobile age. It came south out of Lake City and connected Gainesville, Ocala, Leesburg, Tavares, Apopka, and Orlando before going on to Kissimmee, Bartow, Arcadia, and around the south side of Lake Okeechobee east to Palm Beach. The 9-foot-wide road was paved with bricks in 1916. In October 1925, the entire length of the Dixie Highway opened from the Canadian border at the northern tip of Michigan to Miami.

By that time, Henry Ford's Model T automobile gave entrepreneurs in the cities a way to carry passengers and take fares away from trolley lines. These Tin Lizzies picked up passengers by charging a penny or two when the trolley fare was a nickel. Ford's affordable car also was a big hit in Florida, Crow writes. "Early Fords were built small and high off the ground, so they could pass over the stumps and deep ruts and follow the crooks in the roads more easily," she writes.

She added that Florida passed its first road-building law in 1922, requiring that no stump was to be left higher than 12 inches from the ground. Crow writes:

Joseph J. Griffin stands with his son, Joseph J. Griffin Jr., outside his garage on Monument Avenue in 1917 or 1918.

The clay-surfaced roads of the horse-drawn buggy days were well-worn. The increasing travel and rainy weather caused many holes in them. Consequently, it was necessary to rebuild them. The main highways were nine-feet wide and paved with brick [with concrete re-enforcements along the edges.] That was a great improvement, and going was fine as long as no one was met on the road. Then it was necessary to slow down while passing the other car and run on the side of the road, which in time became deep sand in places.

"Our first car drivers were venturesome fellows," continues Crow. "Some of the 'speed demons' drove as fast as 30 miles per hour, but that was too fast for the average person to travel at that time." She recalls traveling over a narrow brick road to the St. Johns marsh, parking the car on a ferryboat to cross the marsh and river and driving on to Melbourne and the East Coast. "It was a beautiful drive, but the wash-board road was rough, and the many turns were dangerous for heavy traffic," she writes.

Florida roads received a healthy boost in 1931 when the gas tax was increased to 6¢ per gallon, with 3¢ going to the state for construction and maintenance and another 3¢ going to the counties to repay existing debts. Federal dollars for roads became available during the 1940s. Florida's Turnpike, which was called the Sunshine State Parkway, got its start in the 1950s, following portions of the trail General Abraham Eustis blazed more than a century earlier on a route west of the

St. Johns, passing through what would become St. Cloud, Kenansville, and Yeehaw Junction.

Through the years, Kissimmee has found community events to bring people together. One of Kissimmee's largest celebrations came with news of the signing of the Armistice that ended World War I. People came in droves. Lee Rogers remembers the bells ringing along Kissimmee's Church Street and motorists dragging strings of tin cans behind Model Ts.

Ranchers returning home after the war organized rodeos. Ranch rodeos had been around for years, but it took Milt Hinkle to organize the first big-time Kissimmee rodeo in the early 1920s. The Texas-born cowboy is said to have known Wyatt Earp, Bat Masterson, Annie Oakley, Pancho Villa, Geronimo, and Cole Younger. The man who had toured with Wild West shows from his childhood brought portable chutes and bucking stock for a downtown rodeo. The Silver Spurs Rodeo's heritage is traced to the horseracing pastime of the early ranchers. The Silver Spurs Club was created after a barbecue at the ranch of charter members Henry O. "Geech" and Connie Partin in 1941.

Geech Partin in the 1930s introduced Kip, the first registered quarterhorse in Florida, after paying $150 for the horse in Alice, Texas. He raced Kip in Osceola County and in Melbourne, once winning five elimination races in one day. "There is no secret so close as that between a rider and his horse," LaVerne Yates

Geech Partin introduced Kip in the 1930s as the first registered quarter horse in Florida after paying $150 for the horse in Alice, Texas. He raced Kip in Osceola County and in Melbourne, once winning five elimination races in one day.

said at the annual Cowboy Reunion at Fort Christmas Historical Park on January 25, 2003. He was recalling his first horse, a pinto colt named Doby that he bought in the 1930s. Doby, born in Florida after a railroad car full of horses was brought east from Oklahoma during the Great Depression, won a lot of races for Yates.

On July 4, 1944, the Silver Spurs Riding Club held its first rodeo for the Independence Day weekend on Geech Partin's ranch east of town. The contest grew over the years until, by 1951, the club was able to build a show arena on U.S. Highway 192 between Kissimmee and St. Cloud.

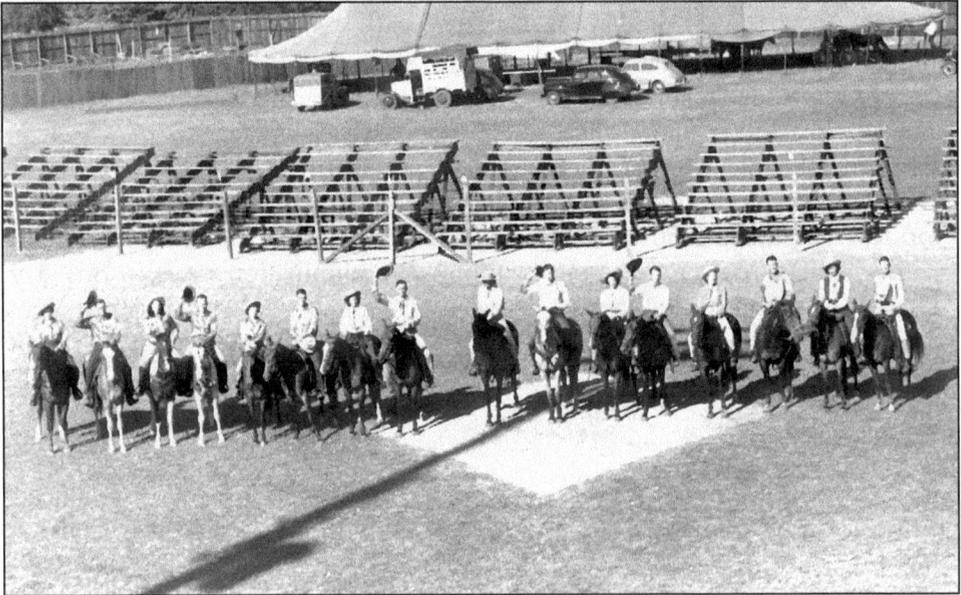

Members of the Silver Spurs Rodeo in 1941 pose at the arena grounds.

10. KISSIMMEE DURING AND AFTER THE SECOND WORLD WAR

In the late 1930s and early 1940s, folks gathered in a cow pasture west of Kissimmee to watch Sunday afternoon flying exhibitions. After the Japanese attack on Pearl Harbor, though, the mood changed and so did the airstrip. The federal government moved in around 1943, opening Kissimmee Air Base as a training field for World War II pilots. After the war, Kissimmee took over the air base for a city airport.

An old ballfield was torn down to provide housing for soldiers returning after World War II. Kissimmee had been the spring training home of the St. Louis Browns. Before the ball club moved to Baltimore, joined the major leagues, and became the Orioles, professional teams drifted around in search of sites for training. Kissimmee's turn came in 1935 and 1936. They used a clay ballpark off Old Tampa Highway about a half mile south of what is now the U.S. Highway 17-92 overpass. The old ballfield would become part of Kissimmee's rich military history.

Ken Murphy, whose extended family traces its Osceola County history to the Iveys, who settled at Shingle Creek in the 1890s, was born in 1944 at what once was Orlando Field. The site of what today is Orlando Executive Airport began in the late 1920s as a city-owned airport just north of Lake Underhill. The Army Air Corps took over the airport in September 1940, using it as a training field. During World War II, the Orlando Army Air Base also served as home for bomber and fighter groups. Murphy's father was stationed there before shipping out to Asia, where the United States set up airbases to fly missions against Japanese targets.

"We lived in government housing across from T.G. Lee's dairy," Murphy writes. "I still remember the cows." That military housing complex west of Bumby Avenue was later turned over to civilian authorities for public housing. The housing survived into the early 1990s, when the small homes were demolished to make way for a new community. One of Murphy's uncles, A.W. Ivey "was in charge of paving the asphalt runways" at Orlando Field, he writes. The airport had one main runway and three short runways. Mostly the

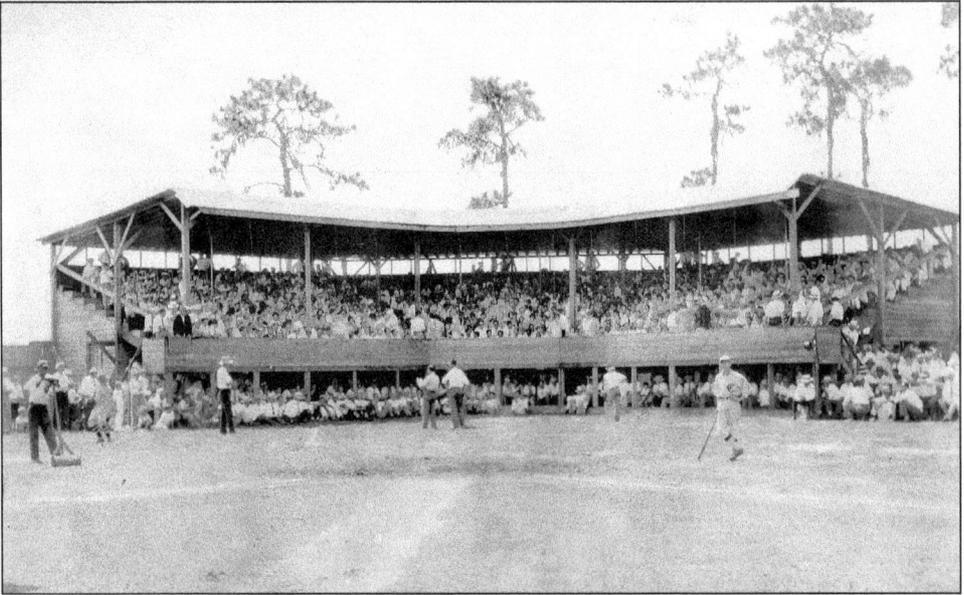

Kissimmee's ballpark on Clay Street is shown in about 1910.

military's P-40 planes used the shorter runways. One of the runways ran north-south starting at the edge of Lake Underhill and ending at what later was called Showalter Field. "You can still see the old runways if you get far enough above the field," Murphy writes. "The east end of Orlando Field was a TAC [Tactical Air Command] base, and the west end was a SAC [Strategic Air Command] base. I think the old Airbase Inn is still there just southwest of the field."

Thousands of military personnel trained at the base. Many were crews of the bombers and fighter escorts who learned to fly in formation and work together during combat missions. Murphy recalls that "Pine Castle opened to accommodate the B-29s. My Dad drove down there every day via Conway Road. He said there was nothing there but the runway and a bunch of tents." Murphy is referring to Orlando's second air base, established in 1941 on city-owned land. The Pine Castle Army Air Field closed after World War II, but Orlando always knew the military could take it back.

The air force, established as a separate branch of the military after the war, did just that. Pine Castle Air Force Base, home to the first-generation B-47 jet bombers and F-89 fighters and site of the early flights of the X-1 rocket plane that Chuck Yeager later used to break the sound barrier, became a Strategic Air Command base with B-52 bombers carrying atomic bombs. The base, renamed McCoy Air Force Base in 1958 in honor of Colonel N.W. "Mike" McCoy, commander of a bomber wing killed in a 1957 plane crash, is today the site of Orlando International Airport. Travelers still find the name MCO on their baggage tickets, which stands for McCoy.

During World War II, the Army Air Forces also trained pilots and crews at a satellite base in Kissimmee, the site of what is now Kissimmee Airport. Murphy notes, "The first field in Kissimmee was out on Michigan Avenue. I have a picture of a Curtis Jenny [a biplane] at the field." The Curtis JN-4 "The Jenny" was originally used to train military pilots and later used for stunts, including wing walking. Murphy's father spent a lot of time at that base. "As I remember the barracks were inside the field, rather than outside," Murphy writes.

"I remember when they built the practice basketball court at Osceola High School, they brought the sand in from the old ammo dump and firing range. There was more lead than sand, and us kids collected the bullets after they dumped the sand at the school." He also recalls the old T-6s "that flew in and out of there all day long. I was in the second grade then." Finally, Murphy remembers when racing legend Don Garlits "ran his first dragster at the field on the old taxi way next to the dump."

One of Kissimmee's favorite sons helped pioneer the use of airplanes in battle. Kissimmee-born Captain Walter R. Lawson Sr. spent his early school years in Florida before moving to Alabama. He joined the Army Air Corps as a pilot, winning the Distinguished Service Cross for acts of heroism in France during World War I. Lawson would be famed air-power proponent Billy Mitchell's choice to fly the lead plane—one of six Martin MB-2 bombers—for a historic demonstration, according to an account reprinted in 1987 for *The Osceola County Centennial Book*. In the years before army and navy leaders recognized the role airplanes could play in the nation's defense, Mitchell, top aviator for the Army Signal Corps during World War I, saw that the future of warfare belonged with air power.

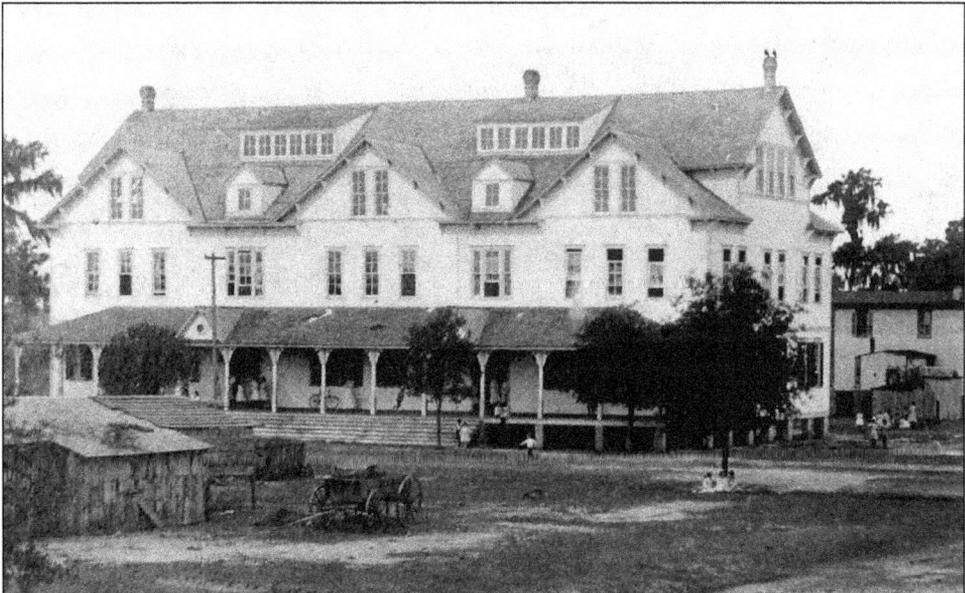

All 12 grades attended classes in this building, built in 1896. It burned in 1906.

His chance to disprove the navy's claim that aircraft could not sink a battleship came in 1921, when after repeated demands Congress granted permission for an air attack on captured German warships. The 27,000-ton *Ostfriesland* was labeled unsinkable. It had survived 18 direct hits from the British Navy during World War I. Three hulls and 85 watertight compartments protected the ship.

Newspaper reporters and dignitaries watched as the Martin MB-2 planes took off from Langley Field in Virginia. Lawson delivered the first 2,000-pound bomb, the first of three direct hits that doomed the German battleship. Twenty-one minutes after the first explosion, the *Ostfriesland* began to sink stern-first into the Atlantic. Lawson and his crew sank the battleship *Alabama* two months later. But only two years later, on April 21, 1923, Lawson and crew were killed when their plane crashed after taking off from a base near Dayton, Ohio. Billy Mitchell pulled Lawson's body from the wreckage.

Mitchell, whose struggle helped create the air force as a separate branch of the military, attended the service at Arlington National Cemetery a few days later when Martin MB-2 bombers flew in the missing-man formation over Lawson's gravesite. "The accident has robbed the Army air service of a man who meant more to the national defense of this country than any other person," Mitchell told a magazine reporter years later. "Capt. Lawson was probably the most expert

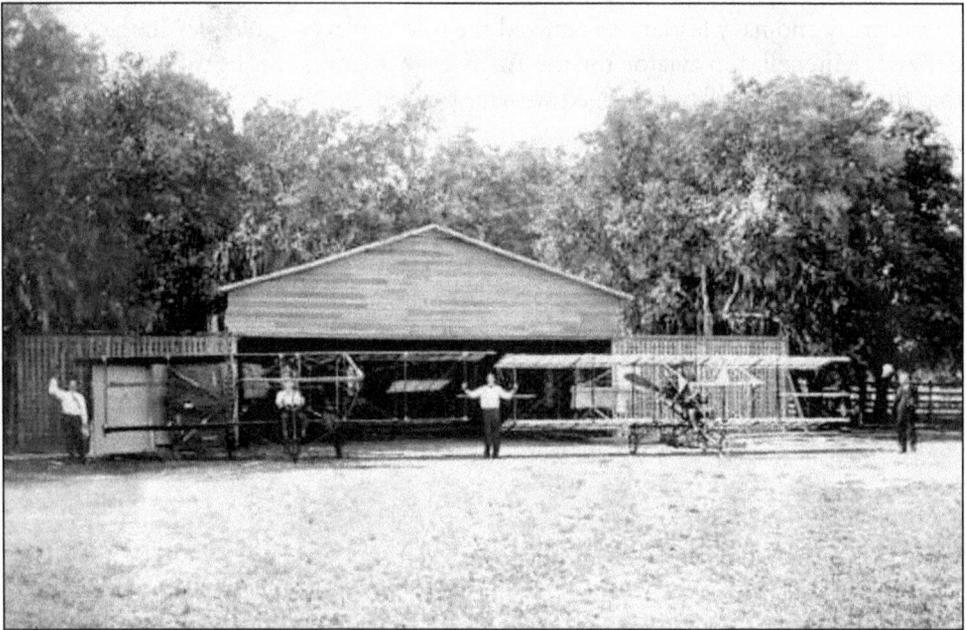

This is one of Kissimmee's early bi-plane hangers, shown in about 1910. Kissimmee had not been enamored with aviation. The city in 1908 proposed a measure to regulate planes, dirigibles, and other aircraft in its airspace and set speed limits at different altitudes. The measure was ridiculed across the country, and a sheepish City Attorney P.A. Vans Agnew, who had drafted the measure, later insisted it had never taken effect.

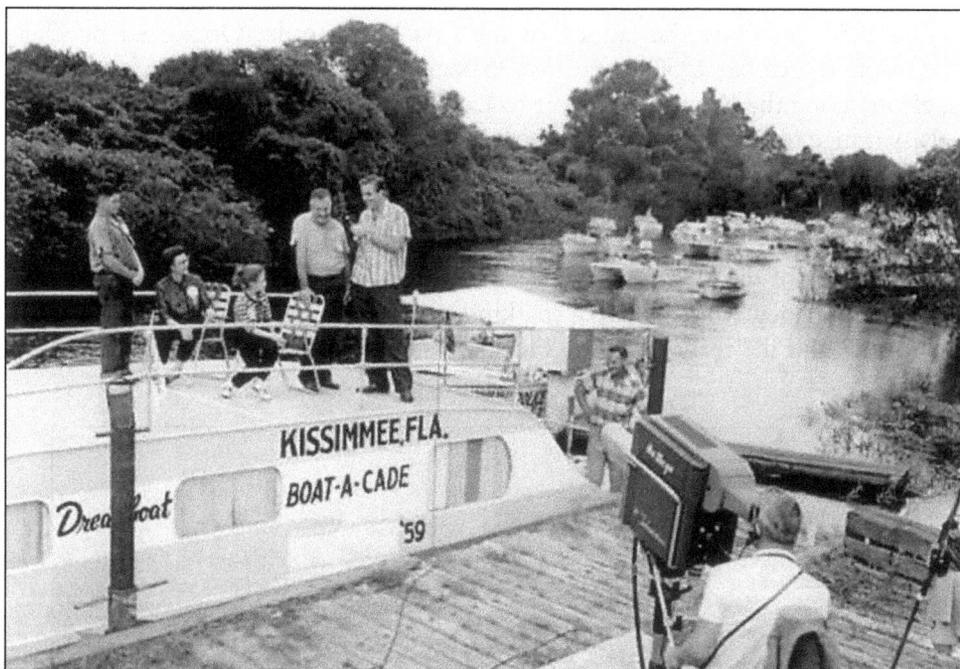

The Kissimmee River boat-a-cade drew a lot of media attention. Here a television crew is filming the 1959 boat-a-cade.

bomber flyer in the air service, God rest his soul." Lawson's father, F.W. Lawson, returned to his home in Kissimmee with the folded Stars and Stripes that had been draped over his son's coffin.

The same war drew women into military duty. Pat Rudd, whose husband, Gerald Rudd, was a navy veteran from one of Osceola County's pioneer families, served overseas in the navy's WAVES (Women Accepted for Volunteer Emergency Services.) She signed up in 1942 when she was 22 as one of the first 200 women accepted as recruits to take over office duties and free up men for combat.

Grace Johnston's grandparents had come to the Shingle Creek area of Kissimmee during World War I. She grew up living in the family home on Old Dixie Highway. She graduated from Osceola High School in 1942 when the nation was fighting the Second World War. Near the end of the war, when Kissimmee needed teachers, she started her 35-year career as an educator, spending nearly all of that time at Osceola High. She never expected to return to the same classrooms of her high school years. "I liked teaching," she told a reporter in 1995, "and that was the last thing I said I would do."

By the early 1950s, several professional ballplayers started a baseball school on Clyde Avenue. Several Class AA teams trained there, but the school never caught on. The Cleveland Indians and the Jacksonville Suns trained at the field in the 1960s. Today, Kissimmee's Osceola County Stadium is the spring home of the Houston Astros.

The 1950s also saw the launch of the first boat-a-cade. Organized by Dick Makinson in October 1950, it featured 75 boats, which traveled from Kissimmee's lakefront along the Kissimmee River to Lake Okeechobee.

Kissimmee residents turned their attention skyward in October 1965, when the Rotary Club of Kissimmee held its first air show, featuring two "aerobatic" flying clubs from Miami, skydivers, and an Orlando flying enthusiast piloting a midget plane. In 1976 the Legislature designated it as the Florida State Air Fair.

The decade of the 1970s would bring the world to Kissimmee. On October 1, 1971, Walt Disney World opened, sparking a period of unprecedented growth for Kissimmee and the rest of Central Florida.

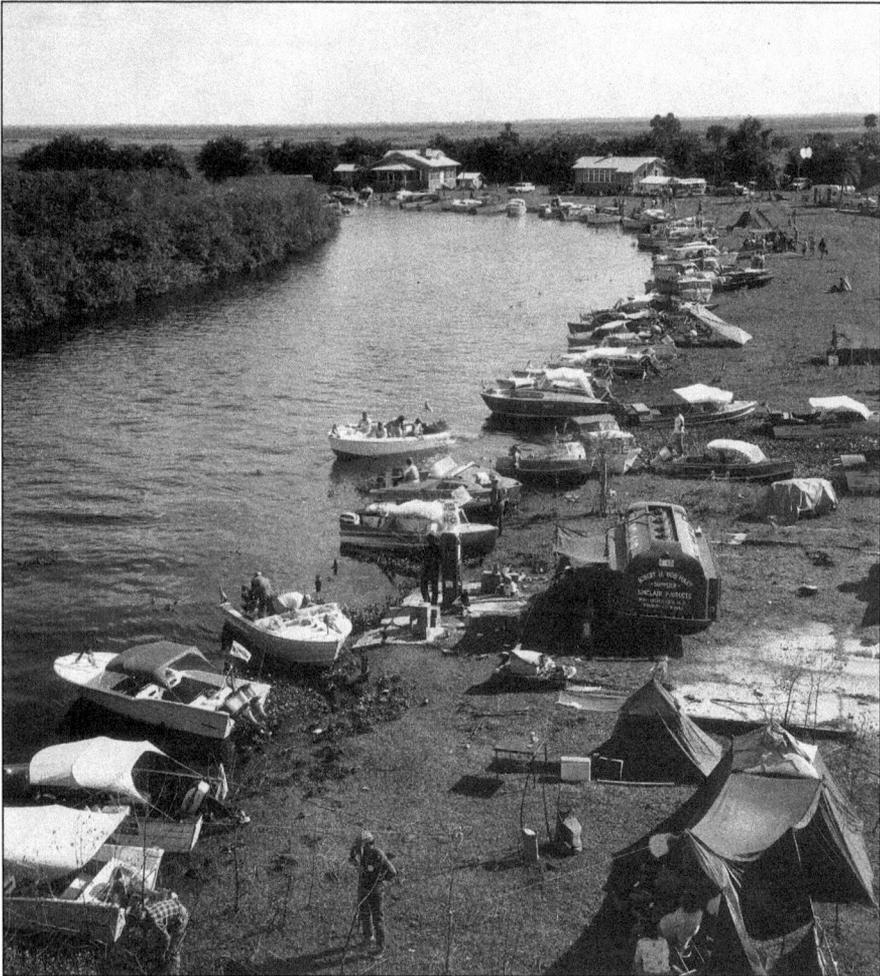

On many of the Kissimmee River boat-a-cade tours participants pitched their tents along the river for overnight stays. This scene was shot in 1955.

11. Opening of Walt Disney World Helps Kissimmee Recapture Its Past

Kissimmee can claim the first mayor of the Magic Kingdom as a favorite son. Joseph Jefferson Griffin Jr., born in Kissimmee on January 16, 1913, wasn't really the mayor of the Walt Disney World's Magic Kingdom. But he was the first mayor of Disney's self-governed village of Lake Buena Vista. He served for five years.

Griffin's family has deep roots in Central Florida history. The family history is featured in *The Osceola County Centennial Book*, published in 1987 to mark the first century since the county split off from Orange and Brevard Counties. Griffin's grandfather, Lawrence Jefferson Griffin, was a Confederate veteran who moved from Gadsden County in the Panhandle to the Lake Conway area of Orange County in 1872. L.J. and Julia Griffin had a big family, three children born before moving south and nine more in Central Florida. About 1910, three of the sons with their families moved to Kissimmee.

One of L.J. Griffin's grandsons, Joseph Jefferson Griffin Sr., born in 1874, was later elected to the Osceola County Commission, serving one term as chairman. He ran a garage and a car dealership on Monument Avenue. He was also an engineer for an Apopka lumber company and for the Florida East Coast Railroad.

One of his sons, J.J. Griffin Jr., opened an insurance company with offices in St. Cloud and Kissimmee in 1935. During his 35 years as an insurance executive, he also served on the board of two banks as well the former Florida Telephone Company, which became United Telephone and now is part of Sprint. Griffin won election to the state Legislature in 1952, taking the seat vacated by Irlo Bronson Sr. when he won a seat in the state Senate. Griffin represented Orange and Osceola Counties until 1967, chairing the Appropriations Committee. His last years as a state lawmaker put him in a leadership position when Walt Disney's lawyers secretly acquired land for the theme park on 27,400 acres straddling Orange and Osceola Counties. Griffin is credited with helping establish Walt Disney World's self-governing umbrella.

Between the fall of 1965 and early 1967, Disney officials lobbied vigorously for the legislature to designate Disney's land as a quasi-governmental district that would have broad powers in road construction, utilities, zoning, building codes, drainage control, and environmental management. The proposed Reedy Creek Improvement District would contain two cities: Lake Buena Vista and Bay Lake. Although still taxed by Orange and Osceola Counties, Disney gained the broad administrative powers it wanted. The bills passed both houses of the legislature in May 1967 with only one dissenting vote.

Griffin did not seek re-election in 1967. Instead, he served as mayor of Lake Buena Vista, one of the two "town" governments within the Disney property. He also served on the board of directors of the Reedy Creek Improvement District. Griffin moved to Brevard County in 1987. He died January 4, 1993.

The Magic Kingdom that Griffin helped establish spurred many new tourism businesses to open along Kissimmee's stretch of U.S. Highway 192. But, by the early 1980s, downtown Kissimmee had become a strip of aging stores and offices. The pioneer cattle boomtown was starting to look like an old West ghost town. Longtime shop owners depressed by the declining surroundings seriously considered abandoning downtown. Business and civic leaders had seen it coming since the 1970s; the Walt Disney World spillover commerce bringing shopping centers and fast-food restaurants to Vine Street was ignoring downtown.

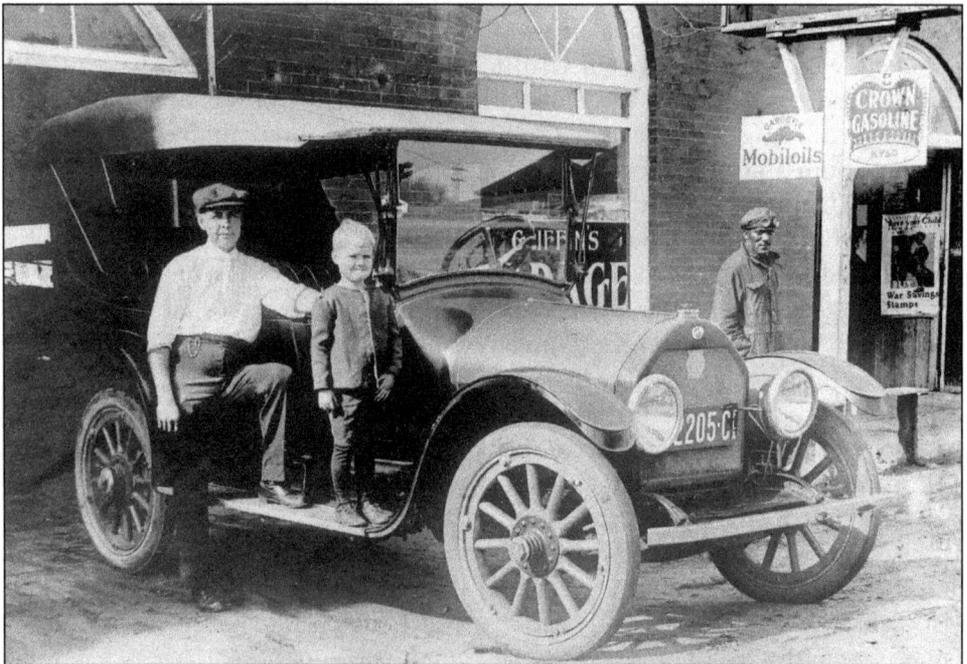

Joseph J. Griffin stands with his son, Joseph J. Griffin Jr., outside his garage on Monument Avenue in 1917 or 1918.

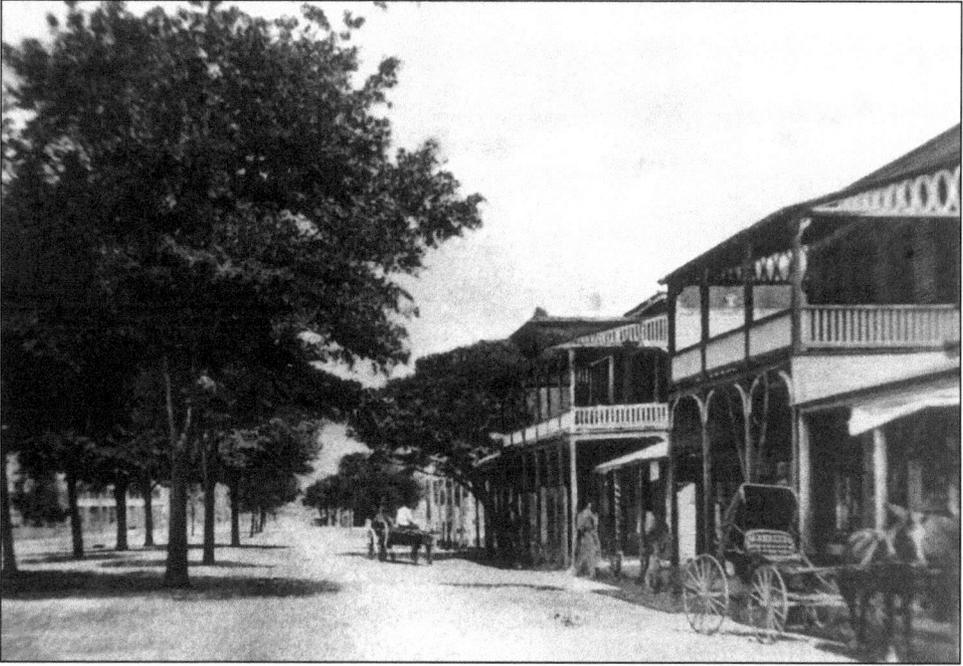

This is Broadway before 1910 when the street was paved with bricks and the line of oak trees was cut down. The Tress newsstand is in the foreground.

It was time to spruce up Broadway with brick streetscaping, new palms and shrubs, and decorative wood casings around street lamp poles. A 1978 referendum approved a special tax. Shop owners started investing in their own remodeling projects. New shops and restaurants opened. Building by building, block-by-block, a little fresh paint, new signs, and repairs restored the downtown architecture's pioneer character. Builders, as they tore down walls that were erected during prior renovations, uncovered old arches and atria. Long-gone balconies were restored to recapture the old-time Western look.

A marina with 55 boat slips was built on the lakefront. City commissioners approved a $25.3 million plan to revitalize downtown. The improvements include more parking, additional landscaping, and sidewalks and new roads. And Kissimmee has its architectural heritage. From grits to grand, Osceola County has some pretty remarkable landmarks.

The Osceola County Historical Society's Cracker House at the Spence-Lanier Pioneer Center off Bass Road south of West U.S. Highway 192 offers a taste of what life was like for many early families. But the secluded Tucker-Ivey Estate, set deep back from Old Dixie Highway, opens a view of the grand lifestyle few could afford. Both properties on the outskirts of Kissimmee hold special places in the history of Osceola County.

Bill Bauer, a St. Cloud architect, included both when he selected Kissimmee's landmarks for a statewide guide by the American Institute of Architects. In the

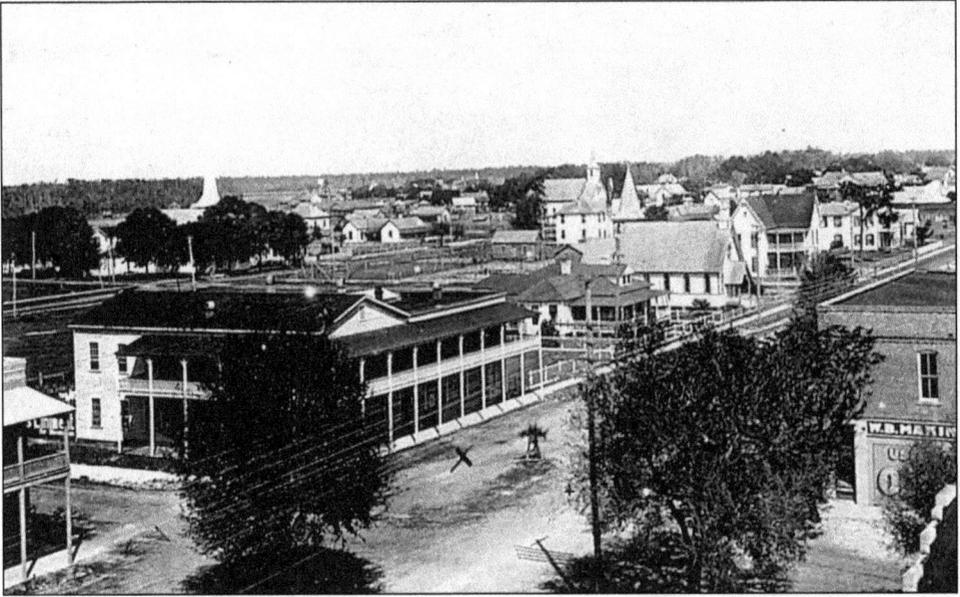

Downtown Kissimmee, shown here in the early 1900s, was in need of renovations in the years just after Walt Disney World opened.

mid-1980s, when Bauer contributed the Osceola County chapter for the institute's *Guide to Florida's Historic Architecture*, the Cracker House, also called the Lanier House, was still on Ham Brown Road near Campbell City. The cypress board house was moved to the oak-shaded Pioneer Center at 750 North Bass Road in 1987, helping mark Osceola County's centennial.

In the 1860s, cattleman John Lanier ventured into the pine flatwoods, wet prairies, cypress swamps, and bay swamps known today as Osceola and Polk Counties looking for pasture land. The dog trot–style Lanier House and its furnishings date from the 1890s. Nearby is Tyson's Store, the country store museum built in the 1890s at Narcoossee for C.J. Tyson and later moved to the society's compound. Behind the old houses are a pioneer smokehouse and washhouse. The white cinder-block home donated by the Spence family is the society's research and administrative headquarters. Across Bass Road is the society's nature preserve with a half-mile trail bordering Shingle Creek.

Osceola County's George Lester Ivey was born near Shingle Creek. The community of Shingle Creek, which had its own post office by the 1850s, took its name from the cypress mill where shingles were split. The mail routes from Fort Mellon (Sanford) and Fort Brooke (Tampa) crossed at the Shingle Creek settlement, where post riders exchanged pouches.

Ivey's investments in citrus groves and the Osceola Fruit Distributors' packing labels of Kissimmee River and Kissimmee Jewel paid off enough to buy the former J. Wade Tucker estate in the 1930s. Tucker, a Georgia lumber baron, built the antebellum-style estate house in 1915 along Old Dixie Highway. The west

146

side of the estate is across South Orange Blossom Trail from Florida Hospital Kissimmee, but tall landscaping and trees shield it from view by passing motorists. The view is much better from Old Dixie Highway.

The estate, which once comprised more than 15 acres, included the Classic Revival style, two-story main house with ionic columned porticoes, Bauer writes. Think pre–Civil War plantations, Tara, Scarlett O'Hara, and Rhett Butler. The estate was once the center of Kissimmee's social life with a golf course and tennis court on the grounds. George Ivey and his wife, Hilda, called the property known today as the Tucker-Ivey Estate the Colonial House. The estate, listed on the National Register of Historic Places, remains a private residence of the Ivey family, which now owns Ivey Groves.

Besides the simple frontier buildings at the Pioneer Center and the grand style of the Tucker-Ivey Estate, Kissimmee and the rest of Osceola County retain many architectural treasures from those early years. Throughout Central Florida are houses, churches, schools, railroad stations, hotels, and other old structures that have survived "progress" in the form of demolition to make way for roads, shopping centers, office parks, condominiums, and suburban neighborhoods. Those historic treasures include riverboat captain Clay Johnson's century-old, one-story Queen Anne-style house on South Vernon Avenue between the lakefront and the courthouse in downtown Kissimmee. Johnson, who ran

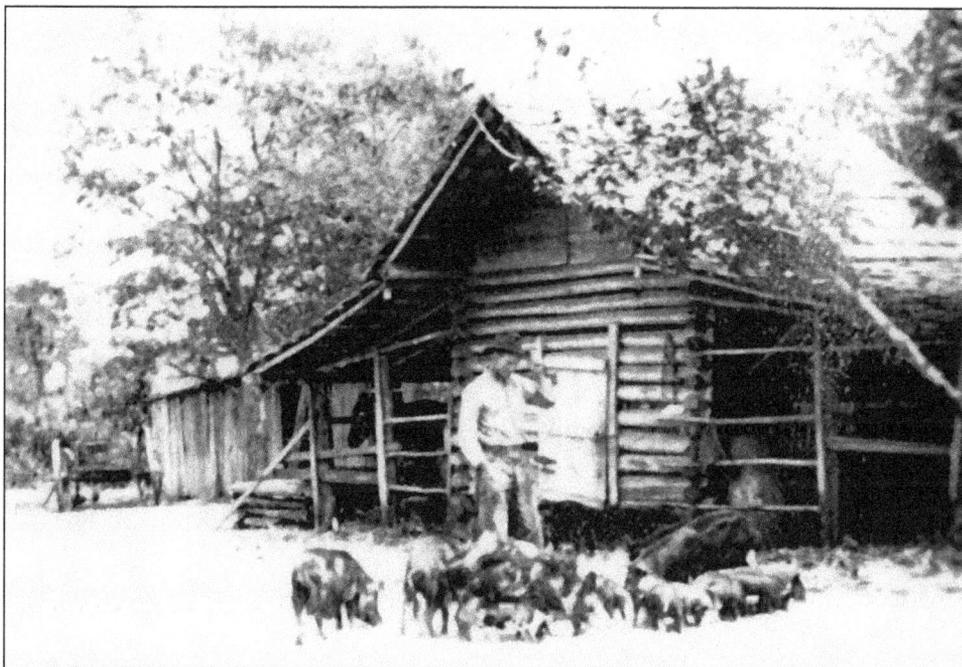

The Lanier Place, shown here when it was at Deer Park, is an 1890-era Cracker House relocated to the Osceola County Historical Society's Pioneer Center on Bass Road to show how many early Floridians lived.

Hamilton Disston's shipyard on Lake Tohopekaliga, and his son, Amory, designed the house built by shipyard carpenters from lumber milled nearby.

In addition to the Tucker-Ivey Estate, the original courthouse, two Kissimmee churches, a veterans hall in St. Cloud, and a Yeehaw Junction inn are on the National Register of Historic Places and the 41-block downtown Kissimmee historic district also is listed as a national treasure. The district is bounded by Aultman Street, Monument Avenue, Penfield Street, and Randolph Avenue.

The two Kissimmee churches are the Old Holy Redeemer Catholic Church on Sproule Avenue, built in 1912 in the Gothic Revival style and later used by other congregations, and the 1913 First United Methodist Church Building on Church Street, which remains of the best preserved buildings in the city.

Also on the national register is the 1914 G.A.R. Memorial Hall on Massachusetts Avenue in St. Cloud. It provided an auditorium on the ground floor and upstairs meeting rooms for Post No. 34 of the Grand Army of the Republic, which in the early 1900s helped draw 4,000 new residents, many of them veterans, to St. Cloud.

Finally, the century-old Desert Inn on Kenansville Road in Yeehaw Junction includes a bordello museum upstairs as part of its claim to frontier fame on the national register.

The Tucker-Ivey Estate, set off Old Dixie Highway, is an emblem of a grand lifestyle few could afford.

EPILOGUE: RESTORING THE MEANDERING KISSIMMEE RIVER

Those who attempted to travel the Kissimmee River, even after dredges dug out crude channels for steamboats in the late 1800s, found its beauty overmatched by its frustrating twists and turns. The challenges of the river, according to the December 29, 1899 edition of the *Kissimmee Valley Gazette*, can be found "in its narrowness, in the rampant growth of the water plants along its low banks, in the unbroken flatness of the landscape, in the variety and quality of its bird life, in the labyrinth of bychannels and cutoffs and dead rivers that beset its sluggish course, and above all its appalling incredible, bewildering crookedness of its serpentine body." The newspaper added: "There are bends where it takes nearly an hours [*sic*] steaming to reach a spot less than a hundred yards ahead of the bow. On either side as far as the eye can reach lies the prairie dotted with small hammocks. Occasionally the bank rises a few feet to a ridge or hammock and the steamers make a landing."

From his sugar-cane plantation at St. Cloud and his land-sales headquarters at Kissimmee, Hamilton Disston began draining massive lands for the Kissimmee River Valley in the 1880s. But Disston did not tame the wild river. Disston's dredges dug out a river highway to the south from Lake Tohopekaliga, but the river's course remained about the same.

In the years after the Disston dredging, Kirk Monroe kept a diary of his canoe travels up the Caloosahatchee River to Lake Okeechobee and along the Kissimmee River to Kissimmee. Writing on February 21, 1892, Monroe records the day he loaded his canoe onto the steamer *Gertrude* for the final journey up the Kissimmee River: "I have made arrangements to go up river on her. All hands are drunk tonight. Gertrude brought three passengers, Northern men, who wanted to see the country and are disgusted with it." When the captain came down with the measles, Monroe took over as pilot. He writes: "I am acting alternately as cook and pilot. Have made two batches of bread since coming aboard."

Days later, he adds, "Captain is very sick and needs all bedding, which is pretty rough on the rest of us as a norther has set in and the night is very cold." Twice the steamer had to tie off along the bank while crews cleaned out the clogged flues of the wood-burning engine. Doris M. Lewis writes in *The Kissimmee Island, Piney Wood Rooters* that Monroe made it to Kissimmee in four

days, hiring a mule team to haul his canoe to Orlando, where he took a train to Jacksonville and back north.

In the early 1900s a gathering of some of the most powerful people in the state and the nation organized the Florida Audubon Society to stop the plunder of Florida's plume birds for profit. The hats worn by fashionable ladies of the late 1800s were decorated with the feathers and plumes of game birds killed along the marshlands of the St. Johns and Kissimmee Rivers. Hunting crane, egret, and other wading birds provided a livelihood for many of the state's early settlers. European designers of women's hats paid a high price for the Florida plumes, the bird's "marriage" feathers, fullest only once a year during the mating season.

On March 2, 1900, Louis F. Dommerich, a wealthy New York businessman who had built a winter estate at his orange groves in Maitland, founded the society. Among the first officers and supporters were President Theodore Roosevelt, railroad baron Henry M. Flagler, Governor Will Jennings, the presidents of Rollins and Stetson Colleges, and the editors of leading newspapers in the state.

The society's first goal was to end the slaughter of the hundreds of thousands of birds killed only for their plumes. "In one year alone in the late 1800s, more than 130,000 Snowy Egrets were killed for their feathers," according to the

Completing the job started by Hamilton Disston, dredging in the 1930s through the 1960s straightened the Kissimmee River into a canal that made it easier to control flooding.

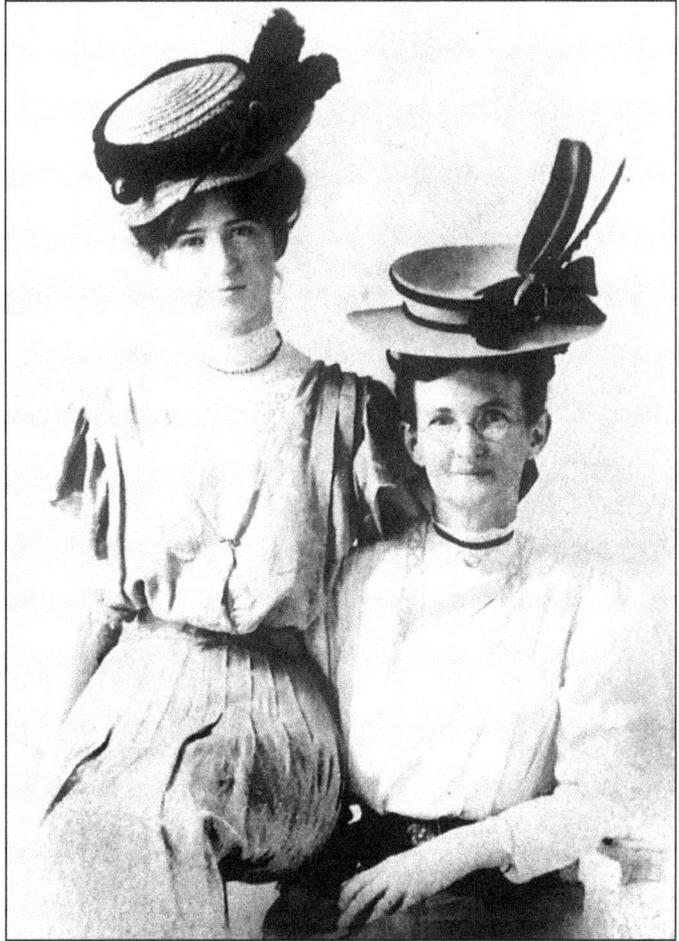

These two unidentified Kissimmee women are wearing the latest in fashion—feathered hats. The popularity of the hats prompted widespread killing of Florida birds for their feathers and led to the founding of the Florida Audobon Society to protect birds.

society's historical research. "Within a year of its founding, the Society helped pass a measure in the Florida Legislature that outlawed the killing of some wading birds—the first time the state had ever considered the protection of nongame birds." Still, New York hat makers were pocketing $17 million a year at the time. Alma Hetherington writes in her book, *The River of the Long Water*, of the widespread plunder, despite the state law protecting the birds and other wildlife. Federal law in the early 1900s stopped interstate commerce in birds protected by state laws.

The Audubon Society also organized public opinion against the poachers and fashion designers and, in some cases, hired game wardens to protect Florida's wading birds. Poachers were suspected in the 1905 murder of Audubon warden Guy Bradley on Cape Sable. The Society responded with rewards and pushed for prosecution of anyone hunting protected birds.

The sport hunters, though, had political power behind them. Mark Derr writes in his 1989 book, *Some Kind of Paradise*, steamboat captains organized

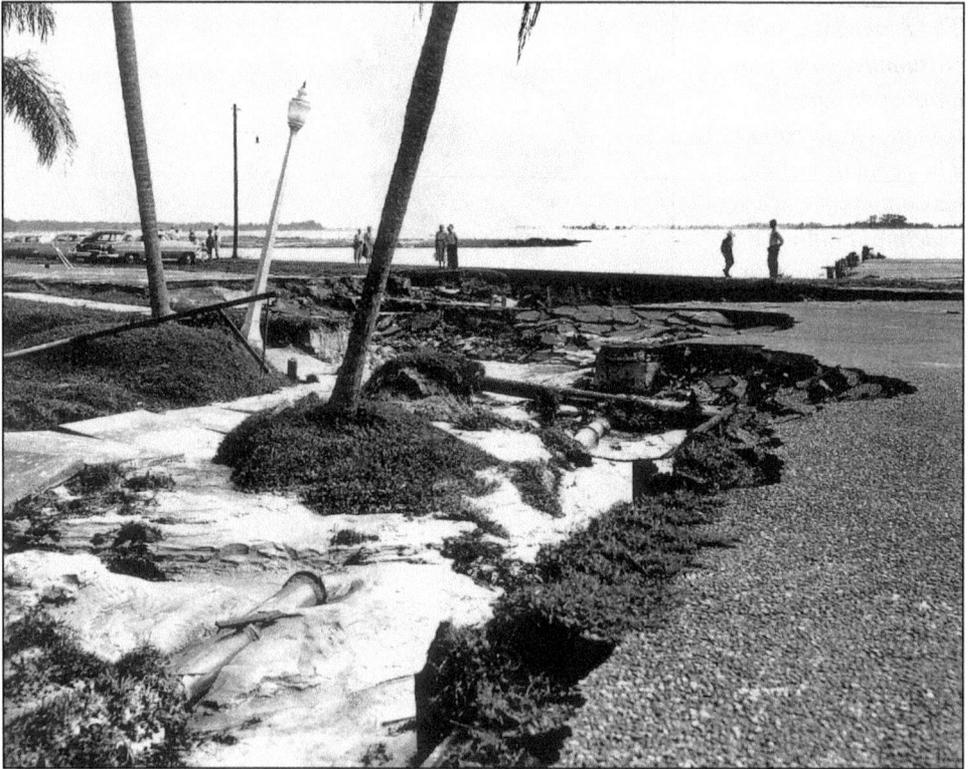

Heavy rains in October 1956 badly damaged the Kissimmee lakefront.

hunting expeditions that allowed the slaughter of egret and herons. "A favorite male pastime involved lining the decks of steamboats and firing at everything in an orgy of noise, gunpowder fumes, and death," Derr wrote. "The census of species hunted to the edge of extinction during the period between 1870 and 1930 is staggering. . . . So thorough was the destruction of plume birds that within several generations collective memory of the rookeries was as dead as the birds themselves."

While working for the Audubon Society, Florida Quaker T. Gilbert Pearson successfully lobbied New York to outlaw its plume trade, but hunters shipped their feathers to Havana. From there, they sent the plumes to Paris and London, where they were made into hats and legally sold in the United States until federal laws were passed to ban their importation. The Society was aided by changing fashions. Derr writes that when feathered hats became part of the garb of prostitutes, finer ladies shunned plumes.

Audubon Society lobbying led to state preserves and sanctuaries to protect birds and creation of the state Game and Fresh Water Fish Commission, now known as the Florida Fish and Wildlife Conservation Commission. The Society started *Florida Naturalist* in 1927. The society's magazine continues to promote conservation and environmental education and to influence public leaders.

About the time the Audubon Society was beginning its effort to save the birds of the Kissimmee River Valley, the U.S. Army Corps of Engineers was studying Disston's canals, eyeing major navigational and flood-control projects on the Kissimmee River. Napoleon Bonaparte Broward's notoriety as gunrunner in the years before the Spanish-American War gave him name recognition when he campaigned for governor of Florida in 1904 on a pledge to drain the Everglades. Digging of canals began soon after he won election. As governor, Broward opened more land on Florida's frontier to the south. The work attracted a new wave of farmers and the Florida land boom of the 1920s when unscrupulous salesmen cheated Northerners who bought worthless land and prompted fraud investigations. The real-estate boom went bust in the late 1920s, on the eve of the Great Depression.

Two late-1920s hurricanes, made worse by the crumbling dikes of earlier drainage projects and flooding that killed thousands of people, prompted the U.S. Army Corps of Engineers to build a flood wall around Lake Okeechobee, cutting off the natural water flow to the Everglades. Extreme drought followed, shrinking the shoreline of Lake Tohopekaliga so that youngsters played baseball on the lakebed for two years. Then, in 1947, a heavy rainy season followed by hurricanes in August and September put much of South Florida under water for months. Bob Cody, editor of the magazine *The Florida Cattleman*, boarded a Piper Cub for a flight over the flooding.

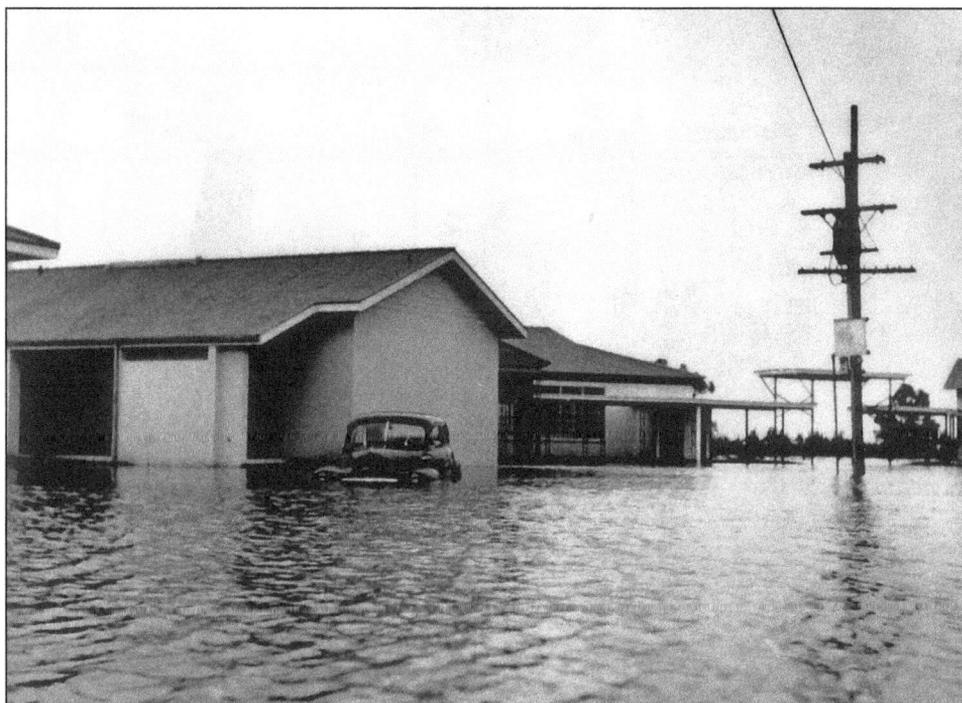

The October 1956 storm caused extensive flooding in Kissimmee. This scene shows Osceola High School at Beaumont and Aultman.

"The St. Johns seemed 20 miles wide, flowing speedily northward to tidewater at Lake Monroe," Cody wrote. "The Kissimmee also had a strong current and ran about 10 miles wide through overflowed pastures near its mouth." The pilot was Clay Steffee, grandson of legendary steamboat captain Clay Johnson, who came from Louisiana when swamp drainer Disston offered him the job of superintendent of his shipyard on Lake Tohopekaliga. Historians rank Johnson as one of the best of the riverboat captains of his time. One wrote in 1911 that Johnson "knows every cove of the lakes and every crook and turn of the rivers in the Kissimmee valley as well as some men know their front yards."

His grandson, flying a small plane over the flooded Kissimmee River Valley, stalled the engine to slow the plane and drift over the flooded landscape. That gave Cody the opportunity to snap pictures later used to convince Congress of the need for massive spending to try to control the cycles of floods and droughts. "I was scared to death the whole time," Cody later wrote. Congress in the 1940s approved straightening and channelization of the Kissimmee River as part of flood-control and land-reclamation projects.

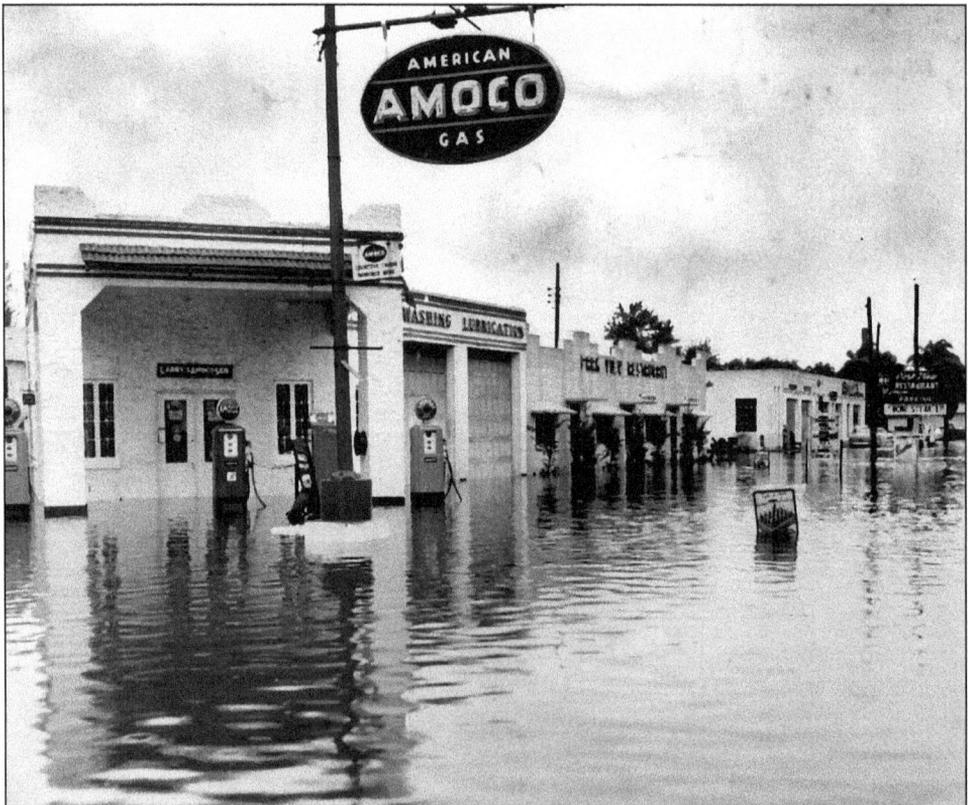

St. Cloud's New York Avenue and 13th Street flooded in the aftermath of Hurricane Donna in 1960.

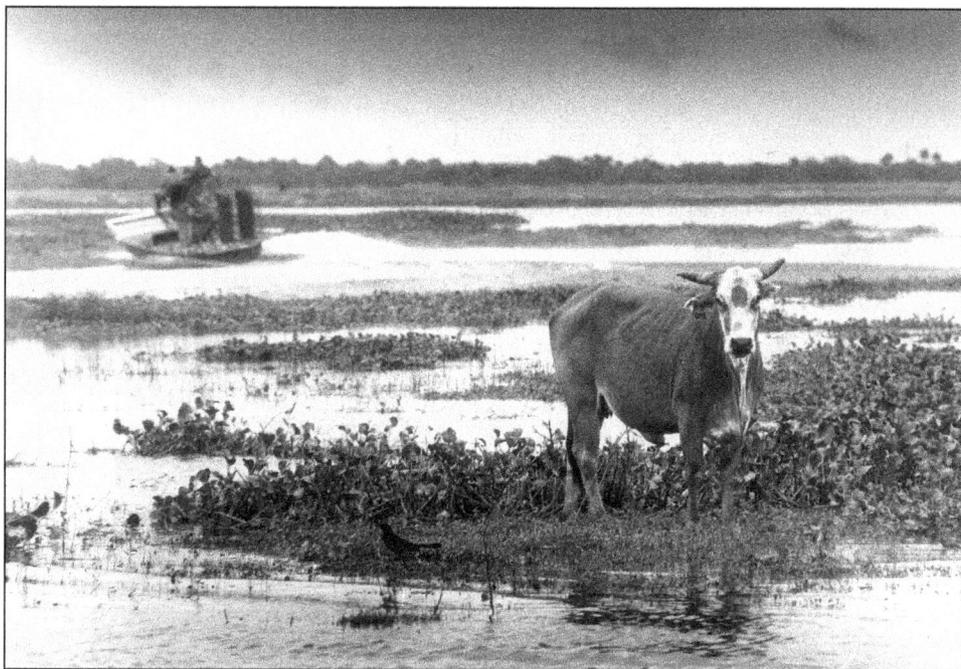

Cattle ranching on the Kissimmee River will likely continue for years to come, but ranchers and conservation groups are working on ways to accommodate each other.

Storms had drenched Kissimmee and St. Cloud in 1947, 1948, 1956, 1958, and 1959, but soggy Hurricane Donna set the benchmark for flooding in most of Central Florida. The 1960 hurricane, considered the worst to hit this area in more than a century, came after back-to-back years of above-average rainfall. Then Donna filled every pond and ditch, saturating the earth.

To further control the cycle of floods and droughts in the Kissimmee Valley, the corps of engineers and a state flood-control district spent $32 million to divert 103 miles of the river into a 56-mile channel between 1961 and 1971. Tens of thousands of acres of wetlands along the river were destroyed. And the canal soon became an environmental mess in other ways: Fish died and migratory birds disappeared. The state began pushing for river restoration in 1976. After decades of debate about the environmental nightmare created by Disston and later canal diggers, public and private efforts are under way to return the river its meandering course.

More money will be spent for upstream improvements, including restoring thousands of acres of wetlands. The Kissimmee River Restoration Project was authorized by Congress in 1992 to restore more than 40 square miles of the river's floodlands. Water birds are coming back. Oxbows are returning. Native plants are returning to the shoreline.

A partnership between the federal government and the Nature Conservancy owns some 3,700 acres on two ranches in Highlands County in an effort to find

155

out whether cattle and wetlands can share the land. The wood stork, whooping crane, and Florida panther are living on the same grasslands where cattle graze.

The Kissimmee of today is not the river of Clay Johnson's riverboat era. Dikes, dams, and canals control the once wild river. Still, the Nature Conservancy's plans to pay ranchers if they agree never to allow development of land near the river offers hope. Cattle still will graze in pastureland, but some ditches and canals will be filled to return ranchland to wetlands for the future of the river and wildlife. Doris Lewis's poem "Tears for the Old Kissimmee River," which should be read to the cadence of "Hiawatha," ends with these lines:

> Dead and gone the great blue heron,
> No more graze the deer and turkey.
> All the trees hang down in sadness,
> All the birds wild and frightened,
> For the poor Kissimmee River
> Is like an old man past his prime,
> diseased and cramped and past his time.
> Tears!!!! for the long lost Kissimmee.
> But, perhaps, the end has not been written for the wild
> Kissimmee River.

Fed by the waters of Shingle Creek, Reedy Creek, and Lake Tohopekaliga, the Kissimmee River made the lakefront city of the same name the headquarters for travel into South Florida and the gulf coast. This book was written to rekindle the memories of long-time residents and to inform newcomers and visitors about Kissimmee's role in opening up the vast Florida interior. As the county seat and largest of Osceola County's two cities, Kissimmee has a rich history. It also retains a strong identity separate from metro Orlando, the tourism hub of Central Florida. Today, Kissimmee and St. Cloud to the east enjoy the economic benefits of Central Florida tourism that includes the Walt Disney World properties, Universal Studios Orlando, Sea World, and other major theme parks. Still, its residents are actively involved in preserving its heritage. Despite three decades of growth in Kissimmee and the north end of Osceola County that followed the opening of Walt Disney World, the vast pine and palmetto ranchlands and cypress swamps to the south along the Kissimmee River Valley, stretching to Lake Okeechobee, remain as close to wilderness as any other place in Florida.

BIBLIOGRAPHY

Akerman, Joe A. Jr. *Florida Cowman, A History of Florida Cattle Raising*. Kissimmee: Florida Cattleman's Association, 1976.

Barber, Mary Ida Bass. *Florida's Frontier, The Way Hit Wuz*. Gainesville, GA: Magnolia Press, 1991.

Belleville, Bill. *River of Lakes: A Journey on Florida's St. Johns River*. Athens: The University of Georgia Press, 2000.

Bauer, Bill. "Osceola". Guide to Florida's Historic Architecture. Gainesville: American Institute of Architects and the University Press of Florida, 1989.

Bruce, Annette J. *Tellable Cracker Tales*. Sarasota, FL: Pineapple Press, 1996.

Burnett, Gene M. *Florida's Past*. 3 vols. Sarasota, FL: Pineapple Press, 1986.

Cantrell, Elizabeth A. *When Kissimmee Was Young*. Kissimmee: Philathea Class, First Christian Church of Kissimmee, 1948.

Chandler, David Leon. *Henry Flagler, The Astonishing Life and Times of the Visionary Robber Baron Who Founded Florida*. New York: Macmillan Publishing, 1986.

Claire, Dana Ste. *Cracker: The Cracker Culture in Florida History*. Daytona Beach, FL: The Museum of Arts and Science, 1998.

Cody, Aldus M. and Robert S. Cody. *Osceola County: The First 100 Years*. Kissimmee: The Osceola County Historical Society, 1987.

Covington, James M. "Formation of the State of Florida Indian Reservation." *The Florida Historical Quarterly* 64.1 (1985): 62–75.

Crow, Myrtle Hilliard. *Old Tales and Trails of Florida*. St. Petersburg, FL: Southern Heritage Press, 1987.

DeVane, Albert. *Early Florida History*. Sebring, FL: Sebring Historical Society, 1978.

Derr, Mark. *Some Kind of Paradise*. Gainesville: University Press of Florida, 1998.

Elliott, Brenda. "Florida Cracker Cattle Lore: The Florida WPA Files." *The Proceedings of the Florida Cattle Frontier Symposium* (1995).

Francke, Arthur E. *Coacoochee, Made of the Sands of Florida*. Arthur E. Francke, 1986.

Gannon, Michael, ed. *The New History of Florida*. Gainesville: University Press of Florida, 1996.

Giddings, Joshua R. *Exiles of Florida*. Gainesville: University of Florida Press, 1964.

Gramling, Lee. *Ghosts of the Green Swamp*. Sarasota, FL: Pineapple Press, 1996.

Harner, Charles E. *Florida's Promoters, The Men Who Made It Big*. Tampa, FL: Trend

House, 1973.

Hetherington, Alma. *The River of the Long Water*. St. Petersburg, FL: Southern Heritage Press, 1980.

Hurston, Zora Neale. "Lawrence of the River." *Saturday Evening Post* 5 September 1942: 18, 55–57.

———. *Their Eyes Were Watching God*. New York: J.P. Lippincott, 1937.

Laumer, Frank. *Massacre*. Gainesville: University of Florida Press, 1968.

Mahon, John K. *History of the Second Seminole War, 1835–1842*. Gainesville: University of Florida Press, 1967.

Matthiessen, Peter. *Bone by Bone*. New York: Vintage Books, 1999.

Milanich, Jerald T. *Florida Indians and the Invasion from Europe*. Gainesville: University Press of Florida, 1995.

Moore-Willson, Minnie. *History of Osceola County*. Orlando, FL: Inland Press, 1935.

———. *The Seminoles of Florida*. New York: Moffat, Lard & Co., 1910.

Motte, Jacob Rhett. *Journey Into Wilderness*. Gainesville: University of Florida Press, 1963.

Murphy, J.M. "Florida Razorbacks" Tales of Old Florida. Secaucus, NJ: Castle, 1987.

Nolan, David. *Fifty Feet in Paradise*. New York: Harcourt, Brace Jovanovich, 1984.

Otto, John Solomon. "Florida's Cattle-Ranching Frontier: Manatee and Brevard Counties." *The Florida Historical Quarterly* (1985).

Parry, Albert. *Full Steam Ahead!* St. Petersburg, FL: Great Outdoors Publishing, 1997.

Robison, Jim and Mark Andrews. *Flashbacks: The Story of Central Florida's Past*. Orlando, FL: The Orange County Historical Society and *The Orlando Sentinel*, 1995.

Robison, Jim and Robert A. Fisk. *St. Cloud*. Charleston, SC: Arcadia Publishing, 2002.

Smith, Patrick D. *A Land Remembered*. Sarasota, FL: Pineapple Press, 1984.

Swanson, Henry F. *Countdown for Agriculture in Orange County, Florida*. Orlando, FL: Designers Press of Orlando, 1975.

Tebeau, Carlton W. *A History of Florida*. Coral Gables, FL: University of Miami Press, 1971.

Tinsley, Jim Bob. *Florida Cow Hunter: The Life and Times of Bone Mizell*. Gainesville: University Press of Florida, 1990.

Tucker, Gilbert A. *Before the Timber Was Cut*. Gilbert A. Tucker, 1999.

West, Patsy. *The Enduring Seminoles, From Alligator Wrestling to Ecotourism*. Gainesville: University Press of Florida, 1998.

Wickman, Patricia R. *Osceola's Legacy*. Tuscaloosa, AL: University of Alabama Press, 1991.

Winn, Ed. *The Early History of the St. Johns River*. Self published, 2002.

Will, Lawrence E. *Okeechobee Boats and Skippers*. St. Petersburg, FL: Great Outdoors Publishing, 1964.

Wittenstein, Joseph. "A Chronology of the Early Jewish Settlers in the Orange County Area from 1875 to About 1925." unpublished manuscript.

INDEX

www.ingramcontent.com/pod-product-compliance
Lightning Source LLC
Chambersburg PA
CBHW050616110426
42813CB00008B/2577